# seduced

*by the beauty of the world*

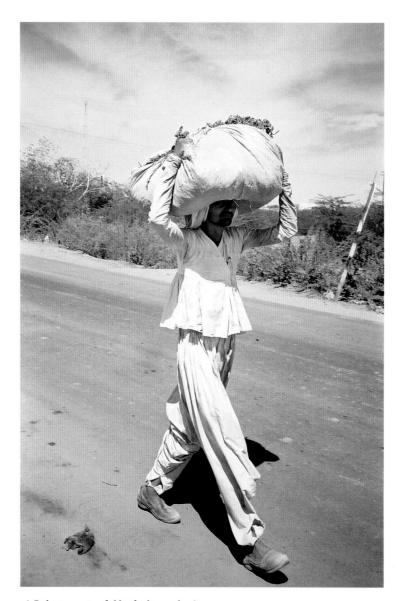

*A Rabari carrying fodder for his cattle, Gujarat*

# seduced

### by the beauty of the world

travels in india

PHOTOGRAPHS BY IMAN BIJLEVELD

TEXT BY DON BLOCH

HARRY N. ABRAMS, INC., PUBLISHERS

*Dedication*
For one another.

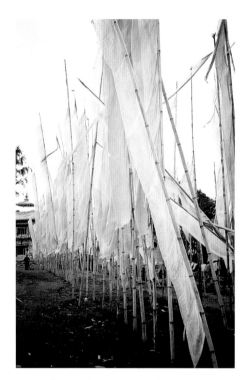

*Prayer flags marking the approach to*
*Tashiding Buddhist Monastery, West Sikkim*

# contents

introduction: *masti,* **6**

PART I: *in the moment,* **10**
1. minding the body, **12**
2. the community of the body, **24**
PORTFOLIO, **31**

PART II: *devotion,* **80**
3. pilgrimage of the common man, **82**
4. God's bodies, **92**
5. who fears not the sky, **99**
6. here are your pearls, **107**
PORTFOLIO, **115**

PART III: *seduced by the beauty of the world,* **160**
7. the body wanders, **162**
8. after-images, **169**
9. the body perishable, **176**
PORTFOLIO, **183**

# *introduction: masti*

THIS BOOK ATTEMPTS TO CAPTURE REALITY IN THE SPIRIT of *masti,* a Sanskrit word highly skittish when it comes to translation. *Masti* is quiet, ecstatic surrender to the beauty around us, an infatuation with the world. It was during one of our later visits to India that we first heard about the concept. As we stood on the roof of the maharajah of Varanasi's vast, decaying fort at sunset and watched the alluring play of light and color on the Ganges, our host took great pains to convey to us, his throaty speech looping back on itself like a jazz riff, that what *masti* means, roughly, is to be drunk on the here and now. It involves seeing the world clearly and whole, and knowledgeably enough to fall in love with it. He impressed on us that a deep, abiding commitment to the act of perception is prerequisite to achieving *masti,* even as he voiced regrets that the younger generation in Varanasi has lost the habit of patient observation.

Later, mulling over what the maharajah had said, we realized that in the attainment of *masti* under the conditions that prevail in India, in particular the unflagging demands that reality makes on the senses, photography can prove a valuable ally. Photographs help us quite simply to see the world by slowing it down. Detaching specific images from the rapid flux that crisscrosses our retinas, fixing reality, formalizing it, they enable us to take in at our leisure what otherwise we might have missed: precise color, detail, the relation of parts to the whole. "Stills" enable us to discern things that at the time they actually happen dazzle, confound, or overwhelm our ability to perceive them.

Since our initial visit to India in 1989, the country has been leapfrogging madly into the future—with nuclear tests and software wizardry, and televised serializations of ancient holy texts drawing the largest viewing audiences

the world has ever known. Yet much of contemporary life, in villages but also even in cities, seems incredibly, indelibly old. Indeed, the photographs in this book attest to how much such continuity attracts us. Our affinity is with tradition rather than change. Many of the pictures might have been taken anytime during the past few hundred years, here and there a bit of shiny, drip-dry polyester or a wristwatch to the contrary (and, of course, the technology of today's camera). The portfolios that follow do not feature photographic stunts. No wide-angle distortions, or long-shutter-time bravura. No feverish, blurry appropriation of reality for the photographer's own ends. They are modest photos, and intimate. People remain themselves in front of the lens. You can look them in the eye.

It is highly unlikely to escape the notice of anyone who looks through this book that there is hardly a photograph without people. People *are* everywhere in India, but Iman Bijleveld's choice of subjects betrays an anthropologist's eye prowling through the viewfinder. Along the way we did attend, with awe, a number of massive festivals and celebrations, sometimes by plan—Gangasagar in West Bengal, the Pushkar Camel Fair in Rajasthan, Dussehra in Kullu Valley, Himachal Pradesh—but also on occasion by dint of sheer, bungling traveler's grace—Saint Eknath's death day in Paithan, Maharastra, and Saraswati Puja in Varanasi, Uttar Pradesh. Great accumulations of human beings who share a common purpose are an important, recurrent part of every Indian's experience. For us, however, the truly irresistible lure of India, the source of our elation, remains more micro than macro, less the grand pageant than the details of the unexpected, everyday scene you find every time you turn a corner. Texts and photographs, we hope, impart that suspense and the excitement of continual surprise and discovery within the context of ordinary life.

Four trips to India during the past ten years spawned this project. The shortest lasted two months, the longest three and a half, a mix of exploring new places and revisits. Although the two of us had worked together for many years in Africa, Asia, and the Middle East, principally in the field of health systems research related to leprosy, tuberculosis, and AIDS control, we were both more than a little bit chary of India, for all the cliché reasons, and so gave her the cold shoulder. Finally in 1989 the now-defunct Dutch magazine *Avenue* tantalized us into exploring Sikkim and Orissa. In no time at all India got under our skin, and addiction rapidly followed. This book is an attempt to show why, to portray the sensory repletion that overcomes you in India. It is the only place we know where at the close of a typical day you are likely to catch yourself mumbling a wish that nothing more will happen, you've already had enough, no, too much to digest! But that's a kind of game you play with yourself, knowing full well as you cry whoa to the rich current that much more is invariably in store for you, right down to the last moment of waking consciousness. Most of the photographs in the following pages come from a journey that lasted from January through

March 1999. We landed in Calcutta, where after half an hour of head-on collisions with humanity, the windshield of our minds had shattered. From there we chugged west by train, renewing our special bond with Varanasi. After stops in Lucknow and Agra, we wended our desultory way by car through Rajasthan and then pre-earthquake Gujarat, ultimately reaching Mumbai (Bombay), where we began an excursion into northern Maharastra. It all remains startlingly vivid. In fact, even as we write this, a day in Calcutta from twelve years ago comes to mind in full detail, one that started at the riverside flower market in the pre-dawn. As we stood watching early bathers out back wade into the sluggish Hoogly, flat-bottomed boats heaped high with roses, jasmine, and coiled chains of marigolds came gliding downstream under the towers of Howra Bridge, vague rainbows emerging from the mist. The market in memory's eye thereafter is a maze of florid stalls: red, gold, pink, purple. Flowers sold by petal weight, scooped onto weighing scales, poured like flakes of grain into see-through plastic bags. Not flowers to cram into a vase, but to wear in garlands or lay on the laps of gods. In the evening, exhausted but reluctant to call it a day, senses tingling, we stroll down Sutter Street congested with people in motion—walking, lifting, shrugging, carrying, bargaining, counting, stirring, slicing, squeezing, running their various errands as if their very lives depend on it. We dawdle along and poke our noses into everyone's business. Cooking fires on the curb. Glowing barber shops, walls lined with mirrors. Sidewalk shrines with altars of glazed tiles and cut glass where points of light burst and ricochet. Crows swoop and blur, rats skip and splash. Halfway down a dark alley there's a sign, Auto Emission Testing, and beneath it, shoulders hunched, a man stands peeing against his shadow. Not looking where he's going, Iman bumps into a child in white who hands him a nosegay of white gardenias and is gone. As he buries his nose in their sweetness, a boy tugs at his sleeve. "A rupee,"—he sticks out his hand. "My money's at the hotel"—the truth sounds lame even to our own ears. "One rupee"—he twists a single finger in the air. We move on, he dogs our steps. "Give me a flower then," he begs. And when we do, he rewards us with a smile that would melt hearts far harder than ours.

Were it feasible we would have chosen a loose-leaf arrangement of photographs for this book to allow for the shuffling and reshuffling of sequences. Images change significantly as they acquire new neighbors. We have tried to make a selection where the whole is greater than the sum of the parts, pictures that cumulatively fuse into a journey full of the unexpected, without repeating. The book consists of three parts: In the Moment, Devotion, and Seduced by the Beauty of the World. This division is not hard and fast, categories spill over into each other organically. Each part comprises two or more essays, most of which, for their point of departure, take some aspect of the human body in India. Let us be clear at the outset; we are in no way experts on India, but we are enthusiastic novices. We know enough to know how little we know.

The climax of each part is a portfolio of apposite photographs. (For clarification of the choice of the body as a red thread, see the initial essay in Part I, "Minding the Body.") Internal sequence follows no hard and fast pattern—at times it is place or subject matter that links pictures, at times it may be some visual consideration. The mind's associative faculties are fully in play.

Appreciating the importance of rigorous editing—*je weniger je mehr*—didn't make the process any easier for us. In our pool of thousands of images, everyone seemed to have different favorites, about which he felt passionately. Our own favorites, in fact, kept changing from day to day. Looking intensively at pictures over a long time turns out to be very educational for the eye, good training

for *masti.* Some photos illustrate specific events, scenes, persons described in the book's essays, but although we hope word and image amplify each other, they are not necessary to each other. The book's verbal imagery attempts to render in a different medium the same sense of wonder at the density of life in India that the photographs do, a world every bit as drenched in color and detail, and similarly exhibiting a profound devotion to and appreciation of surfaces.

Paradoxically, it is the very richness of surfaces in India that gradually becomes the most convincing argument we can advance in support of the position that surfaces are not all there is. Just as the pluriformity and beauty of the body provide the most compelling evidence possible for the existence of the spirit.

DON BLOCH
IMAN BIJLEVELD

# PART I

## *in the moment*

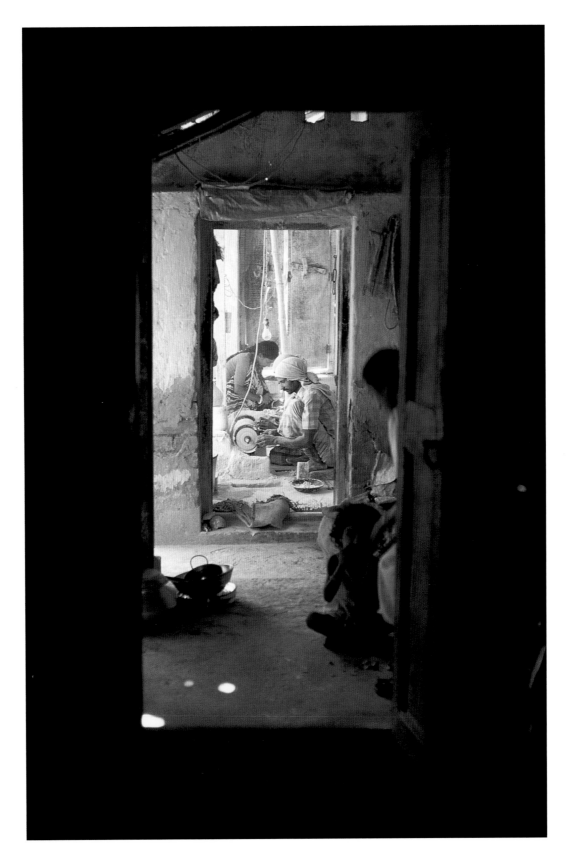

*Gem polishers, Puri*

# 1

## *minding the body*

AT THE DELHI CRAFTS FAIR, THE MAN STANDING NEXT TO me staring at the ground gives a cry and looks up, lifting a cannon ball attached to a chain hooked through his eyelid. In Sankalpur, Gujarat, at the Becha Mata Temple, a fifty-year-old matron kicks her sister along the ground as if unrolling a carpet. The sister, in a water-soaked sari, arms stretched alongside her head, her mane of hair snarling in the dust, rolls over and over, completing forty circuits of the temple, imploring the goddess all the way to make her husband potent.

In Cochin a brother and sister, eighteen and fifteen, demonstrate the waning martial art of Kalarippayattu, developed more than a millennium ago by the Aryan sage Parasurama after he observed fights to the death between snakes and leopards, boars and tigers, in which sudden, flexible moves enabled the weaker adversary to prevail in defiance of the odds. Leaping high, slashing, parrying with maces and *urumi* (a bull whip made of a metal strap)— every blow is choreographed. Nonetheless, scars betray the bloody price of even the slightest slip or hesitation. Calcutta, Sunday afternoon: among the thousands milling in the park that forms the green heart of the city, a girl of four walks a slack braided rope strung between two posts ten feet above the ground. The rope is thicker than her bare feet, and the balance pole she clutches in tiny, doll-like hands looks heavier than she is. Three copper water jars stacked on her head double her height. They flash in the late sun, crowning

her with fire. A few steps away, raucous school-boys in white practice cricket, putting their hearts into every throw and swing. Seated under a nearby flowering jacaranda, a young man with withered flippers for arms breathes into a flute and slaps a pair of drums. Scattered hucksters and con men do a brisk before-and-after trade in aphrodisiacs and remedies for sexually transmitted diseases (STDs). Spread at their feet, colorplates from medical text-books arrest passersby with illustrations of male genitals featuring a vivid and convincing array of sores, rashes, and venereal discharge. In the manicured temple grounds of Khajaraho, an Indian with a party of Japanese tourists in tow slouches as casually as Bogart in his prime, slipping a mirror out of his pocket to deflect a shaft of sunlight onto the private parts of an ancient, amorous stone couple, the pair locked already for centuries in a tricky embrace. Practice has made the guide's aim perfect.

* * *

THE BODY IN INDIA: Why choose the body as the way to penetrate the rich, confusing density of Indian culture? To begin with, stating the obvious: there are so many of them. Everywhere. A billion. And of diverse races and ethnic groups, too. Dravidians, Aryans, Chinese, a far richer mix than Westerners commonly suppose. What's more, bodies are not simply present in India; they are insistently so, enjoying far greater visibility than in the West. The newborn, the fit, the decrepit, the old. Every day their bodies do what bodies have to do. They eat, void, clean themselves, sleep, not in the comparative privacy that a majority of our bodies take for granted, but in public view. Climate conspires to keep the body flimsily covered in most parts of India, at most times of the year. Economic forces also create communities of the thread-bare. Work, moreover, isn't a matter of throwing a switch to start an engine. In India "man-power" means what it says. You see the things people make and how they make them; hand tools are an extension of the body. India is a land of ceremonies, rituals, processions, of bodies combining into crowds, crowds into masses. Worship in India involves putting the body through its paces, with movements and gestures taking precedence over words.

The idea of concentrating our attention on the body in India didn't just fall from the sky, however. Early experiences quickly accumulated. Lawyers in Delhi brought the national assembly to a halt—and us, too—when, to protest the humiliation of a colleague who had been forced by the police to ride in handcuffs on a crowded bus, they spilled into the street to encircle Parliament with a chain of their linked bodies. In Varanasi, formerly Benares, as we moved about in cycle rickshaws, we found ourselves comparing the physiques and ergonomic techniques of a succession of drivers, their taut backs, straining thighs, little quirks of personal driving style designed to ease pressure from saddle sores. At highway truck stops, at village tanks and ponds, along the banks of rivers, beside hydrants and standpipes in big cities, we saw people peel down to bathe. They lathered their bodies

with incredibly lavish quantities of soap. Strangers washed so close to each other they had to be able to hear each other's breathing. The shock I felt the first time I saw bodies burn on the cremation ghat in Varanasi did not fade with repetition. The flames seemed to highlight every feature of the deceased before they consumed it, cradling the corpse. It was as if fire left Death no place to hide. And a few minutes later, the crackling of dead tissue still echoing in my ears, I treated myself to a massage, stretched out on a pallet beside the river. A knowing pair of hands made me aware of my body, muscle, bone, circulatory system, lungs, as I had seldom been before. The strong kneading fingers brought home to me what a brilliant piece of craftsmanship the body is, universal—and universally vulnerable.

At Konarak village on the east coast of Orissa, waking early for a swim, I stumbled upon a graceful ballet of fishermen shitting on the sand between their boats, scurrying crab-like to deposit their steaming waste where the tide would drag it down the beach and out to sea. Side by side, pretending to be invisible, men strained to empty their bowels, as the sun gilded their expressionless faces. Indeed, much of physical life in India occurs close to the ground. Chairs and tables are scarce, beds aren't a big thing. Even classical musicians perform seated cross-legged with the base of their spine in contact with the earth so they can absorb vital creative energy. Indian clothing, not only saris, but also traditional men's garments, shawls, wraps, and veils, accentuates bodies, flatters the human frame, endows the most ordinary movements with languid elegance. Indian sculpture itself—the vast wealth of its temple decoration—has for centuries been obsessed with bodies and desire. Decidedly odd in a country so prudish today, where men, who are natural and easy about demonstrating affection toward other men, with friends typically walking hand in hand in the street, go to such elaborate lengths never to appear naked in front of one another, and where women wade into the sea and dunk themselves fully dressed. The *Kama Sutra,* a bestseller among tourists, is essentially a guide to choosing a mate who's a good genital match—not too snug, not too lax, but just right—and from then on making the best of it with one's partner. The manual condemns adultery in no uncertain terms, unless a man feels certain that if he can't slake his lust he will die. A candid West Bengali confessed to me in tones of despair that in thirty-seven years of marriage his wife had never, not once, taken anything even vaguely resembling sexual initiative. "Not one kiss! Perhaps," he said, smiling, as he pulled back from self pity, "it's better that way." And yet by far the most erotic picture I've ever seen hanging in a public space was a mammoth billboard high above downtown Delhi portraying beautiful lovers entwined in a carnal embrace, an ad for Kama Sutra scented condoms. (Actually, the "safes" were flavored, I discovered, but the company was leery of being accused of promulgating oral sex.)

In past centuries, Indian artists, both Hindu and Muslim, painting the lives of gods and great kings, would conventionally devote

at least one scene in ten to their subject's sexual prowess. Heroes hunted, sang, made war and love. Indeed, Hindu gods have a physicality, a blatant sensuality that I have difficulty reconciling with the way Indian philosophies are constantly exhorting man to rise above the transient, illusory excitations of the flesh. Once modesty yields to urgency, the rampant AIDS epidemic in Maharastra, where the most serious hearths of infection consist of stylish, wife-swapping middle-class cliques rather than manual workers who frequent prostitutes, is bound to thrust the body to the forefront of Indian political life.

And, finally, the body in India has weighed on my conscience since childhood. Weren't we all told when we were little about how Indian parents maimed children to enable them to beg more profitably, about hundreds of people dying daily from hunger, expiring on the pavement where others step over them, about prenatal testing and the abortion of female fetuses? From the moment we set foot in India, I discovered a need to celebrate the body, to accentuate the positive and propose a more balanced perspective.

\* \* \*

THE BRIEFEST GLIMPSE of bodies in India often seems to bite the deepest into memory. Scenes that end before you realize what it is you've seen. Still, experience suggests the vanished image will come back again and again, revived by some associative sight. On other occasions, you may have the opportunity to study bodies at length and leisure, some-

one holding a pose as if in stone, people repeating a gesture over and over. For outsiders, Indian body language can be deceptive. Just as temple statues express specific encoded meanings, the position of hands and feet, the twist of a torso, the tilt of a chin convey a conventional message. The moves and postures of bodies in action appear to be communicating pre-agreed meaning as well. In any culture it takes time to learn to interpret such nonverbal messages; is it arrogance we're witnessing, or modesty, shyness, or an invitation to further intimacy? What is masculine, what is feminine?

It wasn't until a third visit to India that I tardily learned how much of physical activity is governed by rules and standards in religious texts. Yoga, dance, wrestling, martial arts, sex, health, birth, weddings, burial—there are densely detailed prescriptions for what is expected of the body or bodies involved. Almost any bodily performance begins with ceremonial expression of respect to one's teacher, and an offering to one's tutelary god. Movement is a serious matter.

The following narratives present, kaleidoscopically, a medley of images and events featuring bodies culled from several journeys in India, scenes that have stayed with me for years and have lost none of their initial evocative power. I propose to travel lightly, unpacking prejudices and judgements to leave behind, adhering to no logical itinerary but revisiting, as linked images suggest, particularly vivid experiences. My aim is to convince you, the warnings of Kim's guru notwithstanding,

that the body is a good teacher and repays watching. Finally, I'll retell in brief a few Hindu myths and legends in which the body is pivotal: Who are we to turn our backs on what obsesses the gods?

* * *

UTTAR PRADESH, NORTHERN INDIA. With nearly a hundred others, we have enrolled for Yoga Week in the humpbacked, green hills of Rishikesh, city of ashrams. Early morning, there is a chill in the air. The floor of the vast, festive red-and-white tent is decked with plush carpets. The rolled-up back flap reveals, through long butter-bright skeins of marigolds, the Ganges glittering in the mist below. Up front Shri B.K.S. Iyengar, age seventy-eight, the incarnation of Hatha Yoga and its leading proponent and relentless popularizer, prowls in loose white shorts and white T-shirt. His hairless legs, smooth, rounded, almost female, and his voluminous barrel chest make him look top-heavy. His long gray hair falls in orthodox Brahmin style to coil on his shoulders. His strong face looks prehistoric. Calling us up close to watch a demonstration, he then shoos us back to our blankets spread throughout the tent. "Like quinine," a Bengali policeman quips, "he's good for you but bitter to swallow."

As a boy, Iyengar was a sickly weakling who healed himself through yoga. Ever since, he has propagated the gospel that mind is present in the body's every cell. An ancient hypothesis now being borne out, he gloats, by contemporary scientific discoveries. His credo: The body is the bow, the *asana* (one of the fundamental yoga positions) the arrow, the target the self.

"Don't you overdo the physical aspect just a little?" asks Professor T. Shankar, a baby-faced entrepreneur whose thriving Health Beauty Care Clinic in Delhi offers house-wives advice on herbs, astrogems, palmistry, and yoga therapy. "First learn to walk," Iyengar retorts, "before you want to fly!" He summons his heckler up on to the platform and asks him to demonstrate a simple shoulder stand. "They say they do *asanas*, but look at that! Then they go to the doctor with pain in their neck." Iyengar bounces the chubby Shankar lightly on his head, jerks at his heels to achieve the spinal alignment he's after, "and who gets the blame? Yoga." Doing "the warrior" for us, which none of his young assistants can manage, he facetiously complains, "God is punishing me that after sixty years I have to do this myself." Still today Iyengar is inventing language to express what he has learned from and about the body. "Think of a pair of eyes behind your knees, now open them." "Imagine you have toes in your groin. Spread them evenly." "For entering an *asana*, there's a proper moment—like with catching a fish on a hook."

One afternoon I play truant from breathing lessons. Lungs full of fresh mountain air, I follow the winding river north. Some half-dozen miles along, I find a textile factory. In a spacious hall festooned with bright, newly dyed wool in shades of purple, vermilion, and turquoise, old card looms clack and thump

away. At first view an ordinary workplace. Rub elbows with the weavers, however, and you notice cracked, scaly skin, missing digits, wounds. Above the machine operated by a woman who agilely throws and catches her shuttle despite clawed hands, a flashy banner with *OM* sewn into it conjures up Iyengar strutting back and forth in front of his students, revelling in the achieved symmetry of his limbs.

"Yoga, you say, is vital because the body is the temple of the soul and must be cared for reverently?" When next I meet the master in the morning, the words pop out with an accusatory ring. "Well, what about those with leprosy then, where the temple has been cruelly defiled?"

"For them, and others having disabilities, in my school at Pune I am developing therapeutic yoga. Practices, for example, to improve circulation to the extremities." Iyengar's eyes pin mine. "Temple maintenance."

During *savasana*, the yoga relaxation exercise where you emulate a corpse, I hear Iyengar working the room, circling closer, until finally he crouches by my head. Gently but firmly with both thumbs, he presses down against my closed eyes. "Now exhale completely," his soothing growl fills the tent. "First exhale physically, then mentally. Your mind should feel like water at the moment it is about to turn to ice."

\* \* \*

ALONG THE EASTERN coast of India, in the kingdom of Kalinga, present-day Orissa, bloody wars were endemic during the dim past. In the sixteenth century, to save the Temple of Lord Jagannatha from being sacked by marauding renegades, the maharajah of Puri created special religious brotherhoods of wrestlers known as Jagagharas. At 5:30 A.M. the whole outside world is still dark, cold, and silent as we enter the busy beachside training center at Biswamber Pith (The Place of World Conquest), a subsidized state sports hostel intended to maintain Puri's fame as a cradle of wrestling champions. "Ready, go," barks a hefty, young instructor in a smart satin training suit, and instantly a ring of schoolboys in matching blue, dozens of them, arch over backwards and ram their skulls into the mat, arms folded across their chests. Up on their toes they pivot, knees high, prancing to complete a circle.

It is about an hour later and a few miles from the outskirts of town when, from the crown of a coconut palm he has climbed by sisal rope as part of his training, hoisting himself up using only his arms, a near-naked youth waves to us below, then shoots back down to earth to open the gates to one of the forty-six traditional wrestling clubs (*jaga*) still active in Puri. Here a spirit of play prevails. Bird song, greenery, a pond, sunlight. Twenty youths warm up with tapering iron clubs, rolling their wrists to swing the weights rhythmically overhead and behind their backs. The surface of the wrestling rink is covered with soil from the banks of the holy Yamuna River, raked smooth. Off in a corner is a shrine to Hanuman, the monkey-god, patron of wrestlers. Here Guru Gagunath Supakar,

seventy-six, a bear of a man, completes an offering. He has remarkable eyes: large and gentle, yet probing. Clad like the boys only in scanty briefs, he rubs his hairy chest with sand and enters the rink where his disciples approach him, kneel, and touch his feet. All their lithe speed doesn't protect them for long. He demonstrates different holds, including the washerman's throw! By 7:30 A.M., when the boys set off for school or work, they look distinctly smaller in their clothes.

\* \* \*

IN KONARAK, NOT FAR from Puri and practically in the shadow of the chariot-form Temple of the Sun, we sit in on Guru Gangahar Pradhan's outdoor Orissi dance class. Among blossoming casurina and cashew trees, eight girls, twelve to fourteen, so supple they seem boneless, finish warming up. Bare feet slap cement in explosive unison, bodies accelerate, isolated muscles shift with a speed only possible where there is total relaxation. They keep their faces blank. The portly, henna-haired guru chants, beats time with a stick against a block of wood. Through barely parted lids, his eyes follow the girls' every movement like a hawk's. When he was at death's door as a baby, his parents, observing ancient custom, vowed that should he get better they would give him to Shiva, or Nataraja, Lord of the Dance. He became the best *gotipua* dancer of all time, a dance in which preadolescent boys wear elaborate costumes and make-up to impersonate women. In nearby Roghurajpura, a sleepy hamlet full of loitering cows forever nibbling thatch, two skinny brothers in patched white shirts and shorts held up with string dance the *gotipua* for us under the straw eaves of a ragged hut emblazoned with white, geometric flour-paste designs. They undulate in gangly sync, mouthing words to a divine hymn blaring from a ghetto blaster. The whole time they sway, the brothers avoid my eyes as they fight back smiles.

Back bends, splits, balance poses. The components recur and grow familiar. Yoga, dance, martial arts. The name of the game is body control. Rules thousands of years old. Mastery through repetition, control through discipline. The basic positions are fixed in holy texts. Submission to a guru, obeisance to God. The body in motion is a vehicle for developing character. Lessons make the man. Repetition is the true way.

\* \* \*

"EVEN IF A CHILD from a good family has been rather badly spoiled, he will have moral values in his blood and genes." We are finishing tea at the home of Nawab Jafar Mir Abdullah of Lucknow, the hub of Islamic culture in India today. "They are the ones who must come now to politics to save India." The pudgy aristocrat folds his hands high on his belly and prolongs a faint smile. "Our traditions are so strong, they don't just disappear that easily." As we stand to go, I step backward, planting my foot in the middle of the tea things. Cups rattle but nothing breaks. The Nawab flatteringly compares me to a famous late *kattak* dancer so light of foot

that despite the twelve pounds of bells strapped to his ankles he could dance on hollow balls of sugar sweets without crushing them.

After nightfall in Madurai, Tamil Nadu, far to the south, we enter Meenakshi Temple though the towering eastern gate, a tapering marvel of interlocking carved bodies, and we join a sweltering, feverish crowd in the lamp-lit, phantasmagorical vaulted hall. Those in front press up against the spiked railings that cordon off statues of Shiva and Parvati, several sizes larger than life. God and goddess have been vying with each other to see who is the better dancer. At last, the only way Shiva can defeat his consort in their fiercely contested duel is to pull a fast one: position after position, through all sixty-four classical dance forms, she has honestly matched or excelled him. Suddenly he stands on his left leg, raises the right one high and tucks the right ankle behind his neck. When, out of sexual modesty, Parvati refuses to follow suit, she tastes bitter defeat! The passion of the huge statues is electrifying. For a few small coins I fish some balls of butter from a tub of ice shavings to fling at the gods. Together with garlands of marigolds and jasmine and dustings of ash, the butter is meant to cool the fiery couple down. When the gods' blood runs high, people fear them.

Up north and to the west, in industrial Ahmedabad, Gujarat, my turn comes to take the floor. As we wander past, music pours from a walled concrete school-yard. The balmy night is ideal for the prenuptial celebration in full swing. Sixty-some people, both sexes, all ages, from six to seventy-five, are dancing the *gair*, a regional folk dance, revolving in a large circle clockwise, while at the same time individually spinning counter-clockwise. A hand in a silk sleeve reaches out and pulls me into the circle. Attempting to pick up the pattern by watching the others' feet is no use. I stumble until, eyes on the smiles of whirling faces, I stop trying so hard and just let the music sweep me along.

When at times dancing in India merges with trance, however, the best thing you can do is step back and watch. At the small fair we stop off to visit in the monotonously flat, sugar-cane country of Paithan, Maharastra, the dancing of villagers, who have come in covered wagons and on foot in droves to celebrate, gradually sheds all inhibition. To the beat of cymbals and double-headed drums, in small clearings among the compact multitude, quartets of old women brace their feet against their partners', clasp each others' wrinkled hands, and lean back and start spinning, their gaunt arms fully extended. They spin faster and faster until they can't keep their grip on each other and fly apart, tumbling to the ground, crashing into onlookers, skinning their elbows and bruising their knees, with no thought as they scramble back upright, laughing and tugging their saris into place, other than to begin whirling wildly again as soon as humanly possible.

*   *   *

IN SAMODE, RAJASTHAN, a town dominated by a splendid old palace on the fringe of desert scrub, children pick us up in the narrow streets, promising to lead us to their uncle's

atelier. Why not believe them? Half a dozen apprentices sit on the ground hunched over low wooden desks chain-painting miniatures. The master riffles through a pile of their work for us. It's good, very good, though perhaps a trifle predictable. Then he picks out and hands me a miniature that baffles me. Something is wrong with it, I sense right away, but what? It takes me longer than I like to admit to put my finger on the disturbing element. The painting in question is a hunting scene, accurate down to the smallest detail, except that the spear-wielding bodies, racing over rocks, astride elephants or horses, perched in trees with rifles at the ready, all end abruptly at the neck. They're headless. "Faces are the hardest," the guru explains. "I always do them myself, put them in last."

Inside a monastic cave dug out of the mountainside at Ajanta, Maharastra, the art this time is on a grand, overwhelming scale, as I stand face to face with a fifth-century mural depicting Buddha's previous incarnations. From the blur of colors I make out a mound of headless male bodies leaking gore: men seduced, decapitated, and now being devoured by *dakini* (sorceresses).

In Amritsar, the Golden Temple, waiting to gain entrance to the inner sanctuary to see the Sikhs' holy book preserved under thick layers of rich, embroidered tissue, I overhear a hushed conversation about two Sikh brothers who in defense of their king fought on for days after their enemies had hacked off their heads. Then this, the clincher: In Calcutta, on Kaligat Street, row upon row of identical clay goddesses-in-the-making bake in the sun, their melon-breasted torsos splitting by the hundred with widening cracks. In a curbside rickshaw sits a glum fellow who has paid the price for a large likeness of Durga. He nibbles at his moustache, one arm flung around the shoulders of the fiery goddess who, through some flaw of construction or act of carelessness, is headless. Durga's severed head lies on a handkerchief spread on his lap, her snake-wreathed countenance staring up at him with bulging eyes and protruding red tongue.

*   *   *

THE BODY AT WORK in India enjoys a high profile. There is a core repertoire of distinctive postures. The Jackknife, for example, is second nature to the potter I watch milking the form of a pot from a molten lump of clay. Gristle and bone, he plants his feet wide, doubles over, and slaps his wheel into motion. Similarly, women on the rim of a well bend forward, haul up buckets hand over hand, and harvesters, ankle deep in rice paddies, with their skirts tucked up, legs straight, cut fistfuls of ripe grain, chins low to the water. Then there is the Hunker: A truck driver climbs right under the raised motor cap of his rattletrap truck to squat on the engine block while he checks the oil; a temple stone-cutter perches on top of the marble slab he is carving; a grandmother bathes a child protected between her spread knees, withered buttocks an inch off the ground, weight on her heels. In this position the old woman's sari stretches taut, encompassing her like a pod. The Straddle occurs, too, with a high frequency: A shipbuilder inside the

ribcage of a dhow planes a beam with one leg on either side, whereas a cabinet-maker appears to ride the imitation antique bookcase he is sanding, the better to apply rasping pressure.

Small bodies contrive to make themselves smaller: smiths, tailors, shoemakers, miniature painters fold themselves up and fit into their narrow workspaces like walnuts in their shell. Lean shepherds have their own long stride, and a characteristic brazen way of standing with a hip flung out. Bread-making involves repetitive movements not so different from weaving and is similarly demanding on back and abdomen. Some manual labor is pure fingerwork: embroidery, mending nets, knotting carpets, stringing petals into garlands for the gods. Resourceful, seated craftsmen use their feet as a vice. You also see them with a knife or saw clamped between their soles draw their knees up against their chest, then push them down, and so cut through stone, wood, or meat.

Footsteps behind me in Aurangabad, the old town. It is mid-afternoon, scorching hot, and still the streets swarm with shoppers. I step up into the portal of a sweets shop, and look back from where I've just come. Yes, see, there, there's my stalker! A scarecrow in a dhoti, barefoot, walking with a slight waddle, a large stone on his old head. It must have taken four men to lift it there. His shoulder blades jut back like chicken wings, and the bony anchor of his hips swivels as he melts from sight around the next corner. Thirty seconds later and another wraith comes padding along, a building stone propped on his hoary head, too. And so on, like ants, they keep coming, the intermittent file easy to miss in the swirl of street currents. Sometimes they are visible, however, these processions, all strung out, men and ox-carts stretching to infinity. Harbors, dams, salt mines—landscapes re-created by the sheer force of numbers, one load at a time. In Sikkim women in clashing colors sit along roadways under construction, and with their hammers, one tap at a time, they patiently reduce mountains of stone nuggets to gravel. The body as natural machine.

* * *

ONE OF THE BIG drug companies in New Delhi runs an ad in a leading newsweekly that sets tongues wagging. It is a public-interest plea against drug abuse, smoking, drinking, unsafe sex. The image: an Indian hunk à la James Dean, a bit plump, both his hands sunk in the pockets of his snug jeans. The text: "There's just one problem with this marvel of engineering. In case of mechanical problems you can't contact the manufacturer." The homily ends with a flourish: "Take good care of your body, it's the only one you've got." Outside the Jama Mosque in Delhi, the streets are jammed. I can't move forward, or back. The mounting pressure is on the brink of triggering mass hysteria when suddenly the restive, dense crowd parts in two to let a holy man pass. He is barely an arm's length in front of me before I see several inches of steel protruding from his naked chest. It is the tip of a sword that has been plunged through his back. There isn't a trace of blood.

* * *

NOON. A PRIEST on the riverside plat-forms of Varanasi daubs sandalwood on my forehead. We sit facing each other under a bamboo parasol while he chants a Vedic text for me about the creation of mankind. How a primeval Creator sacrificed his own body to give birth to the four *varna* or *jati* (castes): the Brahmin (priests) from his mouth, Ksatriyas (or Rajputs, warriors) from his arms, Vaisyas (traders) from his thighs, and Sudras (farmers) from his feet. The corpus of Hindu mythology feeds my fixation with the body in India. The holy books—the Vedas, Brahmanas, epics, and Puranas—are startling in their physicality, and in the richness of their references to bodies, body parts, functions, and fluids in gods, demons, and men. Even sneezing, fever, and spitting have tales of their divine origin. With the mien of scholars, illiterate Hindu villagers, moreover, will tell you how Brahma first ate rice, then shat us out, and created the demons in the form of a breath from his rectum. Indian mythical birth may be many things; it is never, however, immaculate. Divine seed penetrates the loved one many ways, even through the follicles of her hair. Men also give birth, sometimes after pregnancies of a hundred years. Astonishing metamorphoses abound as well. Consider what happened, for example, to the sage Naranda when he begged Vishnu to grant him firsthand knowledge of *maya*, the illusory nature of reality. At the god's command, Naranda dove into a handy pond and surfaced as a beautiful maiden who married, bore children, and lived to see them butchered in war.

The haunting story of the holy Markendeya illustrates the Hindu conceit that the world *is* god's body. Thousands of years old but of unaging strength and alert mind, Markendeya wandered through the interior of Vishnu's body, the world as we know it, slipped and glided out through Vishnu's mouth into the cosmic sea, for the All-containing One sleeps with his lips slightly parted. Utterly in the dark, splashing about, at last Markendeya made out the form of the slumbering god aglow from within. Before the saint could ask the presence who he was, the giant seized and swallowed him so that once again he found himself back in the familiar landscape of the interior.

And, to end on a high note, a vastly popular myth tells how a hard anatomical rain came to fall all across India. How Lord Shiva lifted his beloved Sati, dead, from her father Daksa's sacrificial fire, where she had immolated herself to protest how Daksa had snubbed her new husband. Of all creatures in the three worlds, Shiva was the only one not invited to Daksa's rites. When the bereft god slew Daksa, Sati's mother cursed him, swearing that mankind would forever after worship Shiva's genitals. Then Kama, god of love, spied Shiva with Sati's corpse in his arms and let fly with a flower-tipped arrow made of honey bees. Shiva, stung, staggered off, babbling to himself with grief and desire. The other gods called back and forth, "Sati's corpse will never decay, not as long as it stays in contact with Shiva." Brahma and Vishnu worked themselves inside the cadaver and dismembered it. Shiva danced, and one by one pieces of Sati

dropped to the ground. Today shrines mark the spots where different bits fell. Certain portions of the corpse were cut into minute shreds, carried by the wind through space, and lifted upward to the fields where the heavenly Ganges flows among the stars, there to enter the stream. Where Sati's head dropped to the earth, Shiva stopped in his witless passage. He fell to his knees and broke into a groan of pain. When he saw the other gods watching him, he was so ashamed that he transformed himself into a lingam of stone, stark and prodigious in the torture of his love.

# 2

## *the community of the body*

RAKESH PANDEY OPERATES A SMALL YOGA SCHOOL IN Varanasi. In the hope that we can help him tour Europe and demonstrate his skills, he has agreed to run through six types of yogic purification rites for us. When we call for him, he is immaculate in a long, white kurta with purple trim and several looping strands of crystal beads. His shoulder-length, wavy black hair gleams with oil. We step from the cool calm of Rakesh's home back into the scorching glare of noon and, led by Rakesh's small son and daughter, we clatter down the steps of Hanuman Ghat. Above and behind us monkeys scamper across the turrets and porches of temples and palaces gone to seed. They have been reincarnated a few rungs down the ladder as Vishnu Lodge, or Shiva Guest House. Women fling wet buffalo dung against paint-blistered walls, where, bearing the imprint of a hand, each patty sticks and dries into fuel. On a broad landing, a large band of old pilgrims, hemmed in by bedrolls and sacks of flour, sit cross-legged in rows, rolling out dough for chapatis and lighting cooking fires. Lanky little boys whack a bit of wood about with scraps of planking, playing a hazardous, impromptu game of cricket. We swivel-hip our way among bulky water buffalo, some wallowing in the river, tolerating their daily scrub-down at the hands of keepers who half-kneel on their broad, black backs, brushing even the under-side of their tails. Up to their shins in the Ganges, washermen side by side windmill sodden clothes against altarlike slabs of tilted rock. The whirl of their spray flashes in a rainbow. In the afternoon, the curving shore-line is one vast patchwork of drying laundry. And yet, however vivid when you first take it all in, if you relax your concentration, the never-diminishing, variegated spectacle of bodies in motion soon becomes almost second

nature to you and turns opaque. You have to make a sustained effort to see what is right in front of your eyes.

No boatman ever looked more the part than ours. The oars seem to grow from his arms; his face is driftwood. As we scud out into the current, I look up and back over my shoulder. There behind the sheer pink facade that we are rowing away from, the sixteenth-century poet Tulsi Das composed his much-loved version of the Ramayana, and, there, a shout away to the north, Buddha lolled under a pipal tree. From the top window of the next sandstone palace, a king escaped captivity and swam to freedom. Where the barbers have hung their mirrors and set up shop in this age, eons ago hundreds of perfect horses were sacrificed in a single ceremony and the goddess Parvati lost a pearl earring while bathing. The edifice with the lions on the cornices is Janghir Khan's palace-turned-observatory (1710). And beyond it the minarets of Alamgir Mosque spear the sky. Beside Jalasayin Ghat, where corpses burn, stagnant water in a deep tank is said to be the sweat Vishnu shed while he worked to create the world.

The far bank is flat, easily flooded, with a vague shimmer of greenery in the distance. The contrast of this void, this exclamatory nothingness out of which the sun daily rises with Varanasi's elevated, congested western shore, behind which the sun sets, is what accounts for the city's special, spatial magic. "I will do numbers one through six." The program Rakesh hands me lists the benefits of the yogic feats he is going to do: "slim body, joyous face, sonorous voice, sparkling eyes, positive good health, virility, exuberance of vitality and radiance and purity of the nervous system." Among the "main features" of a typical performance of his, attractions that we won't witness today, but snapshots of which we had a chance to admire in his scrapbook, are "stopping an elephant with a rope, dragging a jeep by holding with teeth, bending an iron rod with a bayonet attached by pressing against the point with one eye." Thonk! The boatman pokes us clear of a snarl of soggy rattan and bamboo, the dissolving remains of Saraswati, the goddess of learning and music. Here and there abandoned effigies still bob in midstream.

The annual celebration had carried on late into last night, growing wilder and wilder as the statues, escorted in a seemingly endless procession down to the Ganges for immersion, grew larger. Early yesterday afternoon the first Saraswatis, all in white, seated on swanback and holding a *veena* (stringed instrument) and a book, were light enough for a small schoolchild to carry on one shoulder. The last several towering renditions of the goddess had arrived under the stars, drawn by creaky old tractors hemmed in by a host of devotees, drummers, and dancers, wild-eyed, their faces sweat-streaked and stained red with handfuls of flung powder. As so many had done before them, those bringing up the rear shouldered their colossal icon into a skiff which rocked violently, almost capsizing as far too many celebrants shuffled on board. The overloaded boats kept shipping water until adrift in mid-river, where dozens of

straining arms heaved the goddess over the side. With splashdown, the ear-shattering music died, sobriety instantly returned, and as the sculpted clay began to melt back into the Ganges from which it came, the boat plied its way back silently to shore.

"Ha!" Our boatman gives a sharp, short victory cry as, half-standing, he lunges forward to snare a low-trailing kite string, snapping it with a single, smooth gesture, and knotting the end to a reel between his feet. Back on the ghats, a flea-size child stamps and shakes a fist. In the program on my lap I read, "For all those afflicted by worldly sorrow, yoga is the only remedy."

We pull up on a sandy spit. Rakesh ties back his hair and strips for action. The stiff acrylic tennis shorts he is wearing under his kurta don't do much to enhance his image as a timeless ascetic. Iman loads his Pentax, and Rakesh is away, swallowing all but the tip of a fifteen-foot strip of gauze. His aim is to clean the lining of his digestive tract. His kids, bored silly, poke about. Soon a second boat beaches near ours. It is heaped with bamboo-slat skeletons of Saraswatis fished from the river for recycling. Three youths wade ashore with red-and-white checked cloths knotted around their waists, their faces looking heavily hung-over. Rakesh has progressed to rotation of the abdomen in a churning motion. The brashest of the three newcomers holds out a *bidi*, a clove cigarette, and asks the fully preoccupied Rakesh for a light. He's not just being sassy either, but friendly. The others soon row off, but he sits on the wet sand and, propped on one arm behind him, watches intently as Rakesh completes his selection of yogic practices. Then the fellow wanders down to the water's edge, drops his cloth, and soaps his body lavishly, with sure, symmetrical sweeps of his hands, turning himself into a fluent finger painting. The yogi's children hover close, attracted by the bather's delight in touching his own body.

My visits to Varanasi—Benares under the Muslims and the British, but originally Kashi, "the shining one," also known as Forest of Bliss, the Never Forsaken, the Great Cremation Ground—leave me convinced that portraits of the place, whether in words or photographs, are usually misleading. Too reverent and awestruck by half. Godly, yes, but unholy, too, earthy and metabolic, a place of devious priests and devout hustlers, where ascetics and predators rub elbows and pick each other's pockets. Every day as the mist lifts and color floods back into the world, the riot of real life, the splash of it all quickens the waking senses. It may be in nearby Sarnath that Buddha preached his first sermon after enlightenment, but Buddhist Jataka tales also relate how Buddha was born repeatedly in Benares in his previous lives, as a dice player, an ascetic, an acrobat, a gardener, a snakebite doctor, a rich Brahmin.

* * *

"THE DOCTOR SAYS I've begun to get older faster." Propped among bolsters, beneath a yellow tie-dye comforter splattered with bright bursts of egg-yolk orange, Vibhooti

Narain Singh, the former maharajah of Varanasi, still has a glint of mischief in his eyes. He receives us reclining on a divan wheeled out onto the roof of his palatial fort on the east bank of the Ganges. The roof is otherwise bare. Stripped, like other royalty, of ample means at the time of Independence, he has lived modestly as a Sanskrit scholar and deeply religious man. He is the one maharajah who has never left India. As usual he wears a silk Nehru jacket and a white hat that reminds me of a sailboat folded from a paper napkin, only without the peak. His lush walrus moustache is off-white, his eyes as large and limpid as a cow's.

"What was Krishna's theme today?" the maharajah asked us. He had sent us to see Professor Anand Krishna, now eighty-two, an expert in Indian art whose father had endowed the Benares Hindu University Museum with his unrivaled collection of paintings, prints, sculptures, architectural fragments, relics, and coins.

"Benares lost," I answered. "We were sitting in his garden under his moulsari tree . . ."

"Yes, I know that medlar. I am even jealous of it!"

"He said you were. We mentioned how surprised we were by early engravings of the city in the museum that show so many trees. Professor Krishna said that more than the trees are gone. The knowledge of trees and nature that was so much a part of Benares has disappeared too, especially in young people. No one today takes the time to observe things. He used the word *masti* to describe what they have lost: the desire and the ability to be adrift in the world, to drink in your surroundings."

"*Masti*," the maharajah mused aloud.

"Professor Krishna urged us to go back to the museum and choose one of the great sculptures and really look at it. He told us there's a Ganesh that he has been looking at for years and only recently realized how the sculptor contrives to make you believe a breeze is blowing—by slightly tilting one ornament on a necklace, a tiny bell."

For the maharajah the subject clearly touched a deep chord. "*Masti* is second nature to us, difficult for you to understand. Is it happy-go-lucky? No, that is too light. *Masti* is to enter into the moment."

"Seizing the day?" I try.

"Rather letting the day seize you. Going on a picnic along the river and watching the current flow without a thought for what has to be done tomorrow." We follow the direction of the maharajah's intent gaze, and over his shoulder we see a molten red sun slowly sink into the Ganges. The view downstream has gone hazy. The world looks insubstantial, magical. "*Masti*. The gods, you know, are always talking to us, but so softly we need to plunge into a maddening silence if we want to hear them. *Masti*," the maharajah nodded, "is getting drunk on reality."

"How did you find this year's Saraswati Puja celebration?" Iman finally broke the silence that had gripped us.

"Hooliganism," the maharajah half-rose from his cushions, fuming. "Energy that doesn't

come from inside, but from something you swallow, tell me, please, how long can it last?"

*   *   *

ALREADY IN THE damp and murky minutes preceding daybreak, bathers with scarves knotted under their chins come trickling down to the river. This time of year the bottom steps of the steep ghats are submerged. As the sun ladders up beyond the mud bank of the far shore, making the thick mist blush before burning it away, the human current picks up. Bells ring, doves wheel, infants cry. Day after day, regulars return to the same spot to undress, pray, immerse, exercise, groom themselves, dress, depart. I, too, have my place by a tea stall on Rana Mahal Ghat, next to Raj's betel-nut kiosk on spindly stilts. Although alien, seated there sipping tea, I seem to succeed at lapsing into invisibility. Even the knee-high postcard vendors relax their persistence and leave me in peace. And, exceptionally, the gristly codger with perfume vials in a battered leather briefcase doesn't jab my chest with his scented forefinger. My vantage confers extraordinary intimacy, the witnessing of bodily rituals, the sum of which infuses me with a compelling sense of community. Immediately before springing or gliding into the river, bathers pinch their nostrils, or stick fingers in their ears. Up and down, up and down, sending out ripples. An old man helps seven elderly women, each overweight in her own way, push out into the water, all holding hands, his frailty their strength. Two women shampoo each other's cascades of black hair, rubbing until the lather flowers abundantly. One leg extended at a time, men grind their heels callus-free on the stone steps and scrub their undergarments. Fingers deftly wring them out and tie them back in place as their teeth clamp one end. Next they shake their wraps in the air to billow dry like sails. Through repetition their gestures, confident and efficient, achieve a *mudra*-like significance, a dancing grace. As they execute their daily yoga routines, figures with bloated, drum-size paunches prove enviably supple. Others jerk through more modern stretch exercises—part army, part, I suspect, Jane Fonda. Always they lift their faces to the sun, their features gilded. Bathers shiver, drip, flap arms, spring in place. They rub their bodies vigorously with oil mixes, brush their teeth with twigs from the neem tree, rapidly massage their skulls with both hands, elbows high. Pocket mirrors and combs appear and multiply. No lack of vanity along the holy Ganges. Bodies disappear, shrugged, stuffed back into clothing, the molecular bond between people attenuated.

Rakesh Pandey had explained to us how a yogi spends years learning to hold a single *asana* for two hours on end, his ultimate goal. Raj, a small, fine-featured man, black as coal, sits cross-legged in his kiosk for more than eight hours a day. Preparing pan to chew, he fills and sells maybe thirty leaves a day, consuming, he shrugs, another six himself. His earnings come mainly from cigarettes, Western and Indian, sold by twos and threes, supplemented by the soap, oils, and pumice

stones his old mother dispenses from a battered wooden kit. The morning after our rooftop audience with the maharajah, I ask Raj what *masti* means.

"*Masti*? You know—," Raj gropes for words, "a kick. If I know I'm going to a film with my girlfriend Sunday, that's *masti*. Or the feeling you get drinking *bhang*. And if we play a trick on a friend. Pranks—that we call *masti*, too."

I go out in Raj's boat for a massage with his friend Santos, a barber. The ghats swarm with men who walk up and greet you, shake your hand; before you know it their strong fingers have started working their way up your forearm, shoulder, neck and they're haggling over the price. Afloat on the Ganges, enjoying a modicum of privacy, I submit to Santos's skill. Pain flares, deepens, dissolves. At Rakesh's we had found his wife massaging their fragile two-week-old daughter. The woman pummeled and squeezed, folding the baby's limbs with a vigor and force that made me wince. On the ghats it's common to see children climbing on to their father's or grandfather's broad, bare backs, small hands kneading knots out of thick neck muscles. Bathers administer self-massage as well, men standing with their eyes closed, backs to the sun, rubbing their buttocks in circles.

The smell of smoke and a commotion nearby on shore make me turn over and sit up on a thwart. A group of half-naked boys, hopping about, hold something large and black over a fire. They dance with jerky motions, twitching with excitement. One of them runs toward us when Santos calls to him, jumps high from the edge of the ghat and splashes down inches from our boat. We drag him aboard, spluttering. "The bird flew into a kite string which cut deeply into his shoulder. He crashed on the shore. Now we are making him flyable again." The bird, I could see now, was a vulture and the boys were heating a yellow paste and tamping it into the nasty wound. As we watch, two boys in briefs haul the vulture up by a rope around its feet to the ledge of a riverside temple. There, setting it free, they prod it with a stick to make it take flight. With a cry, the ugly bird totters off the edge and tumbles to earth, one wing still partially lame. Before its tormenting rescuers can close in and work fresh mercy, the vulture gets to his feet and goes scuttling off into a urine-soaked cleft between buildings.

Vultures have been a fixture in corpse-rich Varanasi since the beginning of memory. The sybarite Vahika, according to the *Kashi Khanda*, a history of the city, was bad news. He gambled, killed a cow, and kicked his mother. A tiger ended Vahika's life in mid-jungle, and his soul was brought to Yama (Death), but meanwhile vultures ripped and tore his body. One bird attacked another in the air causing it to drop Vahika's foot bone, which fell into the Ganges. Fortunate Vihaka! Suddenly a divine chariot pulled up in Yama's court to take him to heaven. "As Mother Ganges, the river is ever the dispenser of grace. No child is too dirty, they say, to be embraced by his mother."

* * *

LATE IN THE DAY, just below Raj's kiosk, we find a corpse laid out under a threadbare blanket on the stone. A thirteen-year-old girl cousin, wasted by tuberculosis. Family members arrive with bamboo slats salvaged from immersed Saraswatis and rig them into a bier. The girl is swathed—not too tight!—in white cotton and heaped with yesterday's wilted flowers; they're cheaper. With a drum leading the way, the body is borne off to the burning ghat. The rhythm of other activity doesn't even hiccup. The barbers, masseurs, vendors of salty snacks carry on. Giggling brides in bright red and gold come with their husbands to light camphor lamps on leaf-boats as part of a riverside ceremony. A blind man with a pole over his shoulder hung with caged birds sells them to people who earn merit in the gods' eyes by opening the cage doors. Children leap to set temple bells ringing, goats browse on unguarded parcels, card-players shelter under tattered bamboo parasols, priests grind sandalwood into a paste, sell blessings.

Death's visitation leaves no time for stillness or repose. Cremation is hard work: splitting huge gnarled tree trunks with iron wedges (firewood is my gift to the family), laying the pyre, laving the corpse, shaving the skulls of mourners, circling the body with a leaking water pot as it starts to smoulder, tapping the skull to release the soul, stoking and stirring the ashes, disposing of embers in the river.

"In *masti* there is continuity," the maharajah had said. "Every year I go to bathe in Allebad, goose pimples head to toe, lips blue, but I do it. Why? Because my family has done it now for fifteen hundred consecutive years. That's *masti*."

Among the dozen smoking, crackling funeral fires—as trussed corpses shift and settle like restless sleepers—oxen wander and mount each other, and children, their eyes scanning the sky, chase back and forth, screaming, flying their bright, flimsy kites.

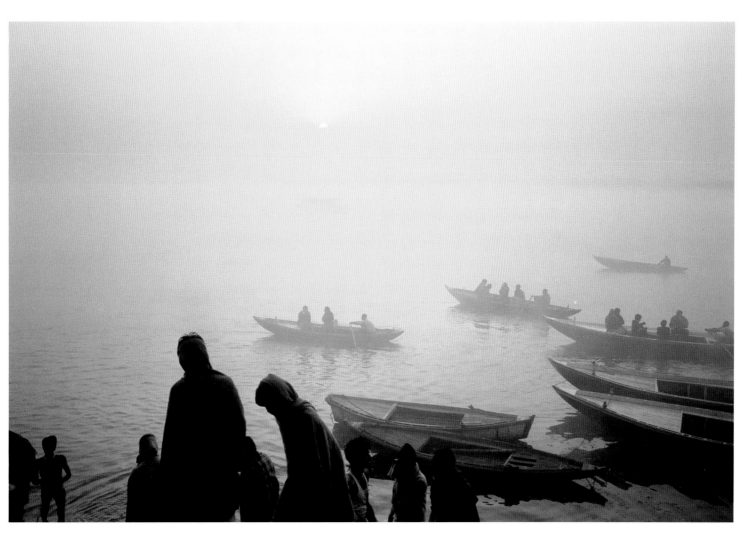

*The Ganges River at dawn, Varanasi*

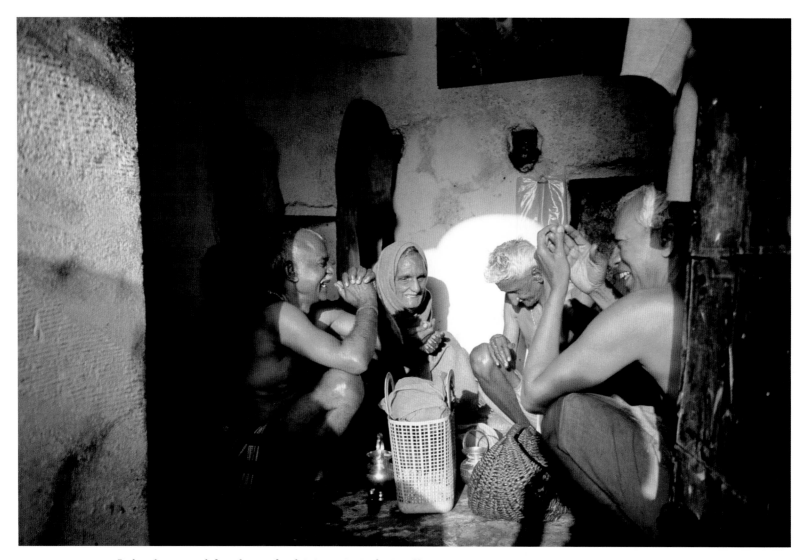

*Bathers draw warmth from the sun after their immersion in the river. Varanasi*

OPPOSITE: *Solitary bather, Varanasi*

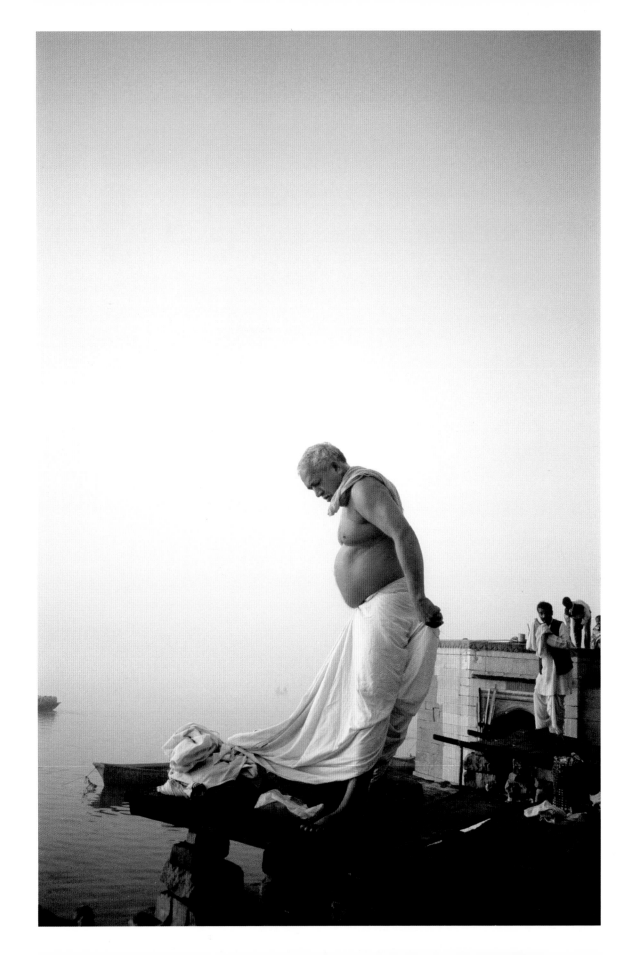

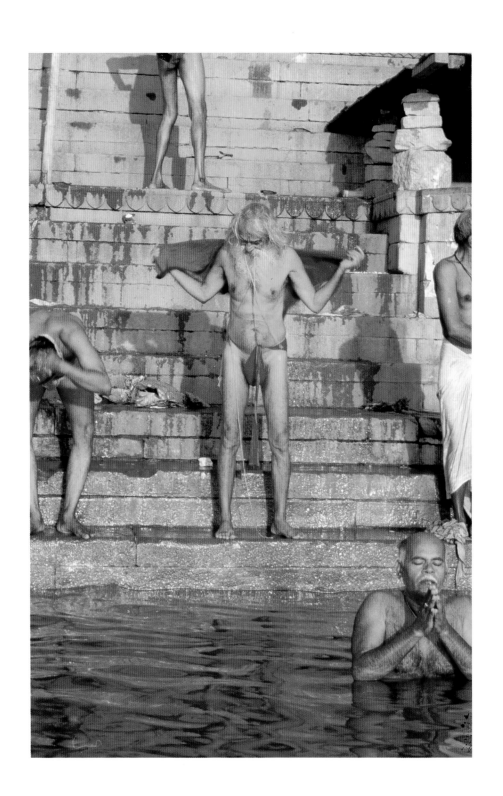

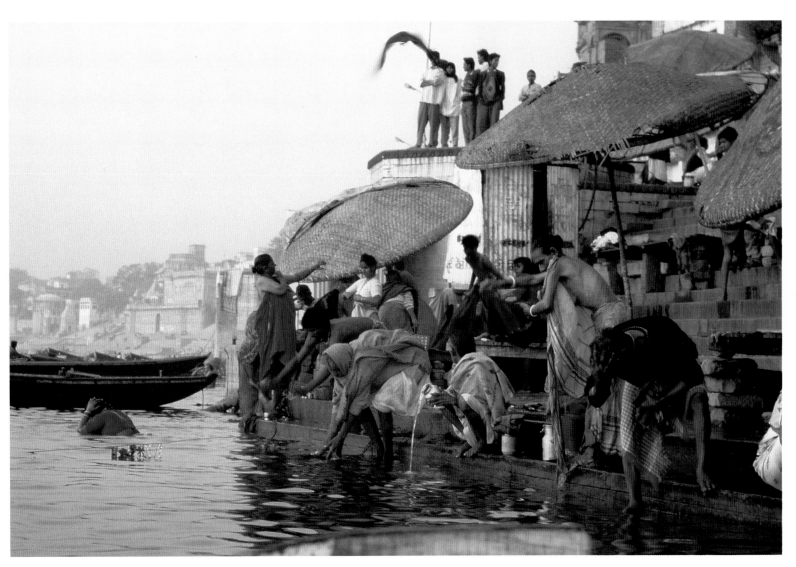

*Morning ablutions in the Ganges River. Hindus practice ritual bathing daily throughout India, and water from the Ganges is believed to have unrivaled healing and purifying powers.*

OPPOSITE: *Privacy in public, Varanasi*

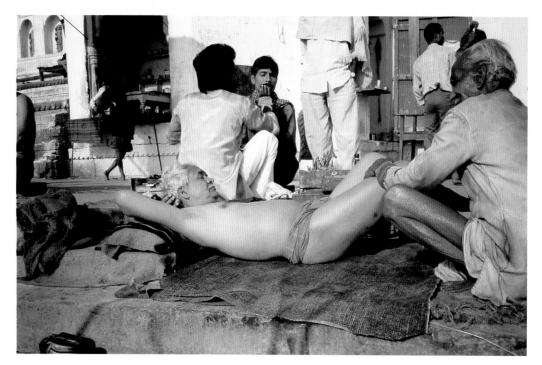

*Morning massage, Varanasi*

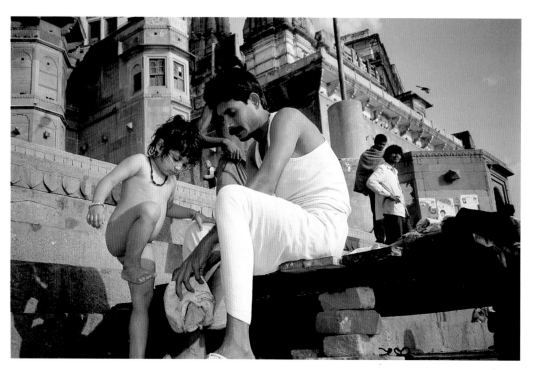

*Father and daughter, Varanasi*

OPPOSITE: *A bather on the ghats midway through his yoga greeting to the sun, Varanasi*

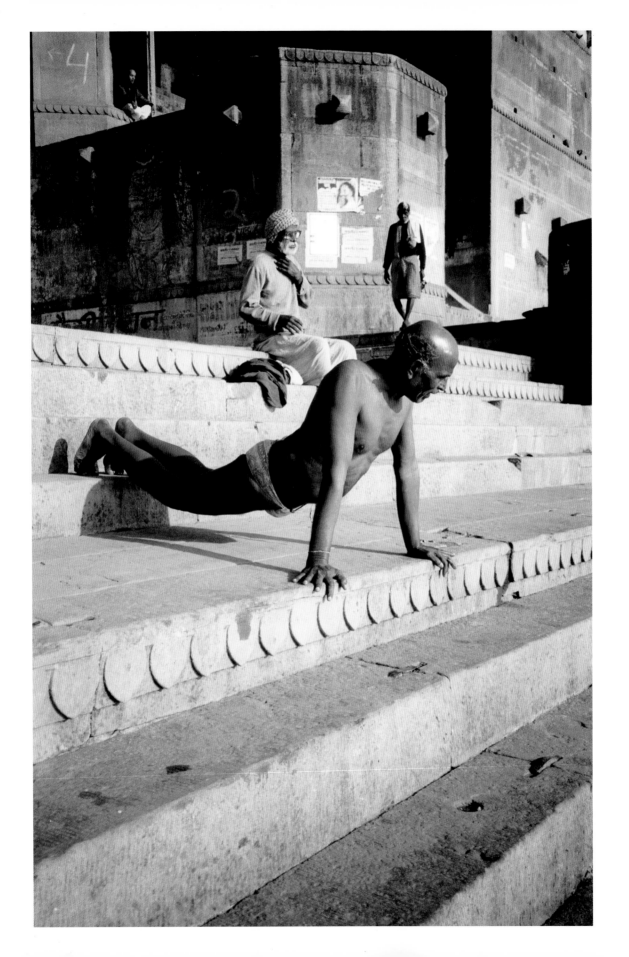

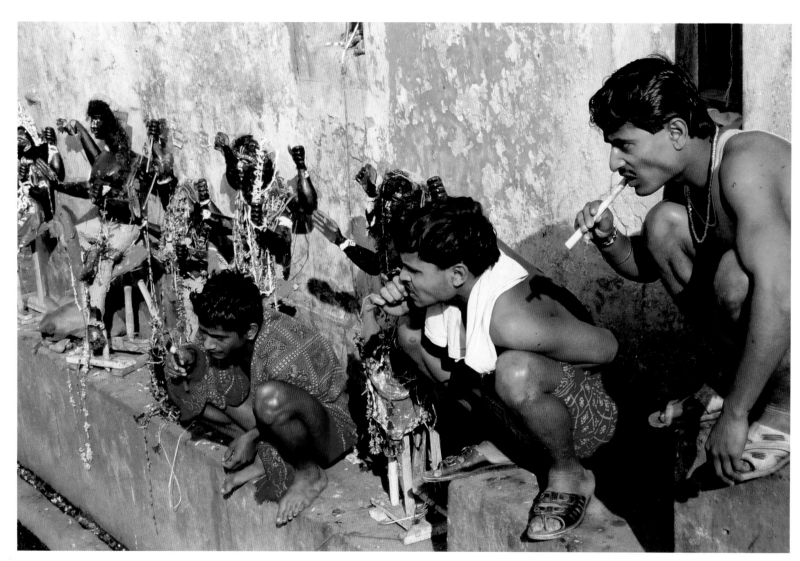

*Morning hygiene on the bathing ghat, North Calcutta, West Bengal. The twig toothbrushes, used everywhere by northern Hindus, are from the sacred neem tree, whose juices have antiseptic properties. The black statues are of the planet god Saturn, who must be placated with prayers every Saturday.*

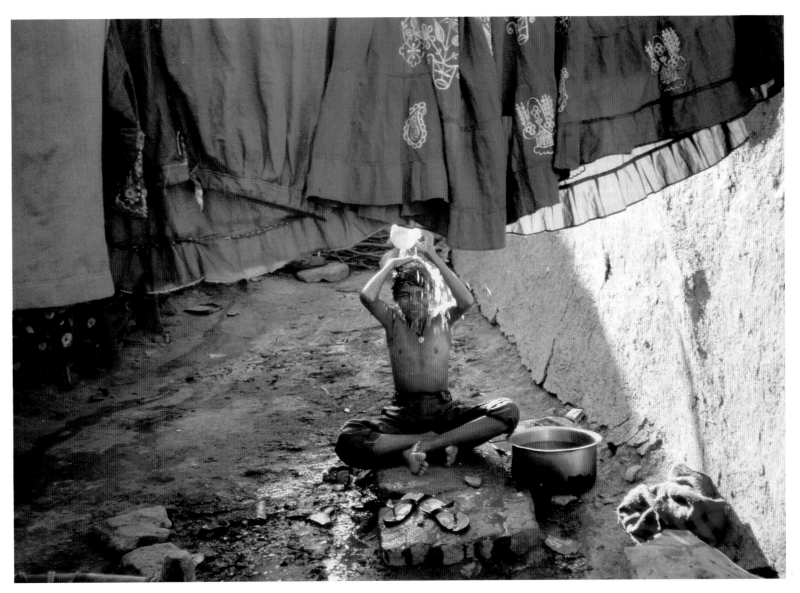

*Alleyway shower, Dasada, Gujarat*

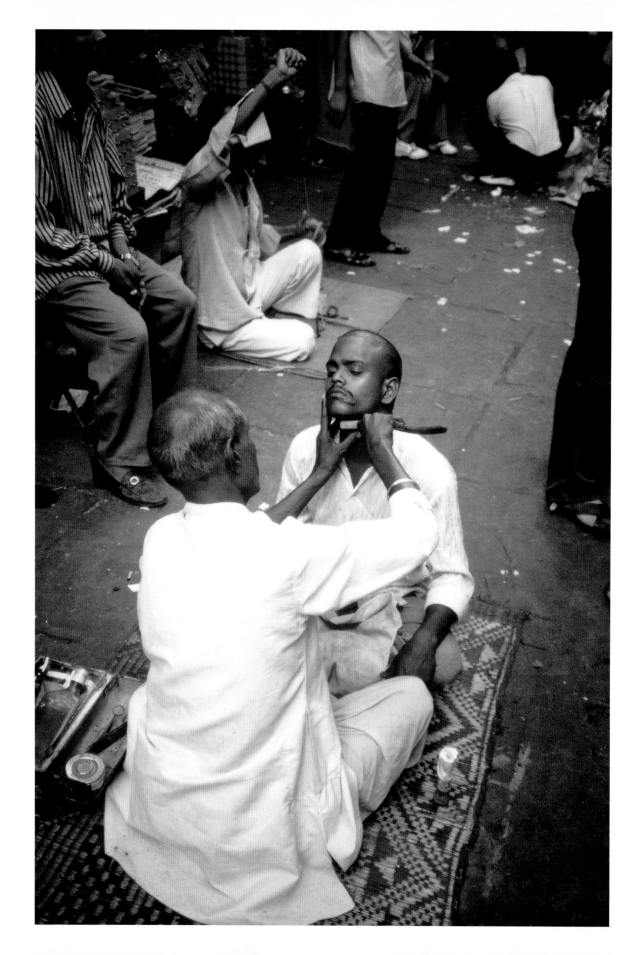

*Tattooing in the red-light district, Falkland Road, Mumbai, Maharasta*

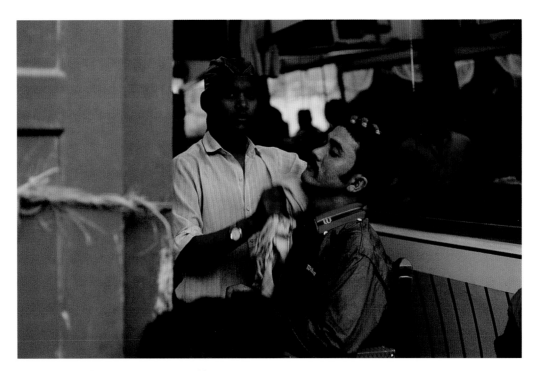

*A soldier in the barber's chair, western Sikkim*

OPPOSITE: *Outdoor barber, Mumbai*

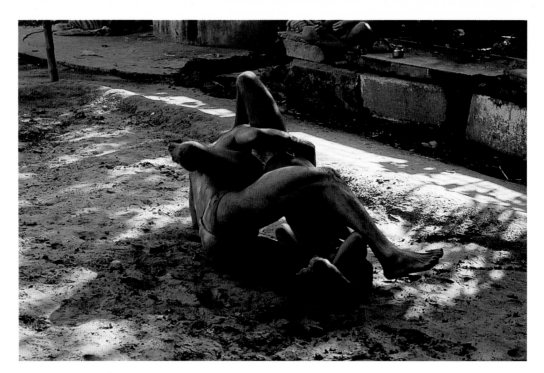

*Body knot, north Calcutta*

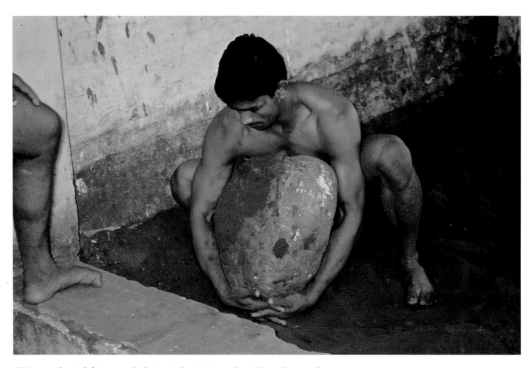

*This wrestler is lifting a rock that weighs 110 pounds at Guru Gaganath Supakar's jaga, a traditional wrestling club at the western edge of Puri, Orissa.*

OPPOSITE: *Youth performing his morning workout with traditional weights*

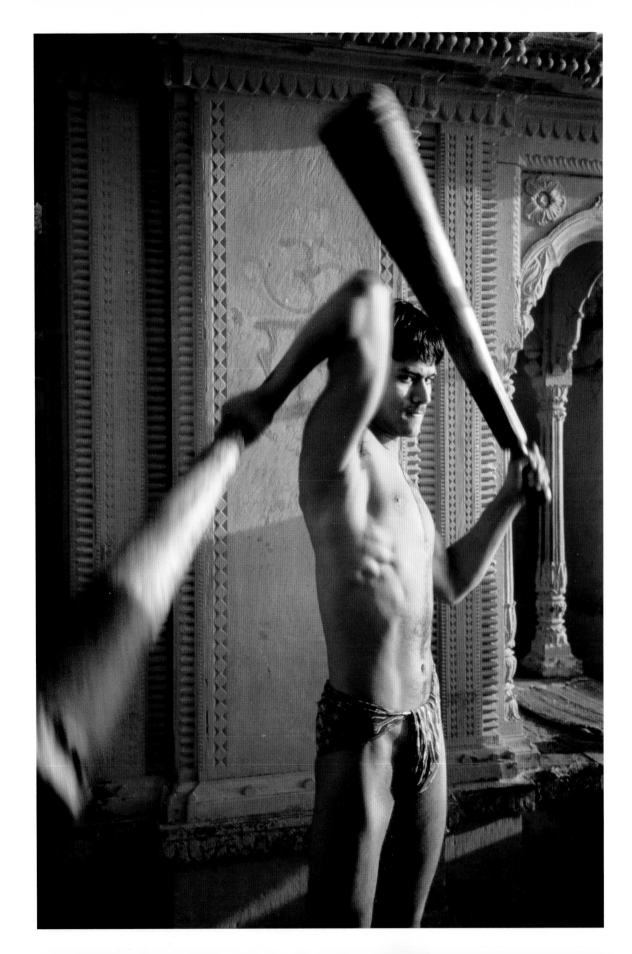

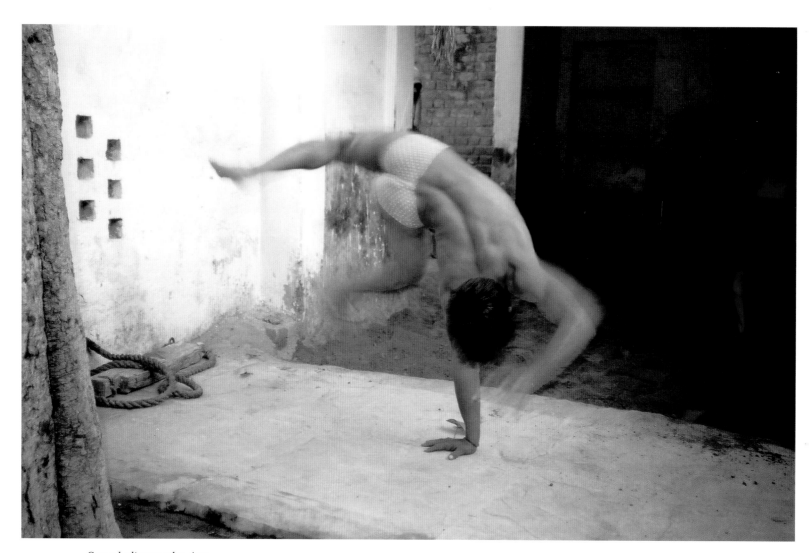

*Cart-wheeling wrestler, Agra*

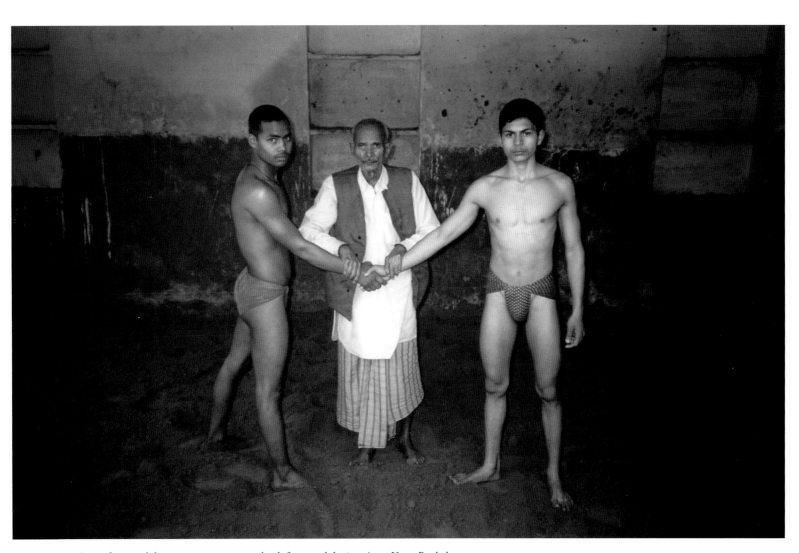

*A wrestling coach bringing contestants together before match begins. Agra, Uttar Pradesh*

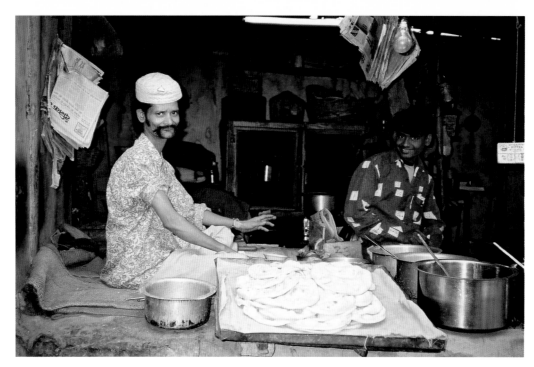

*A hole-in-the-wall eatery in the semiprecious gem market, with freshly baked* roti *still clinging to the inside wall of a clay oven, Ajmer, Rajasthan*

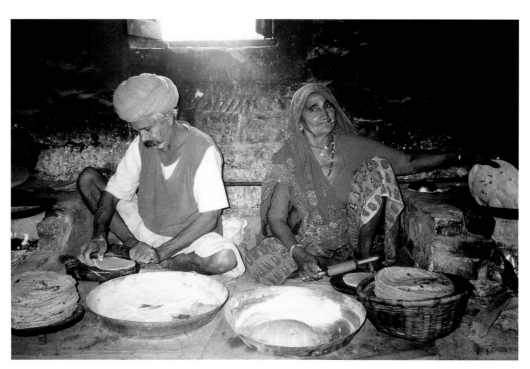

*The preparation of chapattis, which like most Indian breads, are flat and round and eaten as they are made. Kitchen Ram Temple near Rohetgarh, Rajasthan*

OPPOSITE: *Fried sweets in a bakers' alley, Pushkar, Rajasthan*

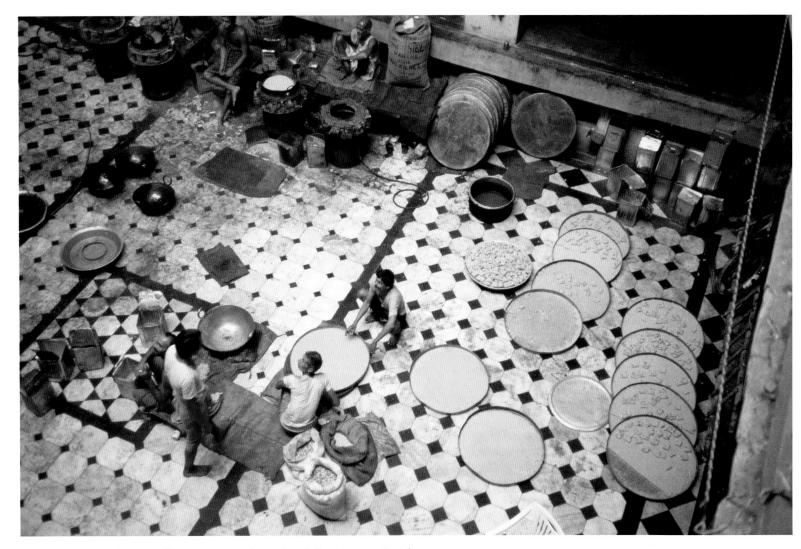

*Candy factory in old mansion courtyard, near Logarh Gate, Amritsar, Punjab*

OPPOSITE: *Dhobi ("washerman") Ghat, a vast outdoor complex for doing laundry in cement tanks and wooden tubs, Mumbai*

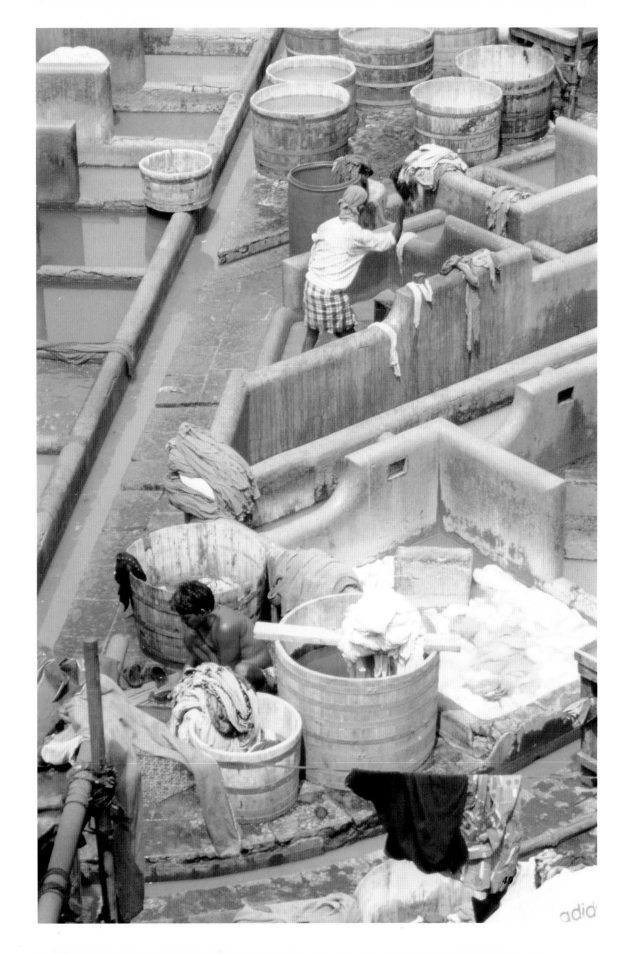

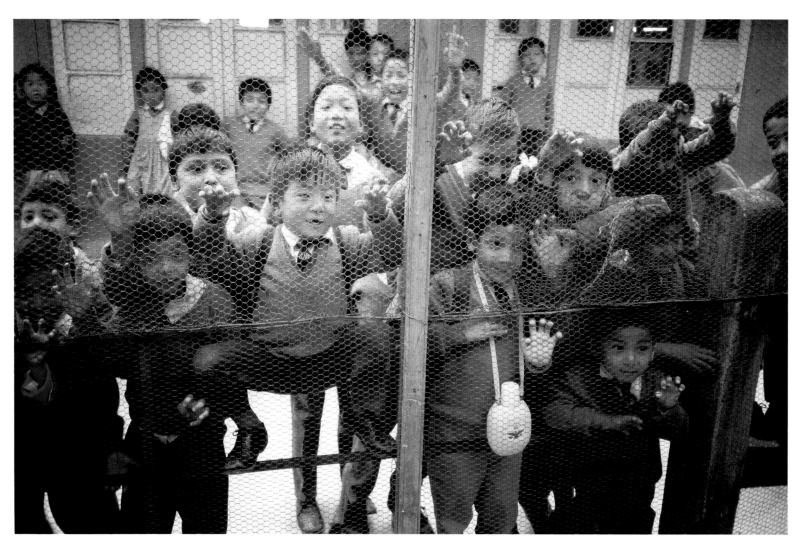

*Public-school morning recess, Observatory Hill, Darjeeling, West Bengal*

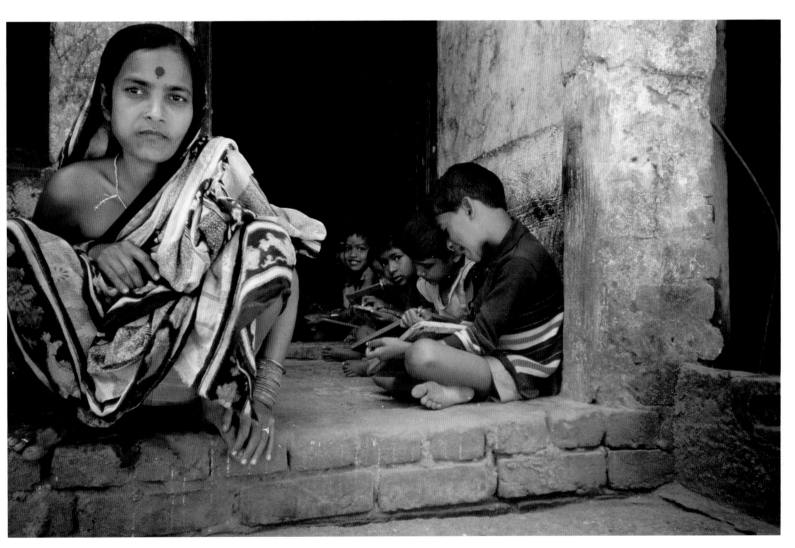

*Schoolteacher and class, Raghurajpur Village, Orissa*

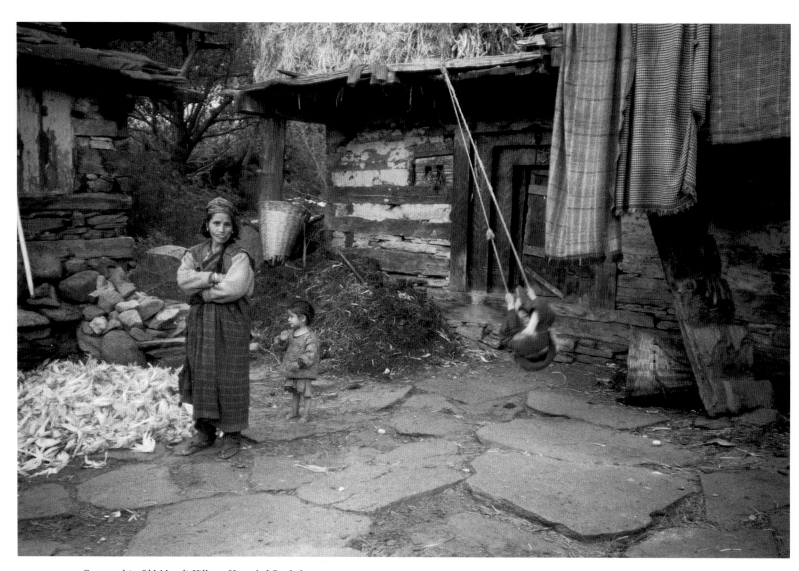

*Courtyard in Old Menali Village, Himachal Pradesh*

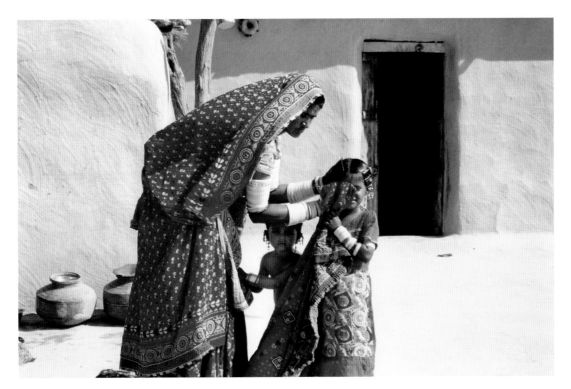

*A Marvada mother gives her daughter's face a scrub
in a village in the Kutch, Gujarat.*

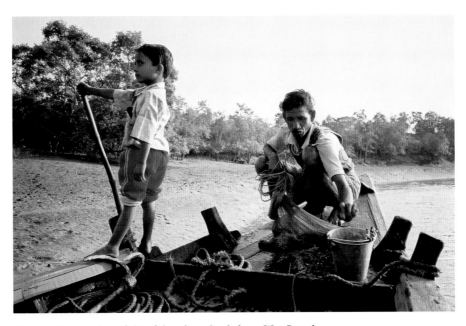

*Father and son on bow of their fishing boat, Sunderbans, West Bengal*

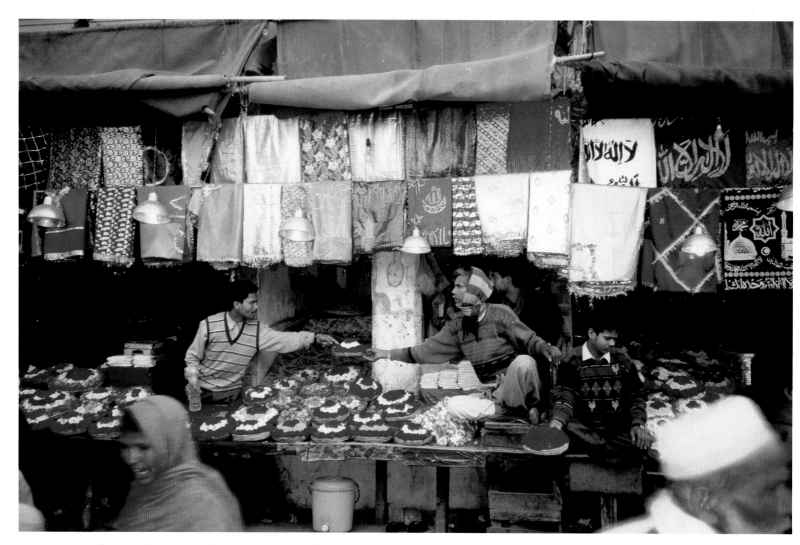

*Stall with textiles and trays of rose petals for use in offerings inside the Dargah, the tomb of the Sufi saint Hazrat Khwaja Moinuddin Chisti, the pioneer preacher who brought Islam to India 850 years ago. Ajmer, Rajasthan*

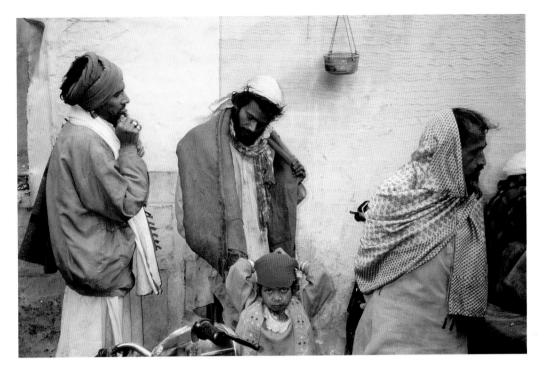

*Loiterers outside the Dargah, the Sufi tomb, Ajmer*

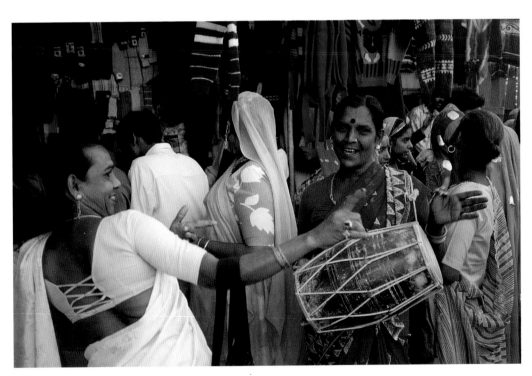

Hijra *making music and money in the market in Pushkar, Rajasthan*

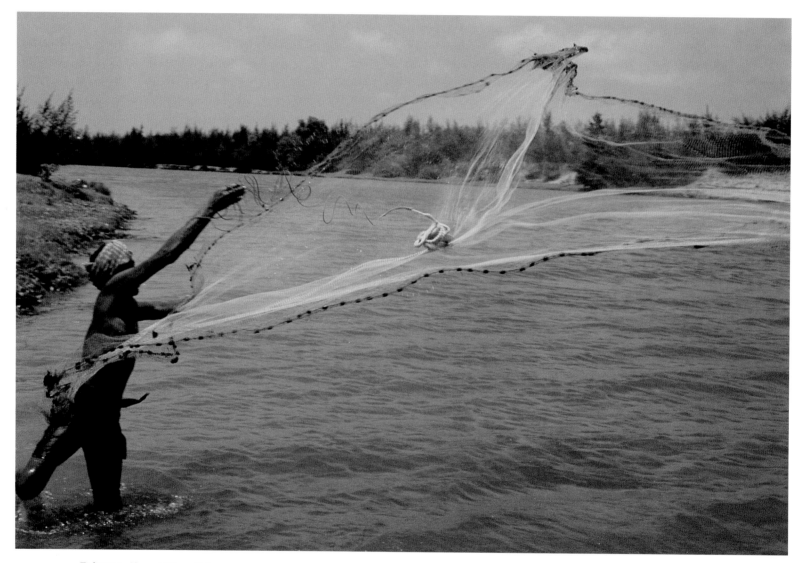

*Fisherman, Nuanai River, Orissa*

OPPOSITE: *Storing hay in the fork of a tree, out of the reach of cattle,*
*Palumpur, Kangra Valley, Himachal Pradesh*

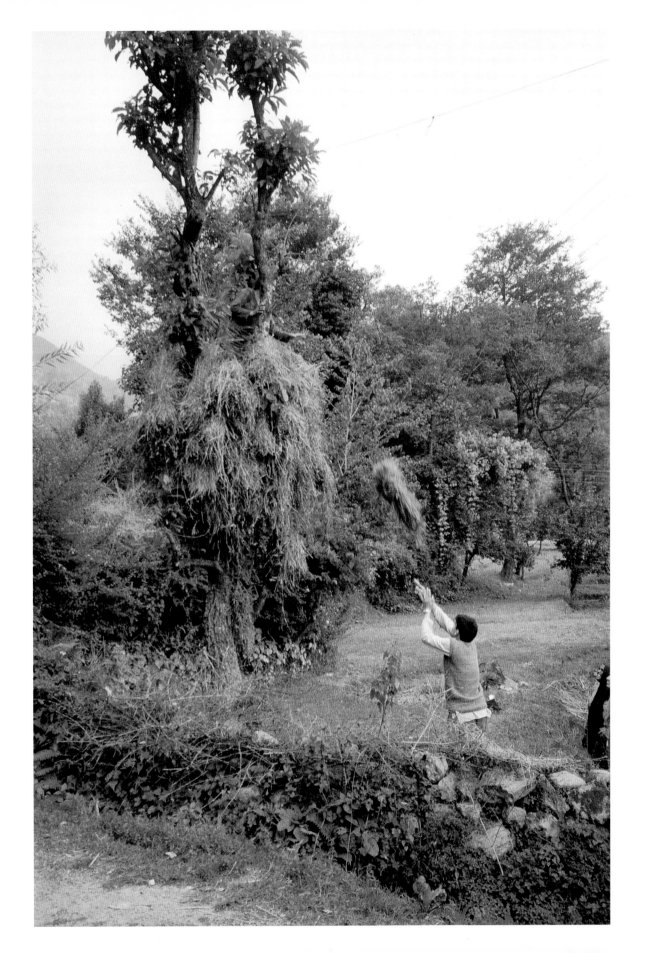

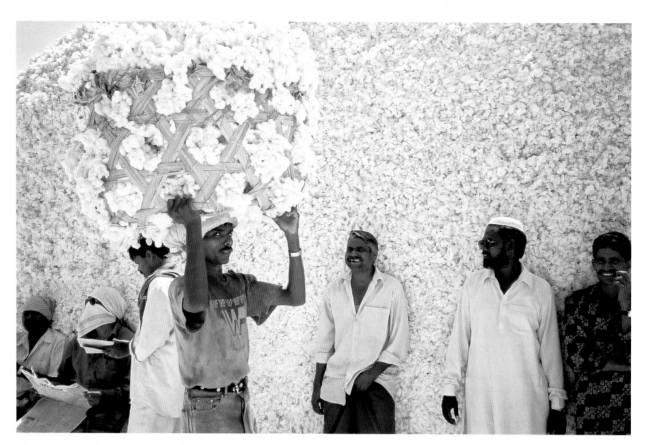

*Cotton-processing factory, Aurangabad*

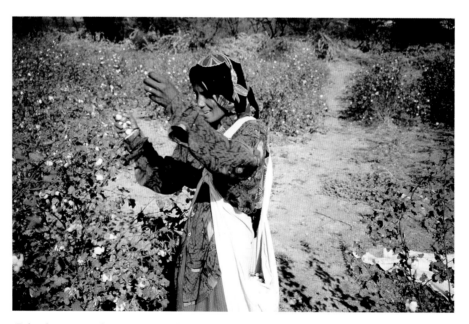

*Fulwadi woman picking cotton, Dasada, Gujarat*

OPPOSITE: *Carting cotton bolls to the cooperative on the road south
from Aurangabad, Maharastra*

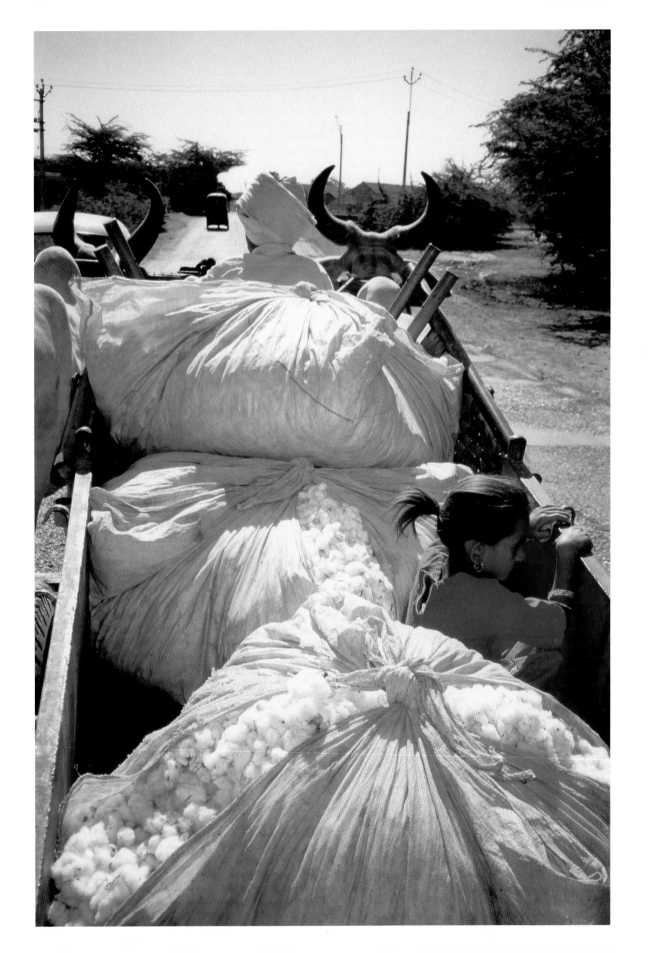

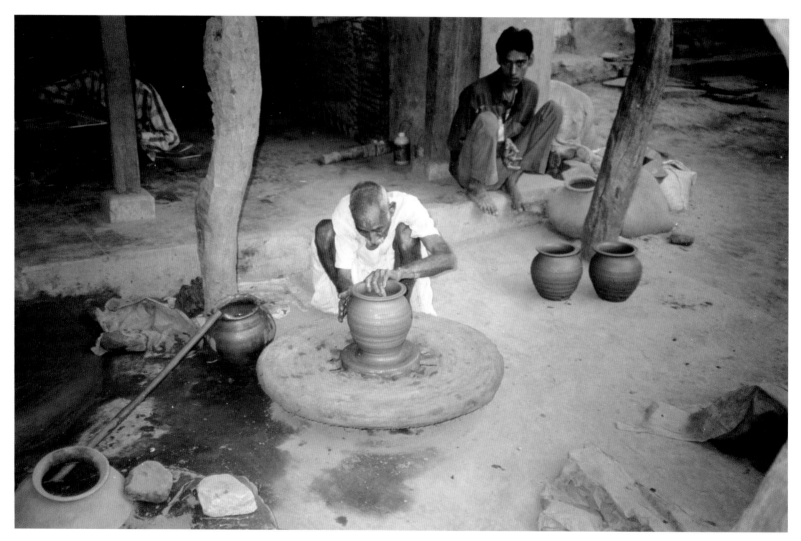

*Potter near Nimaj, Rajasthan*

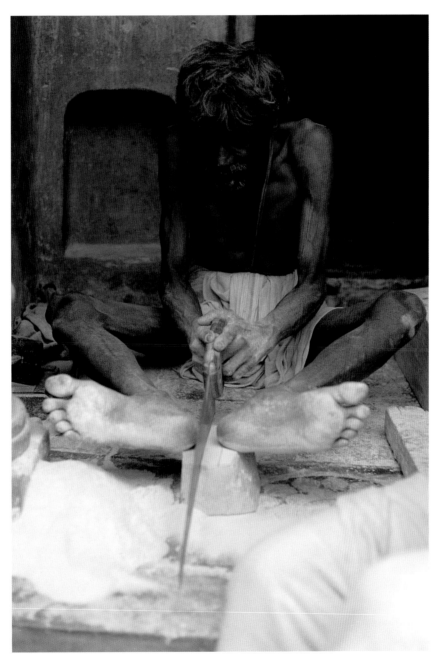

*Veteran stonecutter, Puri*

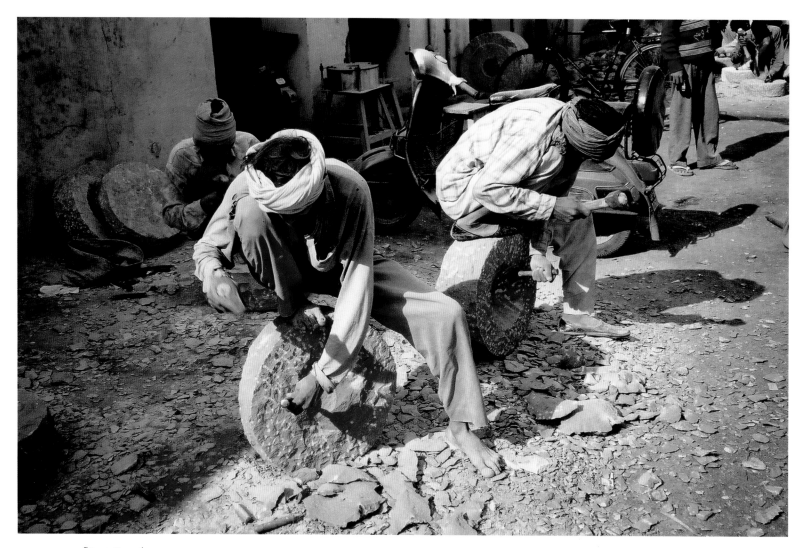

*Stonecutters, Agra*

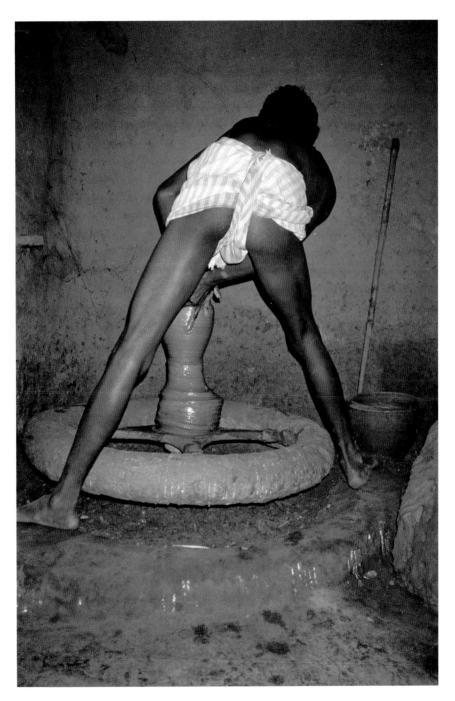

*Potter, Chaitana, Orissa*

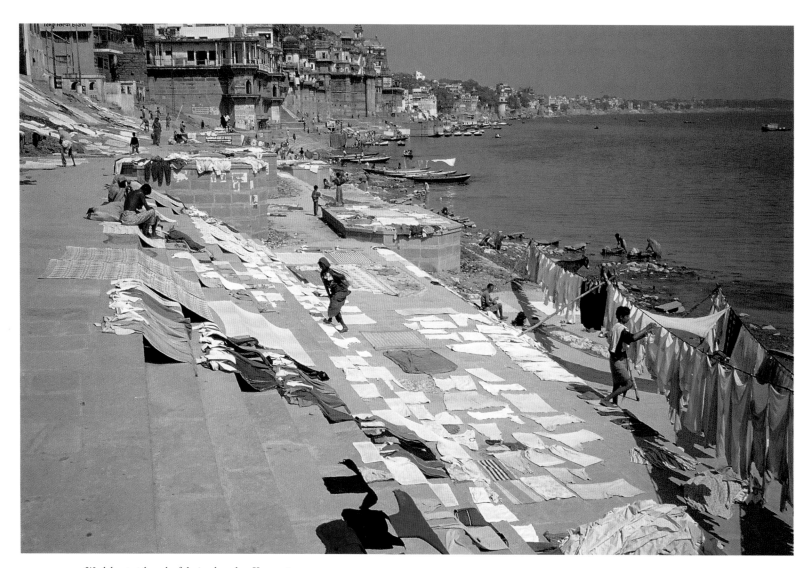

*Workday patchwork of drying laundry, Varanasi*

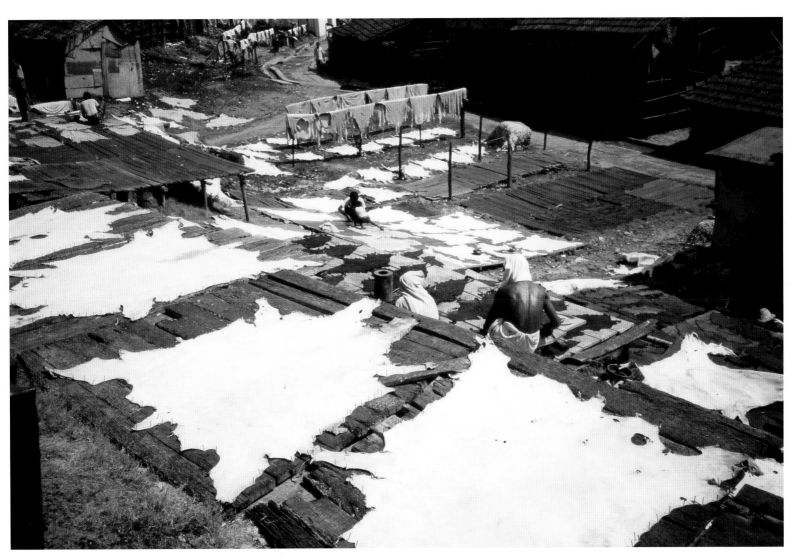

*Tannery workers near Calcutta. These are either Muslims from Bangladesh or harijans
(literally "children of God," a term that Gandhi introduced to replace the now-forbidden
term "untouchables"), as caste Hindus may not handle cowhide.*

*Hindu priest awaiting devotees for* puja *(daily ritual prayer) on the ghats beside the Ganges, Varanasi (Benares), Uttar Pradesh.*

OPPOSITE: *Senior artist in a village of traditional painters, Rhagurajpur, Orissa*

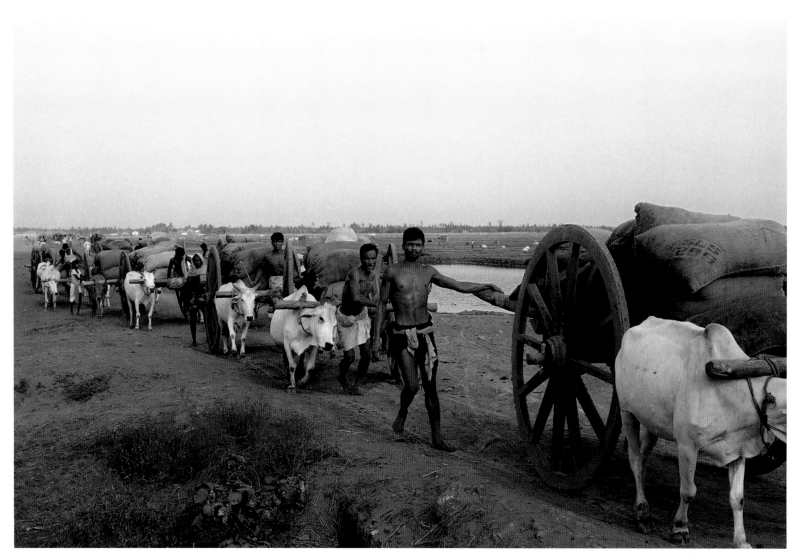

*Transporting salt from Chilika Lake, Orissa*

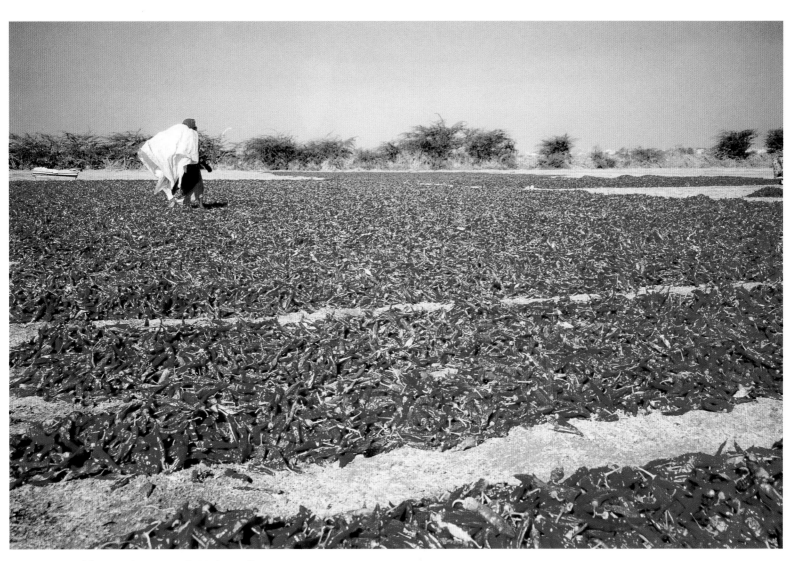

*Chili-pepper harvest outside Wankaner, Gujarat*

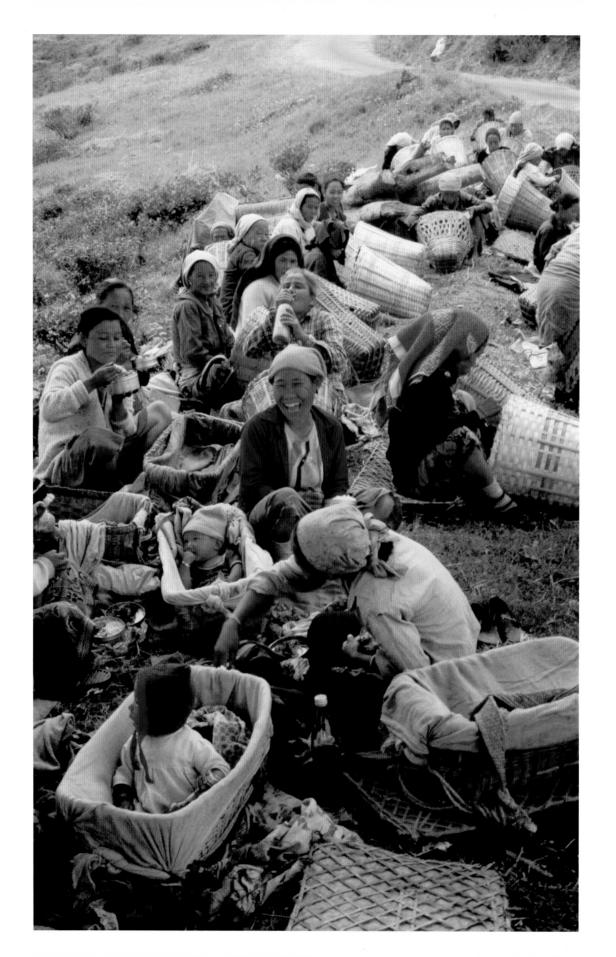

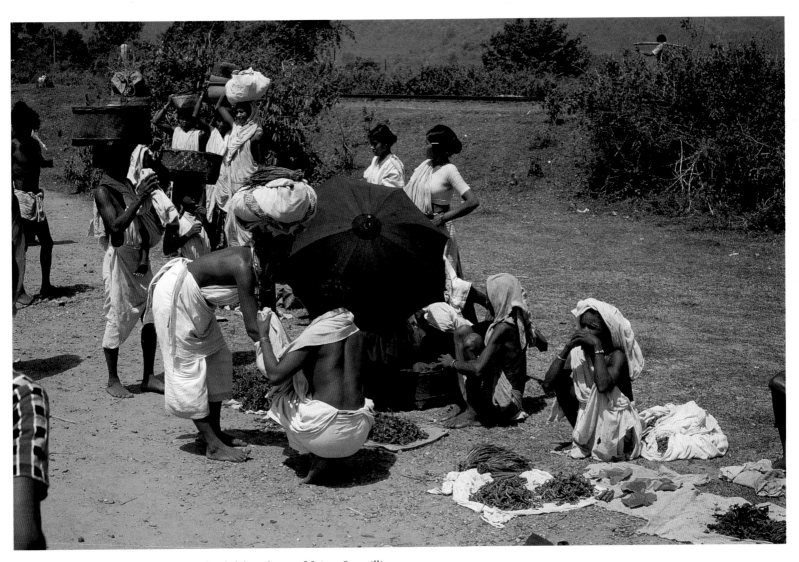

*A Dongria Kondh market in the Phulabani district of Orissa. One million
Kondhs, the most populous tribe in Orissa, were counted in the 1981 census.*

OPPOSITE: *Tea pickers' lunch break, Mirik, West Bengal*

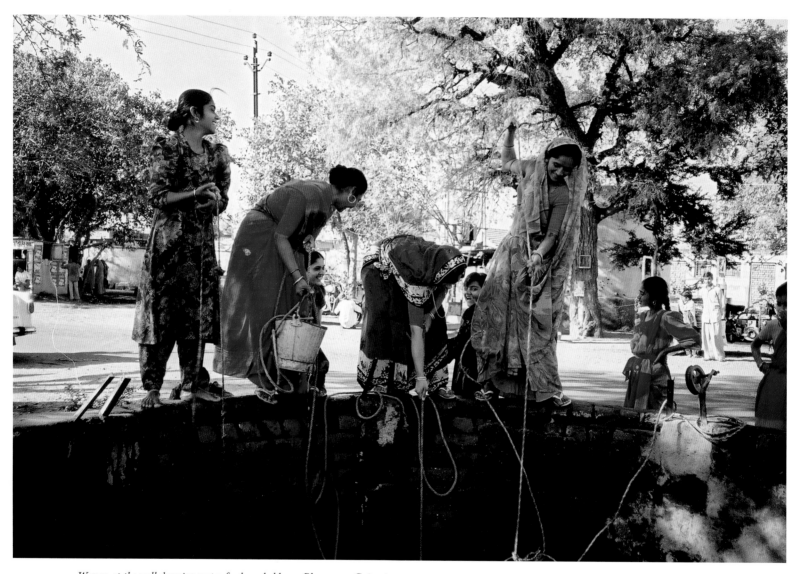

*Women at the well drawing water for household use, Bhavnagar, Gujarat*

OPPOSITE: *A welcoming ceremony among Vishnoi in Rajasthan, near Rohatgarh. The old men from the vicinity gather when a guest arrives to share news and to drink together an infusion of opium from each other's cupped hands.*

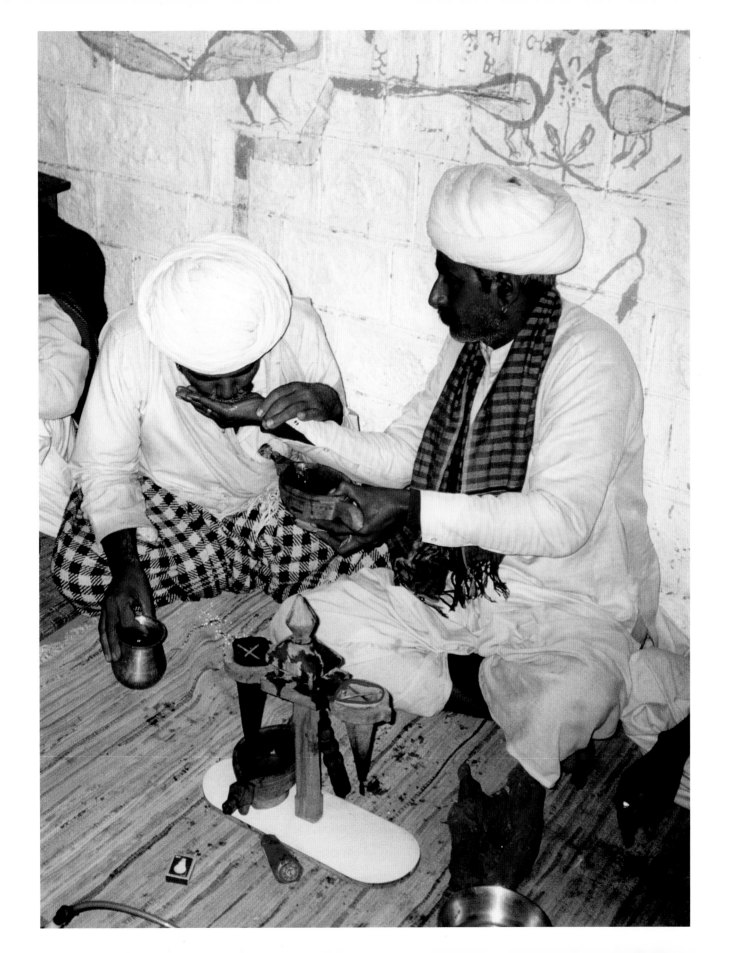

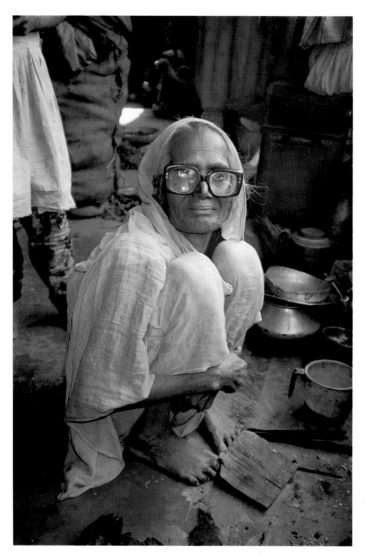

*A "white widow" preparing food for herself. She is one of the old women who come to die in Varanasi and have their ashes strewn in the Ganges, hoping that the power of the river's water will erase their sins and thus enable them to escape the ongoing cycle of birth and death.*

*Elderly* hijra *in Becha Mata Temple, northern Gujarat. Some trace the origin of this group of castrated males back to the arrival in India of Islam, which brought eunuchs who watched over the harems of the Mughal rulers, although there was probably a similar Hindu tradition as well. Every sizable town in India has a* hijra *community, which performs a number of valued social functions for cash and cloth. The number of* hijras *today who are actual eunuchs is a matter of speculation.*

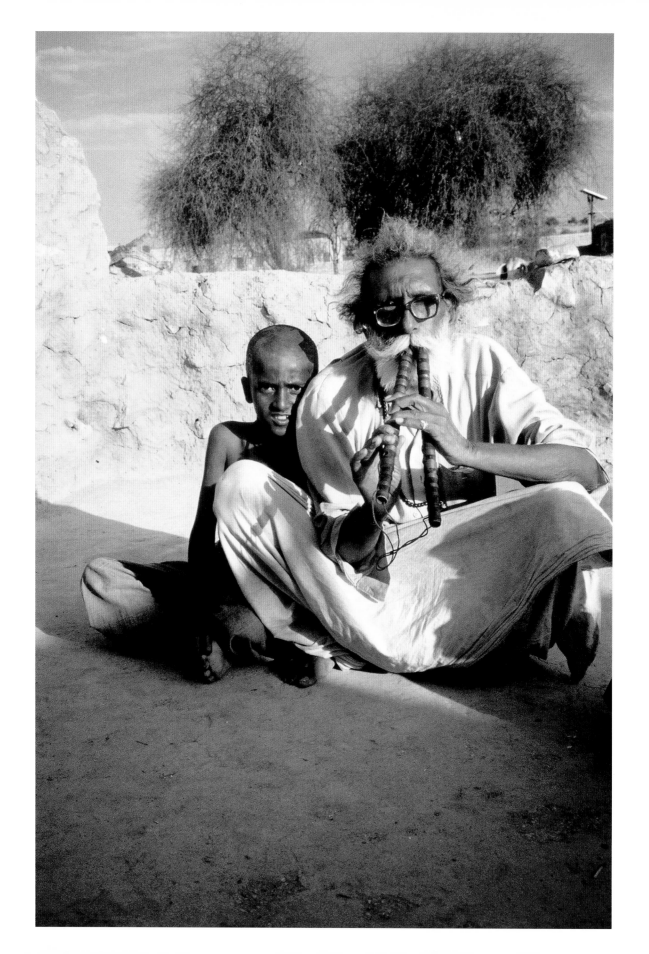

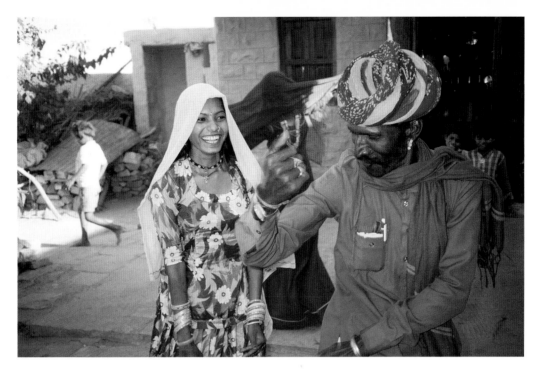

*A musician and his daughters do an impromptu dance to welcome visitors, Jodhpur*

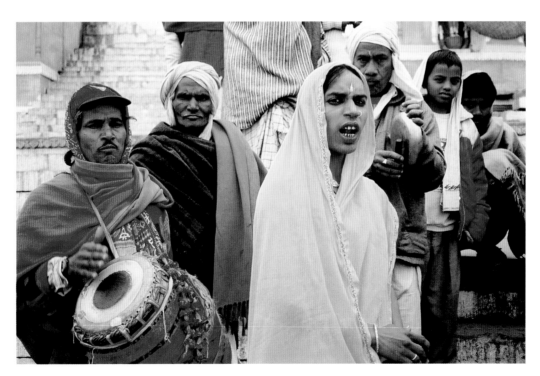

Hijra *and a street band performing on the ghats in Varanasi*

OPPOSITE: *Double-flute* (satara) *player in a village along the road from Jaisalmer to Sam, Rajasthan. Only one of the flutes is played with finger stops. This is a popular instrument among desert Muslims.*

77

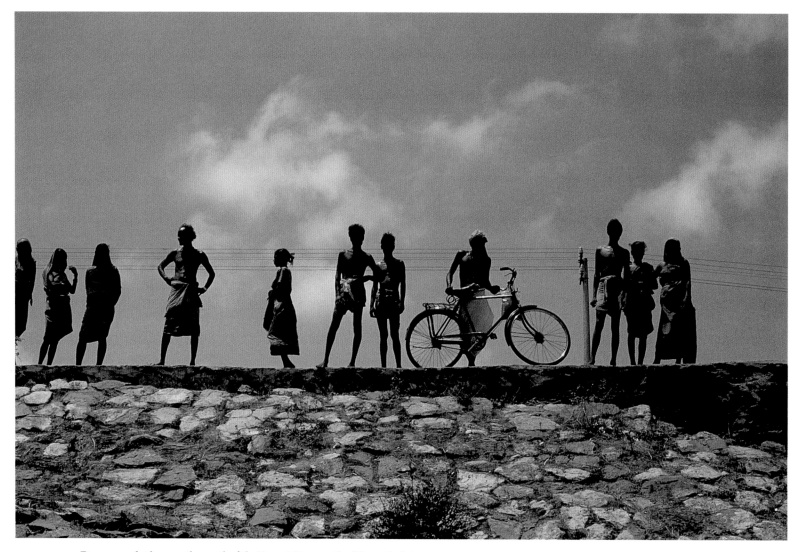

*Figures on a bridge near the mouth of the Nuanai River, south of Konarak, Orissa*

OPPOSITE: *Billboard artists at work on a new automobile advertisement on the outskirts of Calcutta, human flies balancing on bamboo scaffolding*

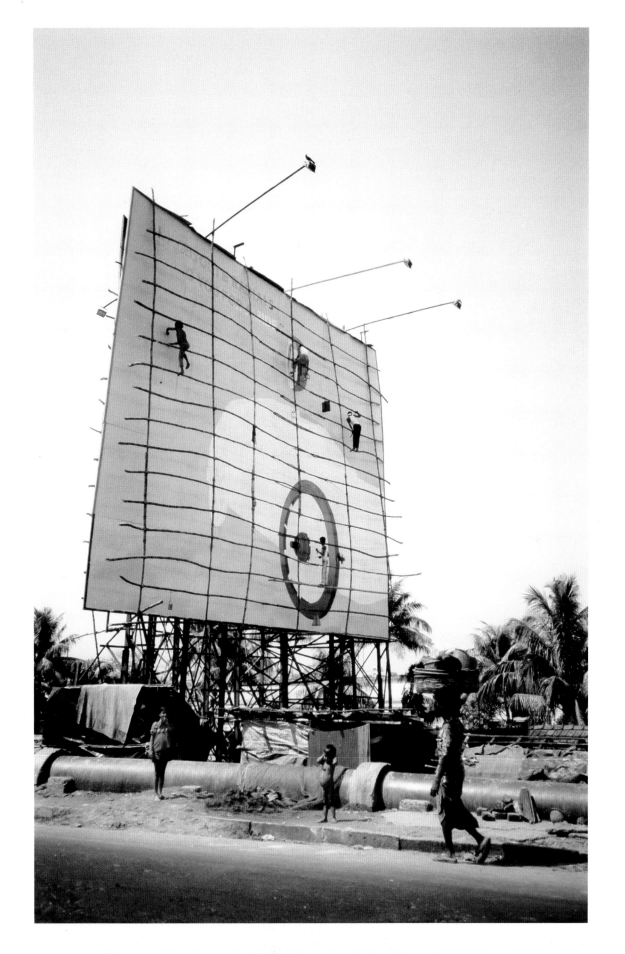

# PART II

## *devotion*

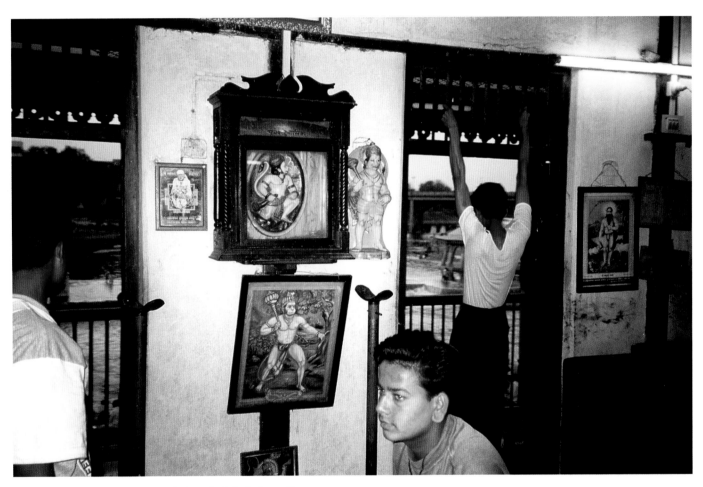

*Hanuman iconography in a gym overlooking the holy Godavari River, Nasik, Maharastra. As told in the epic* Ramayana, *the monkey god and patron of wrestling, known as the Great Hero, rescued Sita for Rama when she was kidnapped by the demon Ravanna and taken to Sri Lanka.*

# 3

## *pilgrimage of the common man*

"OUR PILGRIMAGES IN INDIA ARE LIKE A DRY RIVER BED after the rains come. Slowly, but with great force, each drop swells the current until it overflows its banks and rushes irresistibly to meet the sea. For you, no doubt, Gangasagar will be an immersive experience," Arun Patnaik cautions us before we set out from Calcutta to join India's largest annual pilgrimage. Our destination is the spot where the Ganges River empties into the Bay of Bengal, fifty-five miles to the south. Here in the delta, legend has it, the current descends to the underworld where its healing waters once brought King Sagar's sixty thousand sons back to life. "A lot of people are expected. In the neighborhood of eight-hundred thousand. It may feel like you are drowning in bodies. Don't panic." Arun smiles, "I'll be there." Robust for a man in his mid-fifties, Arun is fanatically proud to be a West Bengali ("we criticize and appreciate") and a Brahmin ("we are the match-stick to light your lamp"). He is a former history teacher and an avid reader and book collector as well. "Gangasagar is the common man's pilgrimage. Every day another coin is put aside, until after thirty years, at the age of seventy-five, you go. Many people who make the journey have never been away from home before. For them it may even be more of an adventure than for you." Arun sports a genuine New York Yankees baseball cap and wire-frame specs. His olive drab fisherman's body warmer has countless zippered pockets where he keeps the small spiral notebooks that contain a lifetime of notes and salient citations. "Sorry." Arun has a habit of apologizing after every spurt of absorbing talk. "Hitler says I don't know how to keep my mouth shut." Hitler is one of Arun's two pet names for his wife. Victoria is the other.

On their way to Gangasagar the pilgrims' traditional first stop is the seething Kali Temple

in south Calcutta. One of Mother Teresa's hospices for the dying occupies an adjoining corner, facing a lane of gum-chewing streetwalkers in bright dresses ("They always wear solid colors," Arun points out, "that's how you can tell. One way."). Across the road "god factories" churn out clay statues of divinities in a seasonal rotation that matches the annual festival calendar. By the hundred, like an unruly bus queue, the gods stand drying on the pavement. Inside the temple precincts, there is a stone toe enshrined behind protective iron to commemorate the temple's origins. It is a said to be the "thumb" of Shiva's beloved Sati's foot, one of many body parts that in the aftermath of her suicide by fire rained to earth while Shiva danced in delirium with her charred corpse in his arms. We arrive shortly before sunset. The press of the throng leaves me feeling I've been swallowed by a boa constrictor. Arun steers us behind the inner sanctuary where from the trunk and branches of a gnarled fertility tree there hang a hundred thousand colored threads, each one knotted in place with a wish for a child. Barren women chant prayers as they press their foreheads to the knuckles of roots, while grateful new mothers present their hard-won prizes to the wishing tree, holding up infants with wrinkled faces wrapped in blankets.

At the opposite end of the temple compound young goats, their necks wreathed with fragrant garlands, are beheaded one after another. The cement underfoot froths with sacrificial blood a brighter red than the fallen flowers. At her turn, a solid, squatting matron lifts a dappled sacrifice and holds the kid's quivering flank flush to her forehead. Skilled hands then quickly sling the goat so its throat rests in a wooden V, where a single downward sword swipe lops the head off into a gory basket, eyes still wide. With his fingertip, the priest daubs blood between the matron's eyes. "Used to be children," Arun shouts into my ear as he draws a finger across his throat. Cries go up from newly arrived parties of Gangasagar-bound pilgrims who shuffle into the temple. They are holding onto a rope to keep themselves together, clutching the veils and shoulder cloths of those in front of them for good measure. Their leader holds a basket heaped with flowers and coconuts high over his head. As bare feet pad along a temple porch at my eye-level, I see that the cracked soles of the women are intricately stenciled with henna. Worn silver toe rings and anklets help to tell wives from widows, and also reveal how many children a woman has had and how many have died.

On Arun's say-so we head for Gangasagar the day before the dawn identified by astrologers as the most auspicious for bathing. We leave Calcutta about 5:30 A.M. Traffic is sparse. The flat countryside is a patchwork of small plots where most of the winter crops have already been cleared from the land. All along the ill-kept two-lane road, farmers and their families thresh and winnow their harvest, flailing bundles of stalks, climbing onto chairs or barrels to pour cascades of grain from woven baskets until the surrounding air blurs with chaff. "Today's real eye-catchers are going to be our Indian holy men." Arun uses the three-odd hours of our journey south for instruction. "What I am telling

you is knowledge from firsthand experience, for my own brother, the oldest, was one himself, a sadhu. Tall, handsome, fair-skinned, someone who had the kind of singing voice you don't often hear and never forget when you do. One of those people with talent who have the good looks it takes for people to notice. He earned a double masters *and* a chartered accountant's degree to go with it. He founded a college for women, which today still enrolls six hundred students. And then suddenly, in the midst of success, he was gone. Vanished. He left his wife and daughter without warning, not a word. Only later our mother said it was right there in his horoscope as a child."

"To become a sadhu, you must break unconditionally with your family. We were completely in the dark for some months, and then at the time of celebrating Kali Puja, one of the servants came upstairs to tell Mother a beggar at the gate was asking for her. Insisting. My mother pulled back the cloth across this man's face and it was my brother. 'If you are to do this thing, you must do it right,' she said, and didn't want to see him. But that day he was allowed to come to our god room and sing the hymns."

"At Gangasagar you will find every thief, pickpocket, and fraud in the country. People will wring their hands and tell you they've been robbed of everything, but they're out to rob you. Of the sadhus, 80 percent are phonies, 'drop-outs' too lazy to earn a living, preying on society; 15 percent are sincere but ignorant; and 5 percent are the real thing. You can always tell the genuine article because he will never ask you for anything. He knows it is your duty to give. In all there are ten orders of holy men as identified by the scholar Shankaracharya; the ten differ in dress, tools, philosophy, and form of worship. And, nationally, there are five centers where sadhus can register. When in doubt, just say to a holy man, 'Father, to which order do you belong?' If he can't answer you, then he is a fake. Examine his companions, too—a true sadhu never goes alone. Each order has specific, distinguishing attributes, but all model themselves on Shiva." Arun unsnaps the pocket over his heart, flips a pad open to a dog-eared page, and reads, "'A mighty bull, a skull-shaped club, an ax, a tiger's skin, ashes, serpents,/And a skull—this, and no more, is your chief paraphernalia'—from the great Hymn of Praise to Shiva."

"And can so many make ends meet by begging?" Iman asks.

"'Big Boss'—that's what my brother called me—'Indians are a strange lot. If I try to raise money for a hospital, people have nothing to spare.' He himself started an orphanage for brain-damaged children and an eye clinic, both of which the family is still maintaining. 'For a holy man's needs, any sum is possible.' My brother was entitled to write 1088 and Maha Mandaleswar Swami Shivanda Giri (the Great Manager) in front of his birth name because to complete his initiation he handed out kashmiri shawls to four hundred sadhus. After ten years, to come higher, he would have had to give ten thousand away. My brother turned holy man at twenty-nine; he died at thirty-nine. Those were ten golden years. He had an enormous

following. His schedule was busier than a cabinet minister's. You could call him the Michael Jackson among West Bengali gurus.

We park in a field of wheat stubble where elaborate banks of lights are rigged at intervals on towering poles. In a row of gaudy tents, popular magic shows and traditional operas are performed after dark to overflow audiences, but now the terrain was largely deserted. To catch the ferry out to Kapil Muni Temple on the delta, however, we close ranks with a waiting queue, obvious lines of descent engraved in the waiting faces. At boarding time, the meek and mild turn into fire-breathers, every molecule of their being set against letting a single interloper embark ahead of them. We are propelled up the rickety, sloping gangplank with stampeding force. As we pull away from shore, shamefully overloaded and wallowing low in the water, a great cry goes up, "Hail, Mother Ganges." Hundreds of hands rise like a flock of birds, flinging coins and rice over the railing. "Not long ago they threw their babies instead," Arun smiles wryly. "Their firstborn, the gods' gift in answer to their prayers." He pauses a moment, seeming to consider the full horror of what he is telling us. "In our Indian classic, the *Mahabharata*, there is the story of one Santanu who goes out hunting on the Ganga's banks and falls in love with a nymph who agrees to live with him if he never questions her actions. She bears him eight sons, seven of whom, one by one, she throws at birth into the river, where they sink from sight like stones. When she lifts her arm, ready to let fly with the eighth baby as well, Santanu at last breaks his word and challenges her to tell him why she commits such crimes. She reveals to him that she is none other than Ganga personified, and their seven sons are the divine Vasavas. By hurling them into the stream, she was liberating them from the curse of human existence."

While I hang on to an overhead iron bar, a heavy-set old woman sinks onto my feet, inert as a sandbag. The lenses of her eyeglasses, thick as bottle bottoms, magnify her watery eyes as she looks up at me and nods and grins. Wind on the water makes men knot their scarves tighter. The hymns pilgrims address to the river have a ring of lamentation. "My brother was buried on the Ganges," Arun says, peering over the rail at the river rushing past our hull. "'Water cremation,' they call it. Two specialists had to come, Brahmins, to break the corpse's back. That way they could arrange him the way they wanted, upright in the lotus position. They packed him in ice, and for three days the crowds kept coming. In the end they put him in a pit filled with salt up to his neck. Lastly they broke coconuts on the head until the skull was fractured, letting free the life imprisoned there, and then they covered him over with more salt and more and erected a Shiva lingam on top of him."

A volunteer corps in hooded yellow oilskin jackets is waiting at the jetty to hand us ashore and to forestall bottlenecks. Arun has only praise for their organization, the Bharat Sevashram Sanghe, a spiritual brotherhood of monks. "Whenever there's a flood, earthquake, or some train wreck, they're the first ones there, beating the government." Inside the imposing gates of the Bharat Sevashram Sanghe ashram, a

neophyte with a shaved skull simply clad in an orange robe leads us to see the tents and barracks where thousands of pilgrims sleep and eat without having to pay. Everything speaks of discipline.

"Has becoming a holy man been a hardship for you?" I ask the fledgling monk. His pure face has the glow of a pearl.

"Leaving the family, that is the one truly difficult thing. Now this is my family."

"Why are you sworn to celibacy? The gods all have their partners. And still they're always wanting more. On every page of the holy books you find still another story of their passion."

"We follow the word of our guru without question."

* * *

WHEN WE LOCATE Arun in the street just outside the gates, he is plunging his wallet back into his hip pocket. "This poor fellow just lost everything he had. His first hour here." A small, dark man cringes pathetically and squirrels away. "No, he really *was* robbed." Arun meanwhile has come up with an explanation for the slackness of the crowd—not that it isn't more than dense enough for me. "They've upped the ferry fare to 25 r.p.h., one way, which no doubt sounds small to you, less than a dollar, but it's enough to put a crimp in many a would-be pilgrim's budget." The way to Kapil Muni Temple is lined with stalls selling souvenirs, gewgaws, and such useful items as sun hats and pocket knives. Scratch a pilgrim, maybe a cash customer lurks beneath. For a few pennies I buy a lurid icon that portrays the temple altar. "In the middle that's Kapil Muni,

the great seer," Arun points out, 'the fiftieth reincarnation of Lord Vishnu, founder of the Sankhya philosophy based on the main principles of Jain and Buddhist religion. Pythagoras, you know, carried his philosophy to Greece. On his right, that is Mother Ganga. On his left Bhagirath, the great-grandson of King Sagara. His name means *ocean* in Sanskrit."

"Who, Arun?" I am hoping for a slower repetition of the lesson, but already a man and woman with music instruments, their leathery faces streaked with sandalwood paste, have diverted Arun's quicksilver attention. "Look here, these two are not *sadhus*," Arun declares. "These are Bauls, our minstrels." At Arun's instigation, the man serenades us, strumming on a kind of small ukulele. "There's a train for Krishna, you just step on board." The song has the cadence and tone of American gospel music. The woman clangs small cymbals. "They are each other's Partner of the Mind," Arun explains emphatically. "No children. If you see a couple with a child, they're not Bauls. Marvelous poetry they make. Love poetry. About a hundred kilometers north of Calcutta tonight the yearly Baul festival begins, determined by the fullness of the moon. They will sing and fornicate all night long, and drink whiskey. They hold their initiations out in the fields. The man lies in the furrows like a corpse and the woman cries, 'My Partner of the Mind is dead, oh bring him back to life for me.'

We reach a kind of county-fair midway and are advancing between galleries of elevated cell-like chambers, each cubicle containing a naked man with plaited tresses swirling in

topknots or trailing to the ground and dark skin smeared with ashes to ghastly effect. The booths have been constructed out of bamboo scaffolding and clay mixed with straw. Their three inner walls are papered with pages torn from garish mythological calendars. Each enclosure includes a small altar, draped with flowers, as well as trays with oil lamps, incense, and camel-hair fly whisks. "Nagas," Arun whispers loud enough to turn heads. "Suicide squads of holy men, the first eighty thousand created in the eighth century A.D. to preserve our faith from the incursions of Muslims and Buddhists. Once they start to move, nothing stops them. They trample right over the enemy. *Naga*, you know, means snake. They are the first to bathe at any festival of holy men. They smear that mixture of ash and dung on themselves with some natural anesthetic like aloe to deaden the feeling in their skin. At their initiation, a guru strikes their private parts with iron tongs to neutralize them. If the candidate naga dies from this blow, a second guru waiting close by has to seize the tongs and strike the first down on the spot. Be careful, they are very fierce."

Instinctively I smile at a boy naga who is hunkering a few steps away. He doesn't growl but smiles back. In his ashen mask he looks to me like a cartoon character who has just lit an exploding cigar. Except that what we are seeing is not a florid, one-day masquerade; this is the boy's life. These men go to sleep with their naked bodies, and they wake up with them. All day in Gangasagar, I have to keep reminding myself of the essential truth that this is no pageant staged for my delight. Rather it is,

typical of India, a rite that arouses deep feelings in the participants, a spectacle with meaning. Each year, for a contingent of believers at least as large as the population of Amsterdam, the visit to Gangasagar is one of the most important events in their lives, a high point toward which they have lived and saved for years. Similarly disposed crowds have been coming here for millennia to perform the same acts of devotion, under the same enormous sky, bathing in the same rising and ebbing tide, telling and retelling the same story of mass deaths and resurrection. We have no equivalent living tradition in the West.

"Why in this age of videos and pornography have you chosen to become a holy man?" Arun challenges the naga boy in a teacher's voice gone crisp with authority. The naga replies that, when he was seven, a guru visited his small village and made a deep impression on him by saying that becoming a sadhu wasn't an easy thing. "Not like buying a ticket for the cinema." When the boy turned fifteen, his parents yielded to his wish to join the nagas' organization.

"Some children feel things deeply," Arun tells us, his voice softening. "That is true. One day the teacher sent my brother home from school because he was crying and he couldn't stop. At the time he was only in the fifth class. When we asked him what was the matter, he answered us that he was crying for mankind."

"Is your guru here, too?" I ask the naga.

The boy steps down and with lanky grace ushers us across the dusty midway, which is filling up with more visitors moving slowly seaward. He brings us to a booth where a powerfully built fellow with hair coiled into

a tower is receiving homage from a procession of pilgrims. One by one he taps their bowed heads with a peacock-feather wand. A Brahmin in orange breaks into the queue with a round tray on which a camphor-oil lamp sputters in five flames; he rotates the tray in homage between the guru's bare thighs. After an exchange of niceties, the guru sketches his life story for us ("Amazing," Arun confides later, "they *never* talk about their lives!"). He came from Uttar Pradesh and had met his guru when he ran away from home to avoid a beating after flunking an examination. We take our leave when suddenly Arun turns and dashes back. We watch as he submits meekly to a peacock-wand blessing. "You saw how I touched his feet. That is our way to show respect to a teacher of any sort," Arun blurts out once he catches up to us, wiping his face with a handkerchief, feeling its dampness, "but I didn't give him our real address. Once they know where you live, they can be very clinging. My Victoria wouldn't like that. He's a good, honest man, though."

"There, over behind the bamboo fence, those people in orange and red, they are all tantric sadhus. See the one with a gold chillum showing off. They're smoking ganja. Those are their women, see their eyes. They are always soaring. When they have sex, it is with the genitals touching but no penetration. Tantrics come from Assam and Kashmir originally, and Bengal. God is everywhere, they believe; God is in everyone." He digs a memo pad out of a pocket: "'In the embrace of his beloved a man forgets the whole world—everything both within and without; in the same way he who embraces the self knows neither within nor without.' *Brihadaranyaka Upanishad.* They use the drug to empty their minds, as an aid to meditation, the way I use my cassettes of Auribindo chants. You see the eyes of their women! Their way of sex—without the man's reaching climax, drains their partners of vital energy. They turn the act of love into robbery." Sprawled on the sand in their robes, the men look rakish, like unabashed voluptuaries. Their laughing eyes stare back at mine, as, invitingly, they hold out a chillum to me and exhale sweet plumes of smoke.

Kapil Muni Temple, built in 1979, is a bright mix of green, red, and orange. We mingle with a thick crowd out front where military sentries with dull metallic helmets keep people moving. From the top of a low flight of broad stairs, priests drop *prasad*, scraps of food blessed by the goddess Ganga, into pilgrims' outstretched hands. Next to me a baby, dead to the world, nestles on his mother's shoulder and oozed bubbles between puckered lips. Loud-speakers crackle with warnings against pickpockets. The cumulative body heat is becoming unbearable. I want to fight free of the devout mob and to walk, alone, far out along the sandy shore. Arun, like an icebreaker, cleaves a path for us, spouting the gist of the Gangasagar story the whole time back over his shoulder. "The king Ajohya was missing a prize horse, so he sent his sixty thousand sons to search for it. Their looking disturbed the sage Kapila at his meditations and with one fierce look he burned them to a crisp. It was left to Sagara's great-grandson, Bhagiratha, to bring

the sacred Ganga herself from heaven down to earth, and from there to the infernal regions where by her watering the ashes of Sagara's sons she became the means of conveying their souls back up to the light."

Laid-back beggars on blankets flank our path to the bay, as do help organizations with banners flapping in the sea breeze We pass lively all-male Baul bands, walking-cane and sword salesmen, the stands of schools recruiting students, and first-aid and missing-persons retrieval posts. Off to one side, a solitary old man crouches with his haunches on the sand and dramatically reads the *Mahabharata* aloud to no visible audience. Not for the last time during the day, the apparent ease with which such a complex event is managed impresses me in a country where stories abound of people who grow old trying to buy a plane ticket, change money, or post a package.

A two-master with brown sails inches across the wide horizon. The tide is coming in. Everywhere I look pilgrims in various stages of dress and undress are strung out straggling along the mud flats. Those who earlier waded out far enough to dunk completely under, now lift their knees as they retreat to the shore. The scene is tranquil, not congested. Husbands are holding up their wives' wet saris by their corners to billow dry, staining the late afternoon sunshine with layered veils of brilliant color. The anatomy of pilgrims glimpsed through the cloth appears in wavy silhouette. Everything takes place in plain view, overtly, but still the experience is more private than public, sooner individual than collective. Here

and there—like a struck match—a moment of intense joy flares up. Women spring up from the sand to dance together, singing heartily in small groups. A husband and wife, both of them with their broad backs bare, hunker together with a priest who is absorbed in making a small offering to their ancestors. The couple shivers slightly, lips still deep blue from their holy immersion, stroked by shadows as the world streams by, parting to go around them like rocks in a riverbed. Vendors shouting at the sky wheel carts with sinuous skeins of yellow and rust-red marigolds. Gradually I spot more and more fantastic, naive papier- maché statues, the lively likenesses of gods and heroes displayed beside holy men and beggars. One waist-high sculpture depicts a woman in a dinghy, a skeleton lying with its skull on her lap.

"Very good," Arun says to the artist. "We are looking, I take it, at Behula, the faithful wife who wouldn't give up the corpse of her husband, Lakshminder. You see, as long as you go on touching a dead body, Jamraj, that is, Satan, cannot collect the soul." After twelve years of Behula's prayers, Vishnu restored Lakshminder to life." The sculptor holds out his hand for money. "What are you, a Muslim? Muslims beg," Arun barks jovially, as he parts with some change. "My brother ate with Muslims," he tells us as we weave among the lingering bathers. "That's the kind of person he was." A tall sadhu in black with a trident, a bright metal pail for food, and sun-bleached human thigh bones dangling around his neck blocks our path. "I am the sadhu of the jungle," he intones histrionically.

"Then what are you doing here?" Arun's arm sweeps the scene.

"This is the human jungle."

"Very good!" Arun reaches out and pulls aside the hem of the sadhu's long black shirt. He has a chain fastened with a ring through his glans. "Hitler said I shouldn't show you these things, but they are all a part of the cultural picture. My brother used to say people express their devotion in one of two ways, either like a monkey or a cat. The monkey surrenders unconditionally, clasping God around the knees. The cat waits for God to pick him up by the scruff of his neck." Arun then walks briskly to the water and paddles in a dying wave with one palm. "There," he says when he comes back, "my good wife will be happy when I tell her I did that."

Reluctantly we turn back. The light is magical now, casting long shadows and charging the air with gold. The crowd around the temple has easily tripled meanwhile, swollen by the arrival of pilgrim cohorts holding on to ropes to avoid getting separated, leaning into each other for security, world-shy villagers making the journey of their lives. We find our teenage naga friend in animated discussion with an ash-stained neighbor. Arun butts in. All three talk at once, then burst out laughing. The neighbor beckons us closer. He takes a bamboo rod about a foot long and after first stretching his foreskin he rolls his flaccid penis slowly and tightly around the center of the rod, tucking the two ends finally behind his thighs and demanding we photograph him like that. "If you hitch a tractor to that piece of bamboo, he says he can pull the vehicle right along. It is my culture, but even so, I admit to you," Arun shakes his head as we move on, "I am well and truly amazed."

"What were the two of them going on about when we arrived?"

"Football. The chap who did the trick with the bamboo was saying Argentina should have played Maradonna in the 1998 World Cup. He would have showed more magic in only five minutes than all the rest of them, in this or other lifetimes. India is a slow country that loves fast football."

"What are sadhus for, Arun? Why are they necessary?"

"Awe. The holy men are the starch that holds the system together. Even the impostors. People fear them. They give them money to escape their curse, like an insurance policy. Now that man there." We have drawn abreast of a bearded figure in orange turban and robe who stands with his arms folded on a cushion, leaning on a swing at chest level. Arun fires a question at him, nodding at the laconic reply." He has not sat or lain down these past fourteen years."

"Why?"

"Comfort is not part of their vocabulary. My brother took vows, too. To keep silent. For three months at a time. All Hitler asks of me is three minutes! Ah, there, see, finally! Holy women." Half a dozen female sadhus, a drab-looking lot in pale apricot saris, most with eyeglasses, occupy adjacent clay booths. Arun sprinkles coins in their begging bowls.

On our way to catch a bus to the ferry, we pass a series of pilgrim lodging houses where hundreds at a time are taking free meals.

Volunteers with buckets and ladles pace up and down the rows, refilling empty plates. "See our little League of Nations! From all over India they come. The colors, and how they knot their clothes, the turbans and saris, betray the whereabouts of their home places. And they eat together in peace. An impressive sight. Oh, yes, the gurus are jealous and out to make an impression, but the people have come clothed in their humility."

* * *

THE JOURNEY BACK to Calcutta, mostly in the dark, is remarkable for the feeling that we are defying some primary law of motion, the only people on earth heading north, moving against an indefatigable current with the rest of the world intent on reaching Gangasagar on time for a purifying morning dip in the sea. Hundreds of buses careen by, none of the latest model, one right behind the other, each crammed to the bursting point and with clusters of pilgrims all but spilling off the rooftop luggage racks, too. Driver after driver doesn't look big enough to control his vehicle.

"Not so very long ago . . . " Once the delta is behind us, Arun breaks the rare spell of silence into which he had subsided. His face, lit by the headlights of the surging southbound traffic, looks positively ancient. "The common people walked to Gangasagar from Calcutta. Our Bengali tigers picked some snacks off on the way. Thuggies, too, who made something ecstatic of murder and gave Tantra a bad name. The trip took days. Now these speeding rattletraps!

"The day my brother left his home to become a holy man—we found this out much later—he had quarreled with his wife. Theirs was a love marriage. She has never been to our place since his death, nor invited me. Near the end he had a dream. 'Big Boss,' he said—he used to call me that, did I tell you?—'in my dream you were more colorful than a rainbow, and brighter than the sun.' They called me to the hospital. The doctors diagnosed a cerebral hemorrhage. I so much wanted to take him home with me, to our god room, but that wasn't possible. So I held his hand right where we were and chanted Hare Krishna and my brother left the world hearing the same words that greeted him upon entering it."

in prescribing proportions, postures, gestures, emblems, weapons, and vehicles. An effigy must be pleasing to the deity it depicts so he will comply with the invocation to take up residence inside once it is finished. Codification is to assure that images are not the expression of any individual vision, but are orthodox, part of a canon. Yet at Ellora, inside the mountain, my feeling grew stronger with continued exposure that each blow of the hammer on the rock face had a revolutionary ring.

During Buddha's pursuit of truth, he shrank to a shadow of his former self: "Let my skin, sinew and bones become dry and welcome! Let all the flesh and blood in my body dry up! Never will I stir from this seat till I have attained supreme and absolute wisdom." His own words! What explains then why Buddha in India is always shown as bloated? By the time he had achieved enlightenment, he would have needed an intravenous drip, and yet every statue or painting of him is plump. In Tin Tal any of the seated Buddhas would need a helping hand to stand up, a hefty tug. But then they are deeply content with immobility. Gradually the inertia of serenity works its calming effect on me. I fold my hands, and something softens inside, something settles. I recall watching the building of an enormous Buddha in a monastery outside the hill station of Darjeeling. Boy monks in carmine robes silvered small packages of Buddha's sayings in paint and stashed them away inside the roly-poly statue's belly. At the time of the image's consecration, these words are believed to animate the statue.

(For newly wrought Hindu deities a rite called *pranapratishta*, instilling the breath of life, is performed at the last moment. At this time, a priest with a golden needle opens their eyes, sealed until now with honey and ghee.) But the Buddhas of Ellora are rock solid. Perhaps with an ear to their chests we might make out the whisperings of a soul buried deep down within. Outside a fragile, tattered cloud trails across the sun. Smiles ripple across the lips of the ancient incarnations of a man who subdued his need and his desire to move.

Back in Cave 14 I am struck this time by the omnipresence of death. It is almost more than I can do to stand still. Just as the artists in Ellora's adjoining caves surely connected differently to the rock they carved, so, too, anyone coming inside and seeing their work must have responded differently. I tell myself I keep moving because the sculptures reveal something new from every new angle, but my movement feels like a kind of compulsive stalking, the wary circling of a wrestler in a ring. If chanting seems an appropriate reaction to the orderly ranks of Buddhas next door, being here makes me want to shout.

Moving into the depths of the hall, down a colonnade, I consider the vastness of the figures in the friezes, reminding myself that centuries ago people were probably smaller than I am. How big do Indians imagine the demons and giants of their mythology to be? To awaken one once, I recall a myth, several elephants were sent to walk over his body. Their stamping on him finally produced a

Volunteers with buckets and ladles pace up and down the rows, refilling empty plates. "See our little League of Nations! From all over India they come. The colors, and how they knot their clothes, the turbans and saris, betray the whereabouts of their home places. And they eat together in peace. An impressive sight. Oh, yes, the gurus are jealous and out to make an impression, but the people have come clothed in their humility."

*   *   *

THE JOURNEY BACK to Calcutta, mostly in the dark, is remarkable for the feeling that we are defying some primary law of motion, the only people on earth heading north, moving against an indefatigable current with the rest of the world intent on reaching Gangasagar on time for a purifying morning dip in the sea. Hundreds of buses careen by, none of the latest model, one right behind the other, each crammed to the bursting point and with clusters of pilgrims all but spilling off the rooftop luggage racks, too. Driver after driver doesn't look big enough to control his vehicle.

"Not so very long ago . . . " Once the delta is behind us, Arun breaks the rare spell of silence into which he had subsided. His face, lit by the headlights of the surging southbound traffic, looks positively ancient. "The common people walked to Gangasagar from Calcutta. Our Bengali tigers picked some snacks off on the way. Thuggies, too, who made something ecstatic of murder and gave Tantra a bad name. The trip took days. Now these speeding rattletraps!

"The day my brother left his home to become a holy man—we found this out much later—he had quarreled with his wife. Theirs was a love marriage. She has never been to our place since his death, nor invited me. Near the end he had a dream. 'Big Boss,' he said—he used to call me that, did I tell you?—'in my dream you were more colorful than a rainbow, and brighter than the sun.' They called me to the hospital. The doctors diagnosed a cerebral hemorrhage. I so much wanted to take him home with me, to our god room, but that wasn't possible. So I held his hand right where we were and chanted Hare Krishna and my brother left the world hearing the same words that greeted him upon entering it."

# 4

## *god's bodies*

ARE YOU A RUINS-AND-REMAINS PERSON? I'M NOT, NOT AS a rule. It's mostly out of some weird and twisted sense of family duty that I "do" them at all, and then without intimations of discovery. Still there have been a handful of on-site occasions when sparks did suddenly fly from the inert and crumbling evidence of spent cultures around me and fall on the tinder of my historical imagination. One such ignition occurred at Ellora, when I happened on a hinge of history in stone. Ellora, twelve miles from bustling state capital Aurangabad in northern Maharastra, is nowadays pretty much stranded in the middle of nowhere, but from the seventh through the ninth century, it was a thriving junction of major caravan routes. Thirty-odd temple caves from the heydays survive. The earliest, and most southern, are rudimentary, low-ceilinged Buddhist *chaityas* (worship halls), which date as far back as the sixth century, a period when local Buddhism was already on the decline. Hollowed out of the hillsides these worship halls contain peripheral cells barely large enough for a monk to turn around in. A series of later Hindu and Jain caves farther north culminates in the Kailasa Temple, a marvel of rock-cut architecture of daunting scale and complexity. Within its precincts there are thousands of sensual, fully realized, free-standing sculptures as well as panels in relief depicting confrontations between gods and demons. The grandeur of Kailasa is that of human persistence, hundreds, maybe thousands of artisans chipping away at the rock, growing old on the job. As long as construction lasted, it must have driven any holy old soul trying to meditate in the other caves mad. Scrambling high along the leafy ridge in monkey territory and looking down at the excavated temple enclosed by sheer cliffs, I couldn't shake the feeling that

while some ancient impresario had succeeded in pulling off a balmy megastunt with Kailasa, maybe God had got lost in the shuffle.

But then I was still high, coasting on the astonishment that had taken me off guard earlier when, misled by my guidebook not to expect much, I had walked out of "Tin Tal," the three-tiered Cave 12, and ambled several yards through the rippling heat to enter Cave 14, once a Buddhist *vihara* (monastery hall), later converted into a Hindu temple. My steps took me from the "last" of the Buddhist caves to the "first" of the Hindu ones. I had the sensation of turning a corner and finding myself unexpectedly in a new world. One moment I had been lazily, even a bit absent-mindedly admiring seven look-alike Buddhas, one each for the Master's earlier incarnations, all serene, frontal, massive, conveying repose and assurance with stylized, encoded gestures. Dallying, I had compared the repetitious rendition of Buddha's thirty-two conventional *lakshanas* (attributes), including his distended earlobes, bulging cranium, and cropped curls. The seven icons in a row were a composite of gentle slopes, roundings, marvels of undulant smoothness. And the next moment I stood in a gallery of bodies gouged in perspective, writhing in action, staring my eyes out at Hindu gods straining to burst from the stone, one swinging a sword, another drawing a bow, a third dancing in three-quarter profile. These were muscular, intemperate beings with animal heads that rose from human necks and torsos, complex narrative friezes of goddesses caught up in whirlwind violence. I backed out into the glare of day, heart thumping and returned, fists in my pockets squeezing my change, to Tin Tal. In the presence of its measured calm where the gracious, sedentary statues kept their distance, relieved by their aloofness, my pulse soon subsided to normal.

I am neither an art historian nor a scholar steeped in Indian religions, but my physical response to what I saw convinced me in my deepest marrow that the acts of carving those contrasting sets of statuary, the relation of the respective teams of artisans to the stone, could not have been anything less than radically different. The large Buddhas were massaged out of the rock; the work of their gestation went on steadily, in no hurry, in the hands of old men who knew the drill, who had done it all before elsewhere, who set the pace. Past models were their point of reference, emulation guided their fingers; nothing singular was expected of them but quite the opposite. On the other hand, to hew those straining Hindu bodies you had to attack the rock to overcome resistance. You didn't turn your back on those images, not for a split second, and they spoke to you in your dreams, revealing where a wedge would find a hidden flaw in the stone, indicating the right angle to tap at so you could free an entrapped hip or shoulder. Your wrists already ached in anticipation when you picked up your tools at the beginning of the day, and you worked in spurts, making chips fly. The Sanskrit texts that instruct the Indian *silpins* (artists) who make images of divinities how to proceed are very elaborate, strict and precise

in prescribing proportions, postures, gestures, emblems, weapons, and vehicles. An effigy must be pleasing to the deity it depicts so he will comply with the invocation to take up residence inside once it is finished. Codification is to assure that images are not the expression of any individual vision, but are orthodox, part of a canon. Yet at Ellora, inside the mountain, my feeling grew stronger with continued exposure that each blow of the hammer on the rock face had a revolutionary ring.

During Buddha's pursuit of truth, he shrank to a shadow of his former self: "Let my skin, sinew and bones become dry and welcome! Let all the flesh and blood in my body dry up! Never will I stir from this seat till I have attained supreme and absolute wisdom." His own words! What explains then why Buddha in India is always shown as bloated? By the time he had achieved enlightenment, he would have needed an intravenous drip, and yet every statue or painting of him is plump. In Tin Tal any of the seated Buddhas would need a helping hand to stand up, a hefty tug. But then they are deeply content with immobility. Gradually the inertia of serenity works its calming effect on me. I fold my hands, and something softens inside, something settles. I recall watching the building of an enormous Buddha in a monastery outside the hill station of Darjeeling. Boy monks in carmine robes silvered small packages of Buddha's sayings in paint and stashed them away inside the roly-poly statue's belly. At the time of the image's consecration, these words are believed to animate the statue.

(For newly wrought Hindu deities a rite called *pranapratishta*, instilling the breath of life, is performed at the last moment. At this time, a priest with a golden needle opens their eyes, sealed until now with honey and ghee.) But the Buddhas of Ellora are rock solid. Perhaps with an ear to their chests we might make out the whisperings of a soul buried deep down within. Outside a fragile, tattered cloud trails across the sun. Smiles ripple across the lips of the ancient incarnations of a man who subdued his need and his desire to move.

Back in Cave 14 I am struck this time by the omnipresence of death. It is almost more than I can do to stand still. Just as the artists in Ellora's adjoining caves surely connected differently to the rock they carved, so, too, anyone coming inside and seeing their work must have responded differently. I tell myself I keep moving because the sculptures reveal something new from every new angle, but my movement feels like a kind of compulsive stalking, the wary circling of a wrestler in a ring. If chanting seems an appropriate reaction to the orderly ranks of Buddhas next door, being here makes me want to shout.

Moving into the depths of the hall, down a colonnade, I consider the vastness of the figures in the friezes, reminding myself that centuries ago people were probably smaller than I am. How big do Indians imagine the demons and giants of their mythology to be? To awaken one once, I recall a myth, several elephants were sent to walk over his body. Their stamping on him finally produced a

slight sensation, like the tickling you or I feel when an ant or a fly crawls over our skin. The hairs of this giant were like the trunks of full-grown trees. His preferred way of fighting was to fasten a huge rock to each of his hairs and charge into the enemy, where he would give himself a good shake, releasing the rocks to crush every last man. From high on the wall, Vishnu with his tapering boar's snout looks down on me. Tricks of size are common to the gods. In Vishnu's incarnation as a dwarf, he wheedles a concession from the demon king Bali who has gained control of heaven, earth, and the lower world by performing fanatical devotions and austerities. Bali agrees to the dwarf's petition that he may keep as much land as he can cover in three strides with words to the effect that a wise man incurs no sin when he asks only for as much as he needs. "It's yours to take!" At that, Vishnu inflated himself, his foot rising upward until with one step he bridged the earth and with a second the heavens, and there was no place left for Vishnu to put his foot down to take the third step that Bali had granted.

In the southeastern corner of the cave, I puzzle out the remarkable sculpture of *Shiva Lingodbhavamurti,* Shiva stepping out of a pillar of stone fire with Brahma and Vishnu on either side. The scene commemorates the bitter dispute among the trinity of Hindu gods as to who, really, was the firstborn: Shiva said he would renounce his claim if either of the others could see the crown of his head or the soles of his feet. Some versions of the myth speak of the materialization of a limitless pillar of fire, others of a phallus without end. In any event Vishnu and Brahma fail to reach its extremities. (Brahma, unable to concede defeat graciously, claims to have been up to the top, a bald lie to which we will later return.)

Among so much passionately incised figurative sculpture, I do a double-take to find enshrined in the inner sanctum of Cave 14 the smooth, sacred stylization of the gods' genitalia found everywhere in India: the vertical stone shaft (lingam) set in a circular horizontal base (yoni*).* The artist cedes pride of place to the perfection of natural form. And all the time in the very next cave, Buddha, the avowed enemy of desire and master of his own animal energy, predicates an opposite truth.

\* \* \*

ON THE HOLIDAY of Nath Shastri, we set out for Paithan, some forty-five miles east of Ellora. The day before we had spotted a two-inch story buried in a regional weekly telling about a fair there to commemorate the four-hundredth anniversary of the death of the nationally revered Saint Eknath, an early opponent of the caste system. We have to cross a sea of sugar cane on the way. Above the refinery ovens, the sky looms a stinking black. It seems a high price to pay for the sweetness of profit! The closer we get to our destination, the more obvious it becomes that we are in for far more than we had bargained for. Not tens, but hundreds of thousands have gathered at Eknath's shrine. Eknath, a Bhakti leader, typically taught that private devotion was the surest way to God. He had no good

word for the priesthood and their remorseless self-interest. Several months of the year, the Godavari River runs behind and below Eknath's grave. The stony riverbed we survey from a knoll is bone dry. It overflows, but with tents and endless processions of devotees beating drums, waving flags, and wending their way as implacably as lava to the courtyard of the shrine. In small clusters the celebrants dance themselves into a frenzy. Some squat down, grab their ankles, and hop about like frogs. Others do pogo-stick leaps in place and turn their heads rhythmically from side to side. A devout few prostrate themselves and roll over and over on the ground, chanting vows to the Mother, a pre-Hindu divinity, pleading for her favor as dissonant cymbals clash. The bustle and fervor—it is Ellora come back to life! The ancient caves silent now, empty most of the time except for the murmur of a guide or the instantaneous click of a tourist's camera, were also once the scene of such effusiveness. I feel reasonably sure, at any rate, that as long as caravans still crisscrossed the Deccan, Cave 14 had been full of music, dance, and smoke. Its mighty sculptures were never alone, not for a minute, as unruly crowds pushed and prayed out loud, the vigor of their bodies echoing the vigor of the shapely stone.

\* \* \*

RAPID INDUSTRIAL GROWTH in Nashik during the past decade has led to the neglect of projects designed to enhance the city's desirability as a tourist attraction. Yet, plumb in the heart of its old center, straddling the Godavari, Nashik features a marketplace that can rival the liveliest in India. The riverbanks, fifty yards apart, are joined by two bridges separated by a quarter of a mile, but in dry season a steady, antlike stream of marketgoers fords the river, shoes in hand. A system of low dams and small waterfalls creates swimming basins, where children dodge the punishing heat, their sleek bodies gleaming. Vegetables, spices, fruits, sweets, bangles, colored powders, tools, old coins, sunglasses, flowers, religious artifacts, and beauty accessories are temptingly arrayed under parasols socketed for balance in cement and beneath awnings of creased plastic slung from iron uprights.

Temples dot the river's northern shoreline. After bathing, sadhus comb out their beards in the shelter of shady nooks. A pick-up game of cricket with a rapid turnover in players adds a note of hilarity. Under the bridges motor-rickshaw drivers sponge down their vehicles, whose yellow and black stripes mimic the markings of hornets. Every several steps you pass a crude, weathered shrine to Hanuman, the monkey god, doused in orange paint. And right in the midst of the quotidian buzz lies Ram-Kund, the holiest spot in Nashik: the pool where Rama in exile bathed with Sita. At Ram-Kund the eddying river water is believed to dissolve bone. Here the skeletons of many great Indians have been consigned to melt: Pandit Nehru, Indira Gandhi, Rajiv Gandhi, National Saint Shri Tukdoji Maharaj, and singer and actor Kishore Kumar.

When Brahma, too scathed in his pride to concede defeat, lied about his having contrived to see the crown of Shiva's head, Shiva in anger struck off one of Brahma's own five heads. Shiva did everything he could, but still the decapitated head stuck fast to the prongs of his trident. The gory evidence of Brahmacide went everywhere with him, until one night in Nashik he overheard a bull calf talking to his mother and telling her that whoever immersed himself in the Ram-Kund was instantly absolved of all his sins. In a flash Shiva jumped into the river, and to his immense relief Brahma's severed head floated loose and swirled away. That is why Kapaleshwar Temple opposite the Ram-Kund is the only known Shiva temple in India without a stone *nandi*, a bull calf, out front: because the calf had been Shiva's teacher, Shiva exempted him from temple service.

The main attraction at the Nashik market, however, presiding over the Ram-Kund, is a gigantic orange version of Rama's warrior ally, the monkey god Hanuman at attention in a blue sentinel box or, more accurately, a Siamese-twin Hanuman, two simian bodies joined back to back all the way down their spines. The blue booth has only side walls and these pin Hanuman's muscular arms, immobilizing him. Both whiskered monkey faces are identical and stare blankly straight in front of them in opposite directions. At Ellora there was nothing remotely resembling this mascotlike effigy. Yet flowers have been laid here at Hanuman's glossy orange feet, too, high heaps of them, and bunches of burning incense sticks sweeten the air. Passersby genuflect, touch the divinity's feet, cross their arms over their chests, wag their hands behind their ears. At night when the rest of the market has trickled away, Hanuman remains on guard, erect in the moonlight, solemn, cartoonish, and alone.

At the core of Hindu belief resides the absolute, or the Universal Soul, immanent and transcendent, without shape and form and without beginning or end. This Nirguna Brahman is a god too impersonal and too difficult for ordinary mortals to grasp. People like us need a body to fix our thoughts on during prayer, to cling to and caress admiringly with our imaginations. Something, anything solid, visible. A round stone at the base of a tree, daubed with vermilion, rubbed with vegetable oil, or perhaps wrapped in aluminum foil, a house-tall Hanuman, deities of clay and straw, painted, worshiped, then jettisoned back into a river, the rock-cut virtuosity of Ellora: it takes all kinds.

\* \* \*

TRIMBAK, AT THE SOURCE of the Godavari fourteen miles west of Nashik, lies at the foot of towering ghats with rugged vertical scarp. The town has two foci: Gangasagar Tank and, at the other end of its unpaved main street lined with picturesque two-story blue and green wooden houses and shops, Trimbakeshwar Temple. Trimbakeshwar is one of twelve *jyotirlinga* in India, places where Shiva's energy manifested itself in the spontaneous emergence of a lingam that thrust itself up out of the earth. With a population of

eight thousand eleven years out of twelve, when Trimbak hosts the Kumbh Mela millions converge to bathe in the "Ganges of the Deccan." On "off" years an overabundance of priests scrape together a living primarily by performing rites to mark the anniversaries of deaths. Mourning couples in ritual white wraps light small pyres of dung cakes and then purify themselves with a dip in the tank. Men bow their heads to the barber's razor. Young priests console the bereft, who may be twice their age or more. Our visit coincides with an astrologically auspicious day for marriages. Grooms on white horses surrounded by capering musicians parade past the terrace where we drink tea. Other bridal pairs lumber by on a tractor. One couple perched atop the back seat of a vintage tomato-red Buick convertible wave, only their smiles visible under a particolored umbrella, while a man who is carrying the keyboard to an electric piano wired to the car's ignition system walks alongside the hood and provides processional music.

After a friendly talk outside the temple, Ganesh, a handsome, slender priest in his early twenties who had just that morning passed his exam in India's ancient holy texts, the Vedas, invites us to his parents' house for tea. The elephant-headed remover of obstacles for whom he is named is perhaps the most beloved and most frequently invoked god in India. As we enter the family home, his father, an astrologer, is giving an audience in the front room. We catch a glimpse of a client kneeling to touch his feet. We are seated in a cool, minimally furnished and antiseptically clean sitting room, where if Ganesh were to stand up straight he would be decapitated by the rotary ceiling fan. The tea is steaming and served in fine bone china cups. At my elbow is the glass-enclosed family *puja* room, the place for daily offerings, with a sliding door like a shower stall. There is space enough inside for one person to close himself in and sit on the floor in front of an altar of several semicircular shelves, covered with a cloth of the deepest red. On the altar I count more than a dozen, exquisitely worked silver statuettes of the goddess and various gods the size of chess pieces.

What, I wonder, does it do to your relation to your god to be able to pick him up and dust him off? Or in a clumsy moment to knock him over, or drop him? Were the fierce, contentious gods in Ellora, "lost" for many years, starved for human company, impatient for the drone of human praise, humiliated by neglect?

For the Buddhist images in Tin Tal, a breath of fresh air, a breeze on the cheek should have been sustaining enough. They were, to all appearances, very much more self-sufficient. Perhaps once in a century a drop of water would slowly glide down a shoulder slope. Or diffuse anatomical moss would send down roots between Buddha's compressed lips, or his blunt, ticklish toes.

# 5

## *who fears not the sky*

GANTOK, THE CAPITAL OF SIKKIM, STRADDLES A RIDGE. THE rich live higher up; the poor, of whom there are far more, lower down. Unlike Darjeeling, though, the nearest city of any size to the south, Gantok has no British Raj past. No flamboyant gingerbread to hearten the eye among the drab six-story concrete flats that dominate the townscape. Gantok is growing fast, with nowhere to go: like a weed sprayed with a pesticide that does its killing by accelerating growth past the bursting point. The boom dates from 1975, when, according to the history books, India annexed Sikkim by referendum. Many still have a bad taste in their mouths about what they say really happened— the slander and betrayal of the king by his prime minister—and remain royalists at heart. What passes for a main drag, Mahatma Gandhi Marg, meanders between slabs of rock laid on top of gurgling open sewers. Steep and narrow alleyways branch off to either side like the paired legs of a centipede. To enter our cliffside hotel we go down a chute like an airplane boarding sleeve that bounces slightly underfoot, and then, to reach our room, we descend a further three flights of stairs. There are many light switches recently plastered into the walls, but we flick them on and nothing happens.

Sikkimese have faces that are hard to read, at least for an outsider. They resemble Mongolians. Indeed, it's a lot harder to sort out the mix of peoples—Lepchas, Bhutias, Nepalese, and Tibetans—than I had anticipated. The pace of street life is agreeably slow. The bookstore also sells birthday cakes to order and pocket-size video theaters run a constantly changing menu of Western horror films and chase thrillers. In shop windows cuddly stuffed toys from Korea, rabbits and whales, sit cheek by jowl with Swatch watches, air-cushion Nikes, and ultra-flashy skateboards. There are many liquor shops and dingy, cheerless little bars with wooden booths. While you take your poison, you can pull

the faded curtains to shut out the world. One of five Sikkimese dies, a young documentary filmmaker told me, of "substance abuse." Men will guzzle almost anything that ferments, including battery-acid cocktails. (Later I was to learn that for India the alcohol and drug problem in Sikkim is, relatively speaking, moderate.) Up and down the Marg, swarthy Nepalese porters in caps and shorts loiter in small cliques. Their thighs bulge like a horse's. They look lost in the city where work, we are told, is hard to find. One just went by, barefoot, bent double with a taut cloth strap across his forehead, a cast-iron pedal sewing machine slung across his broad back.

At opposite ends of the Marg, banners span the road overhead. One touts a three-day Spiritual Camp, the other a Rhododendron Trek. Lured into a Sweeties and Salties shop by goodies in the window, I bolt down something very pink that gives me a sugar rush. Above me a bird no larger than a child's fist adds a twig to a nest between the icy white neon tube and the sky-blue ceiling. Birds in Gantok are intrepid, swooping in and out of buildings as they please. It makes me self-conscious to notice such things, like a new boy in town. As I streetcomb further, I lose count of the subterranean tailors who, like squinting gnomes, look up from sunken doorways with tape measures draped around their necks. Most of the action in town, however, centers on the state lottery, Sikkim's leading source of revenue, advertised even as far afield as the dailies in distant Delhi. The lottery, the army (there is a heavy presence of soldiers, as

a rule big spenders), and distilleries keep the precarious local economy afloat, barely. All three are anathema to Sikkim's dominant Buddhist culture. A tourist poster of a cute, pointy-nosed red panda with the text "Land of Wild Passions" puzzles me. While I admire a second poster of rugged, snow-capped mountains proclaiming Sikkim to be the "Land of Tranquility," a motorcycle backfires behind me. Still, they must be doing something right. The one jail in Sikkim has only six people in it.

We have appalling weather. Mist and more mist kill the views. Locals claim that it's freakish, like the black snow in Kashmir in the aftermath of the Gulf War's oil field infernos. For the rest, we enjoy our due share of travelers' luck. Take yesterday. We corkscrewed over to the monastery at Rumtek on the far side of the Ranipool Valley, a "red hat" bastion as opposed to a "yellow hat" one. Down through the ages this schism has been the source of much bloodshed and misery. From what I can make out, the split is largely a matter of whether or not monks may marry. Feelings still run high on the issue. At Rumtek we pulled into a parking area filled with battered buses, jeeps with loud tape decks blasting out film music, and unruly kids barreling about playing football with beanbags. The situation had all the makings of a major domestic tourist overload. Inside the monastery walls, however, milling around in the imposing spacious cobbled courtyard, sedate monks and pilgrims set the tone. The air vibrated with tension; a rare ceremony was about to begin.

To release nervous energy, teenage monks in red robes aimed careless kicks at dogs, played at pole-vaulting, traded punches.

In a cramped corner print shop, two monks were up to their elbows in ink, finishing last-minute texts for the occasion. They worked confidently with wood blocks, rollers, and strips of handmade paper. I climbed upstairs to a deserted gallery with a sniper's vantage of the pomp below: the main hall of the temple was ablaze with brilliant yellow and orange bunting. A raised chair stood empty, draped with layers of rich fabric. Row after row of monks in maroon robes filed in and sat on red runners laid down for the occasion on the streaky green marble floor. Elders claimed the best places up front, leaving the younger monks to jockey for position, slipping, falling, shoving. Horns blared, drums rolled, cymbals crashed. The *rinpoche* (head lama), whose skull had the sheen of old ivory, was boosted onto the highchair. He was given strips of red ribbon and baskets of rice to bless before they were passed out to the crowd. The rush to clutch as much as possible was like the thrashing of fish when bread crumbs are tossed into a pond. While I was kissing good-bye to my notions of Buddhist serenity and indifference to the things of this world, monks below began sneaking cameras out from under their robes and snapping away.

A hush filled the hall. A large round box was placed on the *rinpoche's* lap, and gingerly he lifted out what looked like a gold-embroidered tea cozy. He plopped it down on his head, supporting it with one hand (the thing looked uncomfortably top-heavy), his elbow crooked awkwardly above his shoulder. Then the praying began in earnest. Through a standing microphone, the *rinpoche* had a high, flat feminine voice with erratic, shrill peaks. There was no telling how long the chanting might go on, so we ducked back outside. Thousands stood beyond the monastery wall listening as loudspeakers crackling with static broadcast the priest's words to the surrounding mountains.

Rumtek prickled the imagination, but our ignorance kept us from appreciating what we saw. A few days later as we browsed among the treasures on display at the Sikkim Research Institute of Tibetology in Gantok, the librarian, Mr. Ghosh, attached himself to us like a barnacle. He looked familiar, but I should add that his appearance was far from ordinary. A frail Bengali, almost elfin, in a woolen beanie, he had great soaring eyebrows like startled bats. Only four of Mr. Ghosh's upper teeth were in place. Protruding, they seemed to move independently when he spoke, as if a ghost were fingering the keyboard of a piano. The man was a walking encyclopaedia, and full of dry wit. His commentary made Sikkim's idiosyncratic brand of sensual Buddhism accessible to us.

"Each of our bodies," our companion said as he gestured to his own slight frame, "in fact embodies the universe." And for a moment, under the spell of his voice, I believed it. Like the effigies of Buddha, their bellies crammed full of mantras and relics and gems to bring them to life, my own body contained

the sun and moon, rivers, mountains, and seas—that at least would account for the gurgling.

"You were at Rumtek!" At last I placed him.

"Yes," he smiled, caressing a primitive flute made out of a female femur. "I saw you there, too."

"Please, what was going on?"

Mr. Ghosh went on to explain that the ritual at Rumtek involved the recitation of special prayers to mediate evil influences into benevolent ones. Our "tea cozy" turned out to be a priceless gift to the "red hats" from a Chinese emperor in the fourteenth century, a crown woven from the hairs of one thousand fairies. "His holiness has to hold it down to keep it from flying away home."

\* \* \*

WE'RE HIGH ON THE AIR. No, that is not a typo. In Yaksam, the first capital of Sikkim, a place so tranquil you can hear the grass grow, the more you breathe, the more you want to breathe. A high, sleepy mountain valley. Can this be the same planet Earth on whose surface a Calcutta exists? We have stowed our gear in a trekkers' hut. It has no mod cons, but I'm happier here by far than in the stained lap of luxury. With such a sky, plumbing becomes irrelevant. From under a rhododendron tree, I look out across paddies electric with the unique green of young rice shoots. This was the site of holy Lake Kecheoperi until eighty years ago. After a dead cow polluted its waters, the lake flew away over the mountains. Legends don't survive in these parts, they flourish. For the first time since

our arrival, the summit of Sikkim's guardian deity, Khangchendzonga Peak (25,000 feet), is visible. The eternal ice and snow gleam with a frosty wetness. Shaggy yaks, beasts of vast bulk, amble by, their neck bells swinging. They splash up a stream bed and head for the arid reaches of the rocky north. You'd think a snail would soon outdistance them, the way they pick up and put their feet down so slowly, but yaks never stop.

Yaksam is a handy base for visiting Sikkim's historic monasteries. Pemayangtze, Tashidang, Dubdhi. If you've seen one, you haven't seen them all. The more you see, the sharper the details stand out. The steep hikes up, real thigh stretchers, last an hour, an hour and a half, with frequent stops. You follow inlaid stone pathways, slippery underfoot with mosses and trickling currents of cold water. The earth has been spitting up stones around here for aeons, rising like bubbles to the surface of boiling water. Stone walls, stone terraces, houses with stone foundations. The idea of so many hands lifting, carrying, placing all those stones over time generates a feeling of fellowship with the past. Along the way we're constantly discovering plants and flowers. The root sacs of young ferns are brimful with sweet water, the only nourishment that fasting monks allow themselves. Wild strawberries. Walking shrubs, which, as they approach, turn into stocky girls with vast bales of leafy animal fodder trussed to their backs. The steep woods are riddled with butterflies and darting birds that unleash iridescent flashes. Batteries of worn

prayer wheels creak, powered by waterfalls. And leeches, pesky little things that given half a chance wriggle inside your boots and sink in their teeth. A sprinkle of salt does in "the Chinese Army," so called because if you stop to remove one, before you know it, five more are all over you.

On the brow of the hill, long lines of flimsy white prayer flags rigged to supple bamboo stand sentinel. The ghostly rows flap in the wind and then go slack in turn. And inevitably there are stupas, white-domed graves with carved stone mantras like discarded license plates encircling their base. All the way up, at every turning of the path, a splendid new view unfolds. It is the outlook from the top, however, for which the lamas chose their sites. The vastness invades your spirit—receding mountains, range beyond range, rampant forests, looping rivers, an ocean of sky startling in reach and purity. Your mind empties, and at the same time every last cell in your body sits up alertly and takes notice. How expendable you feel, without grieving! This landscape needs no witness to exist.

Sometimes you have to fetch the keys to a monastery from a lama's cabin nearby. Mostly, however, the door will yield to a stiff push. It takes some minutes for the eyes to adjust to the dimness inside, to decipher the muted riot of colors—thick licks of red, orange, yellow, green, blue. Shoeless, you prowl over polished beams, which lie cold underfoot. Elements repeat: carved ceilings, cloth hangings, pillars, low benches for pupils, raised seats for teachers. Yet in Sikkim, monasteries are not dust traps. Anything but

anachronistic museums, they are in daily use. Religious objects shine on the altar or beside the teacher's platform, polished from constant handling over the centuries: trumpets, drums, and drinking bowls fashioned out of split human skulls, bells, gongs, ewers with peacock feathers, silver-crafted thundersticks. Sikkim's Buddhism—Lamaism—is "dark," demonic. It appeals to all the senses, not what Lord Buddha with his antipathy to worldly distractions had in mind! The tone that makes the music is a legacy, we're told, of the Bon religion, which Buddhist emissaries fanning out to the north in search of converts found entrenched in the region. Cannily, they absorbed ritual elements from the popular local animism into their practices.

Scaling the summit at Dubdhi, we circle the weathered wooden monastery we have come to see. From outside it looks abandoned. Inside, however, we find candles lit, delicate paper prayer wheels rotating above the flames, the air pungent with burning joss sticks. A pair of eyeglasses and a string of prayer beads lie on a lectern next to an open book. A lama, the glaze of his complexion cracked like old porcelain, steps soundlessly from the shadows, smiling, carrying a tray with cups of steaming butter tea for us. Our excited chatter outside had alerted him that guests were coming.

Back down again at Yaksam I hike to a holy grove on a nearby promontory behind the cabin, the site of the coronation of Nal-Jor Ched-Shi, the first *chogyal*, or king, of Sikkim. There is a high, wide stone throne, which seats four: the lonely shepherd who became king, and the three wise men who, following

their dreams, converged from afar to find him there. *Yaksam* means "three lamas." (Sikkim means "land of lightning.") Hovering over the throne a colossal screw pine rises, older than time; its twisting branches drip with beards of lichen, ferns, and hundreds of vivid white, yellow, and purple orchids. Some thirty feet in front of the throne there is a stone slab the size of a manhole cover which, with help, I tip up for a look underneath. I find a human foot clearly imprinted in the stone, water puddling in the toes, which have sunken in more deeply than the heel. This is said to be the last place one of the three lamas stepped before seating himself on the throne. His name was Lhatsun Namkh Jigme, the Reverend Lord Who Fears Not the Sky.

In western Sikkim we follow footpaths down to hillside villages where—except for minor details such as zippers and the odd plastic bucket—life appears to go on much as it must have when the first *chogyal* was crowned. Again, the impression of continuity gives me great pleasure. Most of the settlements are Lepcha, some are Bhutia. The two tribes build their homes differently, but otherwise their lifestyles are very similar. As someone spoiled by invariably being able to buy what I need, I'm a sucker for self-sufficiency and for simple applied technologies. Install a shower curtain over a weekend, and I feel I deserve a medal! These mountain people are nonstop do-it-yourselfers. From the doorway to an elongated wood and stone cabin, I watch a local smith pump a buffalo-hide bellows with the help of an old bicycle wheel, and I can feel myself glow along with the embers. Men chopping and grinding sun-dried roots to make a bright vermilion dye meet my eyes without missing a beat. Others strip saplings to twist the skeins of bark into rope. Haste and hurry are foreign to their universe, yet their fingers fly. Women with wooden tongs wade into the brush to harvest nettles or they use a knife to lop off the curly tops of young ferns to fry up with potatoes. In rickety bamboo sties built on stilts, pampered pigs while away their halcyon days, chins resting on their trotters, peering out over the distant chain of hills and valleys through tiny slits of eyes.

There's every chance, however, that remoteness in western Sikkim has had its day. Villages far from any beaten track have electricity masts, water standpipes, schools. India isn't merely talking development, although I admit I do feel qualms when in the back of the beyond we come across teachers talking to shoeless tots in English, India's national language still, although when they do so, the children can't understand a word they say. A peculiar shiver passes through me watching these children at their splintered desks learning how to spell—*air, water, earth, fire*—using sets of the same bright, plastic, magnetized letters that I shuffle about to make shopping lists on the door of my fridge in Amsterdam. Concentration was at fever pitch in one classroom where the teacher sketched chalk dinosaurs on the blackboard and had the class recite in unison the extinct creatures' terrifying names. Is the gesture at education under such circumstances valiant or

mad? Change is the apparent goal, progress, but where traditional culture *seems* virtually intact, as in the outlying villages of Sikkim today, change is likely to mean an unraveling, a dissolution. Thumbtacked to the outside wall of the dilapidated school I found a news clipping from 1984 with a blurry photo of a nine-year-old girl chess genius from the local village who was humiliating one Grand Master after another at a tournament in Calcutta. When I asked, no one knew what had ever become of her.

My proclivity for romanticizing the primitive threatens to run away with me altogether when we make the ascent to the shrine of Sa-nga-choe-ling, high above Pelling village. Just inside the entrance to the compound, a separate building houses the famous prayer wheel wound with a cloth scroll nearly four and a half miles long, whose text is alleged to have been completed by the shrine's founder in a single inspired night, "The Entirely Victorious Essence of Goodness." (Talk about names to live up to!) A dozen child monks are having a chanting lesson in the shade of the shrine's overhanging porch. A sturdy monk halfway up a bamboo ladder is repairing a fissure in the dome of a milky white stupa. *Masti*! From the upper story of the shrine, a single, long clarion blast sounds on a horn, a solitary wail drawing us to a small, dim study cell dedicated to Kali, the goddess of Destruction. Inside, visible through a half-open door, a bald elder in dark robes sits on the ground, striking a gong at intervals with a padded drumstick. Ghosh had described

such rituals, enacted to convert evil forces into benevolent ones, a favorite pastime among Sikkim's holy men. Scrunched up close to him, half-hidden in the folds of his dark, wool cloak, a wide-eyed child moves his lips with the monk's. The boy's tiny fingers are busy kneading tallow drippings from one of the thick candles set on the floor. The surrounding walls are black, painted with demonic figures in gold outline and emblazoned with skulls and skeletons. There is a boxlike, bright yellow altar decked with brocades of green and silver. Next, oblivious to our intrusion, the monk rotates a lamp flame in front of his face. If this is a performance, it is meant for the gods, and not for us. A perfect devotional moment, sacral, unselfconscious, timeless, matter-of-fact, deeply moving.

Back downstairs and outside on the porch, as soon as I slide one foot back into a shoe, I know that something is wrong. My support arches—without which walking is sheer torture— are gone. My first instinct is to doubt whether I had them with me. Maybe I left them back at Yaksam? The only alternative smacks too much of Agatha Christie: Which of the obviously good people at this holy place could conceivably be guilty? The children's chanting pierces my panic and suggests a solution to the mystery. The support arches, old-fashioned ones, are metallic. Metal shines. No child can resist shiny things, not any more than a magpie. When I circle out back, a sunbeam flashes in my eyes. Shading them with my hands, I find myself face to face with a knee-high monkling who holds

one of my arches clamped between his lips. The wavy chrome surface focuses and reflects sunlight the way mirrors can do to beam messages or start a fire. Lie after lie tumbles out of the culprit's mouth. Other tourists, he first alleges—invisible they would have to have been—had thrown the arches away. Luckily for me, he had rescued them. Next it was a monk "from the plains" who had actually slipped the arches out of my shoes, that is, a boy from far away and thus by definition scapegoat number one for all suspected misbehavior. When, whether out of fear or defiance, the child refuses to say where the second support arch is, an angry teacher half-drags him into the stable. The sound of blows and tears shatters the peacefulness of the afternoon. The harsh measure does, however, produce the goods.

What a downer, I think. Robbed not so much of valuable property, as of a lofty experience. As the afternoon shadows lengthen further, however, the old monk's ritual in Kali's chamber begins to do its work, and bad influences yield to good. Where does it come from, my need to inflict piety on young monks? Children are children, everywhere. You can shave their heads, dress them in the robes of one order or another, insist they sit still—but that doesn't turn them into little saints. Suddenly I recall the magical footprint under the slab of stone in front of the historical throne at Yaksam; it is at least three times the size of my foot. My lips burst into a smile. Maybe, finally, I'll prove capable of learning to travel more lightly?

# 6

## *here are your pearls*

WHEN NATURAL DISASTERS COINCIDE WITH HOLY DAYS, believers are going to want to know why. In Kullu Valley, Himachal Pradesh, during the weeks preceding Dussehra in October 1995, the heavens burst open. A hard rain fell nonstop right up to the eve of the festival that marks the high point of the annual religious calendar, a celebration of Rama's victory over the giant Ravanna. (*Dushet hera* means "the demon slain.") The Beas River leaped its banks to gouge out a new course and tossed giant conifers about like so many toothpicks, dislodging boulders larger than a man standing on another man's shoulders and sending them crashing like cannon balls into the valley, where they flattened everything in their path. The torrent tore houses in two, leaving behind unstable ruins that teetered on the brink of sheer new precipices. At least eighty died, and many bodies were never recovered.

"Sometimes even the gods have to make a detour," Paddy Singh remarked as he ran a long finger along the sludge mark halfway up the wall of our recently flooded hotel room in Kullu. "The bridges are still out, but Hadimba is on her way." He had just explained to us how every year Dussehra began at the moment Hadimba, the tutelary deity of Kullu Valley who resides in Dughri temple thirty miles to the north, leaves home and links up with her grandson, Ragunathji (another name for the god Rama), in Kullu. "She left Manali this morning on time and Hadimba loves speed." Paddy, oldest scion of the last maharajah of Lahore, a former army officer and policeman who tramped for years all over the Himalayas before trying his hand at tourism, is the tallest, thinnest Indian I have ever met. When he sits, he turns into a question mark. In the next few days, Paddy would more than live up to his reputation for getting things done under impossible circumstances.

"We should leave now if you want to be there when she arrives at the town center."

Kullu Valley is known as the valley of the gods. Every village on the wooded mountainsides south of the Rohang Pass has its own deity. No two are alike, and they are all very jealous of their place in the pecking order. "The story goes"—we trail Paddy out to his jeep, two steps of ours necessary to keep up with one of his—"that a maverick god lifted the lid to a chest in which the small, round images of the gods had been trapped, and a sudden gust of wind scattered them throughout the valley. Once a year, on Dussehra, the villagers carry them down here—some two hundred in all, I believe, are expected—to pay their respects to Rama."

Just as we left the lobby, a god in full panoply was lurching past outside. Two men in front and two in back supported thick, parallel wooden poles on their shoulders surmounted by a four-foot-high, hive-shape icon that was decked with rich brocades and silks in clashing colors and hung with beaten gold and silver masks. Eight masks faced each cardinal point of the compass. A gaudy, round canopy of shiny fabric ringed with tassels completed the trappings. A pair of drummers and trumpet players whose instruments were larger than they were, walked in front, while an edgy, dazed-looking figure with a deeply lined and suntanned face clung close to the god's side. He is the village shaman, or *guur*. "From a low caste," Patty tells us. The gods rule by oracle. They speak through the *guur*. His word is final, always. Whether to marry, when to sow, how to settle disputes. "The thing is, though," Paddy grins, "you can bargain with the oracle—by bribing the *guur*." If accused, Paddy always vehemently denies having a cynical bone in his body.

Gods were converging from all sides as we reached the main arena of the festival, the plain, or maidan, in downtown Kullu. Dussehra, I feared, would take crowd-infiltration skills and a stamina we lacked. Slick mud churned underfoot made keeping one's balance a tricky business. The vicinity seethed with gods and their motley village escorts. Now to the left, now to the right, one or another god would suddenly rush forward toward another, like two bulls about to mesh horns, only to pull up short at the last instant as the bearers bent their knees in a ritual greeting. The music of drums and horns was pure cacophony, pierced by tidal bursts of human shouts and cries. Two gods rumbled into view much larger than the rest, seated high on thrones that were lashed to carts with giant wooden wheels. These monumental carts skidded dangerously in the mud as they were towed forward by a dozen thick ropes each and hundreds of straining attendants. "Hadimba and Rama," Paddy shouted in my ear.

Only one of the many litters circulating on the maidan bore a living human being: a swarthy, middle-aged man with a pipe-cleaner mustache. He sat on thick cushions, dressed in fairy-tale finery, gold slippers, gleaming brooches, strands of pearls, and a shiny turban with peacock feathers. As he mingled with the gods, shamans accosted him, laying an

inverted bell in his lap, then sprinkling him with flower petals.

"He's the king, or rather he would be if there still was one. He is serving the area now in the upper house of parliament. M. Singh. During Dussehra, for the whole week, while every day he is carried in circles around Hadimba and Rama, he will receive petitions, and interpret the gods' replies to what people ask them." Paddy, a consummate networker, led us into the royal family's pavilion for introductions to the maharani and her two cricket-bat-toting young sons. Here, in the eye of the storm, we could keep track of the coming and going of the gods and observe the subtle settling of feuds.

Next we scouted the area below the maidan. Invariably celebrated after the monsoons, Dussehra has been for 160 years an important commercial as well as religious occasion. With their fruit and potato harvests just in and sold, the upcountry folk are flush with cash. The plains people are notorious for conning gullible mountain dwellers in their transactions. Cloth and clothing, toys, tools, and radios are for sale, as are gold and silver metal discs, crude facsimiles of the gods' faces. A knife sharpener pedals a bicycle in place to make his whetstone spin. Astrologers do a brisk business drawing up charts. There's even a fun-fair midway swarming with electric rides: Spinning Teacups, the Whip, the Cyclone. Crowds swarm around food stalls. Some places offer sweets only, others do whole steaming meals. Striking a contemporary note, various interest groups

have set up information booths where they buttonhole passersby to hand out warnings against pesticides and excessive use of fertilizers, pleas for massive reforestation, and the test results of the health-enhancing properties of ayurvedic cosmetics. Under the snaky branches of old neem trees, a battery of scribes with ancient manual typewriters take dictation, banging out love and business letters for the tongue-tied and illiterate. A distressingly scruffy performing bear with muzzle, his trainer playing the accordion, paralyzes small children with fear and delight. There's even an amphitheater cordoned off for folk dancing competitions at night. "An awful lot of soldiers," I say to Paddy.

"They're here to clear the roads and clean up the mess," he explains.

"With automatic weapons?"

"That's just the raj's bodyguard. He's been complaining a lot, and according to me rightly so, that Delhi's relief efforts have been a classic case of too little, too late. Everything goes by hand. They haven't even sent in machines to dig, nothing."

On the outskirts of the fairgrounds, small tents in tidy rows occupy a large field. God City, I dub it. Here, ceremonially dismantled each night, the gods sleep two or three to a tent, like canaries with a cloth thrown over their cage. Musical instruments are also stacked inside. Pit fires for cooking glow between the rows. We pause several times as we make our way among groups of chattering villagers. Paddy shakes hands, talks affably. "You're in luck!" he tells us excitedly. "Something is

going to happen here that may not even take place once in a lifetime. I've never seen it before myself. In two days time a special meeting of all the *guurs* will be held with the Raj to find out why this damn flood took place."

"Surely they already know why. Cutting down trees."

"I doubt that's the answer M. Singh will come up with."

* * *

BRIGHT AND EARLY the next morning, Mani, Paddy's personal driver, a Nepalese, takes us on a slithery jeep expedition some seven miles northeast to Naggar, once, long ago, Kullu's capital. We probably could have gotten there faster walking. Out in the country the ravages of the flood are visible everywhere. High above Katrain on the east bank of the Beas River, stands the primary remnant of Naggar's former grandeur, once a fortified palace, now a hotel. The wooden building is surrounded by a roofed veranda on piles and encloses a series of interlocking courtyards. Mani points out a shrine in a neglected corner. It consists of a thick slab of stone that a great swarm of bees carried up on their wings from the valley floor far below. "When there is danger, people come here to pray and the power of the stone puts an end to natural disasters." Why, we wonder, had no one invoked the stone's magic to tame the devastating floods of the past weeks? We don't confront Mani with this question, however, since answers to such direct challenges seldom prove illuminating. We wander a few hundred yards up the hill to a Krishna temple erected on the site of a previous king's palace. There we meet a local school teacher who is amused by our horror when he tells us how this king, owing to his unnatural cruelty, had been burned alive in the palace by his subjects. "He was a lover of milk, this raj, and each day he obliged a different shepherd to bring him a fresh supply. One day the poor chap whose turn it was tripped and spilled the milk he was carrying to the king. He returned to his wife, who was nursing a child, and from her breasts he filled the king's jug back up to the rim. His majesty thought very highly of the milk— one sip and he wanted to buy the cow. The man told the king the truth about what had happened, little anticipating the consequences. Afterward, when- ever a baby was born, the king would have it put to death so he could enjoy the mother's milk. Whoever it was who set the palace on fire was never caught."

When we ask if Naggar's *devi,* or god, has gone to Kullu, we are surprised to hear no for an answer. Last year the god from a lesser village had barged forward to occupy a position closer to Rama than that to which he was entitled, rudely jostling Naggar's god as he did so. M. Singh saw what happened but did nothing to set things right, not even after a protest was lodged. Until an apology was offered for the insult, the aggrieved *devi* was boycotting Dussehra. Gods, I still smile at the thought, will be gods.

* * *

FOR THE SPECIAL conclave of oracles, a circular enclosure of canvas panels was prepared with an orange tent in the middle. A web of tinsel was spun overhead, silver angel hair flashing in the sun. One group after another of village musicians playing their instruments entered through a peacock gate to take up places along the periphery. The shamans, smoking hemp, bunched together near the royal family altar, many carrying incense burners as well. Only M. Singh was late.

"How is Dussehra going?" we asked Paddy.

"People are complaining there is no money. The local apples all have blight, which is serious because America has turned this valley into a mono-crop economy. And the trucks up north loaded with seed potatoes can't get down through Rohang Pass, so famine is threatening the south. All further evidence of the gods' anger."

"In Naggar we heard that the person responsible for most of the illegal cutting of timber is M. Singh."

As if conjured up by mention of his name, the raj appears, looking extremely portly and moving slowly but, dressed in red from head to toe, still cutting a commanding figure. After he has seated himself under a tent flap raised and stretched to make an awning, one by one the long-haired, wild-eyed *guurs*, approach to accept bits of sanctified food from his hands and to address him in inspired tongues that only he in his capacity as Rama's steward can understand. Everyone wants a turn. Deliberation drags on for an hour, two, three, and still there is no foreseeable end in sight. Historical occasions are not necessarily interesting to live through! The king, a masterful politician who plays his role to the hilt, displays none of the boredom he must feel. Toward dusk a slight drizzle is chilling us to the bone (any heavier and the rain will spell a fresh disaster), when a sudden fanfare from all the giant trumpets on hand, followed by a thunderous, collective drum roll signal the raj's withdrawal to weigh all the testimony and opinions he has heard. He will consult the gods as well. No one knows when he will speak to the question of the source of divine anger.

It is after midnight when Paddy bursts in with the news that the raj has come out with his verdict. His official statement has attributed the god's wrath and displeasure to two causes. First of all, out of their ignorance young people were disrespectfully eating *prasad*—blessed offerings of food—before the priests themselves ate theirs. "A clash between generations," is Paddy's comment. "You hear about this happening more and more all he time." And, second, at Naggar Palace a public convenience has been built too close to the talismanic stone.

"He must be kidding?" I blurt out. "And not a word about erosion?"

Somehow after the raj trivialized the forces underlying Kullu's natural disaster, the rest of Dussehra skidded downhill, eviscerated of meaning. We went to the closing day's rituals, including the sacrifice of a buffalo, goat, and cock, but we had definitely been disenchanted.

The dismantling of God City took next to no time at all. We watched the deities disperse on the long walk back to their villages with a deepening sense of dejection. The dancing bear sprawled in a pool of its own vomit on the deeply scarred maidan. To give us a lift, Paddy suggested a sulfur bath at nearby Manikaran in Parvati Valley, whose sides are so steep that sunlight scarcely penetrates to the valley floor.

* * *

FOUR HUNDRED YEARS ago in Kullu, there was a mighty king who would have been a model ruler but for a single flaw in his character. Nothing was safe from his insatiable greed. The raj sent his tax collectors to the farthest corners of his kingdom to collect all the precious things his people owned. If you gazed directly at the riches in his treasury, their dazzling brightness could blind you. Now it so happened that the raj made a habit out of attending to affairs of state in the morning as he bathed in the hot springs of Manikaran. One day a few leading citizens came to see the raj while he was soaking and told him that a certain priest of their acquaintance had concealed a beautiful pearl necklace from the tax collectors. "Sire, together the strands weigh no less than three pounds." The priest they accused was a good man who, because he was good, had many enemies. At first the raj couldn't believe his ears. He dismissed the accusation as the interference of troublemakers. But try as he might, from the moment they first poisoned his mind, morning, noon, and night, he could think of nothing else. The necklace began to glow brighter and brighter in his mind's eye. Gold and silver, these ores he could perhaps resist. But he had a particular weakness for the shimmer of pearls. Before the week ended he sent soldiers to summon the priest for an audience.

"I have come to learn that against the law you have in your possession a pearl necklace that weighs as much as two doves." The priest understood right away that this false information was the work of those who wished him harm. And all, he knew, was lost! "Go and bring the pearls to me at once! Perhaps I will treat the matter as a mere oversight." The good priest stood there silent, his head bowed. "What are you waiting for? Go!" the raj commanded.

So the priest hurried to his poor and humble dwelling. In truth, his family owned nothing but the tattered clothes on their backs. Goodness, he was fond of telling the people who mocked his poverty, was all the treasure a man needed in this world. He called his wife and son, whom he loved very dearly. He told them about what the king had said and that they were in grave danger. Coolly and efficiently, he locked his wife and son inside the house and set it on fire. Otherwise, he feared, the raj was going to treat them far worse and apply inhuman tortures to make them divulge the hiding place of the nonexistent necklace of pearls! Neither cried out, not a sound! As soon as everything had burned to ashes, the priest returned to Manikaran.

"Well?" the raj blared out when the priest stood before him again. "Have you brought the necklace? Let me see!"

And still the priest did not speak. He had not uttered one word since the raj had first made his accusation. He began to tremble in the whole length of his body. From under his wrap he took out a knife. It was so sharp that you could cut yourself just by looking at it. Slowly, steadily, fixing the raj's greedy eyes with his own, the priest cut away a slab of flesh surrounding his heart area and threw it to the king in the water, saying, "Here are your pearls!" The water boiled red and they had to carry the raj from the basin, screaming. Even before the next sunrise the raj's body began to show signs of decay. Where once the pampered royal skin was fine and flawless, sores appeared and multiplied, and each sore like an open mouth echoed the dying priest's last words, "Here are your pearls. Take them!" The raj, nearly mad from pain and distress, at once summoned a holy man famous in Kullu for his knowledge of healing. "Yes, Sire, there is a way to get better, but one only. Otherwise this leprosy of yours will continue to eat your flesh alive until nothing is left."

"Tell me what I must do," the raj bristled impatiently. "I will do anything you say."

"To atone for your sin, you must send a man to the sacred city of Benares, where he is to steal a certain statue of Rama and return with it here. Then you will surrender every-thing that you own, keeping nothing back, and offer it to the god. And you and your descen-dants will serve Rama for ever and ever."

The raj chose his emissary with care from among the ranks of the bravest and most trusted of his court. It was a long and solitary journey, charged with many perils, but the thief reached Benares safely. He went directly to the temple where he had been instructed he would find the statue of Rama that was wanted. When he first saw it, he thought there must be some mistake. It was such a little thing, nothing much to look at, a lump of stone with no one standing guard. Everything looked so easy that the thief forgot the holy man's instructions of what he should do after he found the statue. He bent over to pick it up but found it was impossible to lift. It was as if the stone had deep roots that bound it fast in the earth. Strain as hard as he could with his every muscle bulging, the thief couldn't budge Rama. Then, just as he was about to despair, the natural needs of his own body reminded him what it was he had to do. Crouching down, lifting his *dhoti*, he soaked Rama with an outpour of his urine. After that, he could pick up and walk away with the god easily.

With all speed, the thief delivered the statue to the anxious raj who, during his absence, had been growing sicker by the day. The holy man performed a purification of Rama's image. Such a reconsecration was required after its contamination with urine. It wasn't long before the ailing king recovered good health, and then he gave his title and all of his possessions to the god and spent the rest of his days as Rama's servant.

Another bizarre Indian legend, absurd to our ears with its quixotic twists and turns.

Only this time, a coin dropped. Weren't you also struck by the consistency of the internal logic of this tale from 1600 with M. Singh's edict concerning the causes of the flooding that preceded Dussehra in Kullu Valley in 1995? A statue that loses its inherent powers when you piss on it. A local shrine no longer capable of shielding the inhabitants of the valley from natural calamity, because a urinal has been installed in too close proximity.

No, M. Singh may himself be a catalyst contributing to deforestation and flooding. My hunch is that he is not unaware of the connection, but the reasons that the raj advanced to account for the disaster after his consultation with the assembly oracles were fully compatible with the traditional belief system of the celebrants of Dussehra.

The last blush was ours.

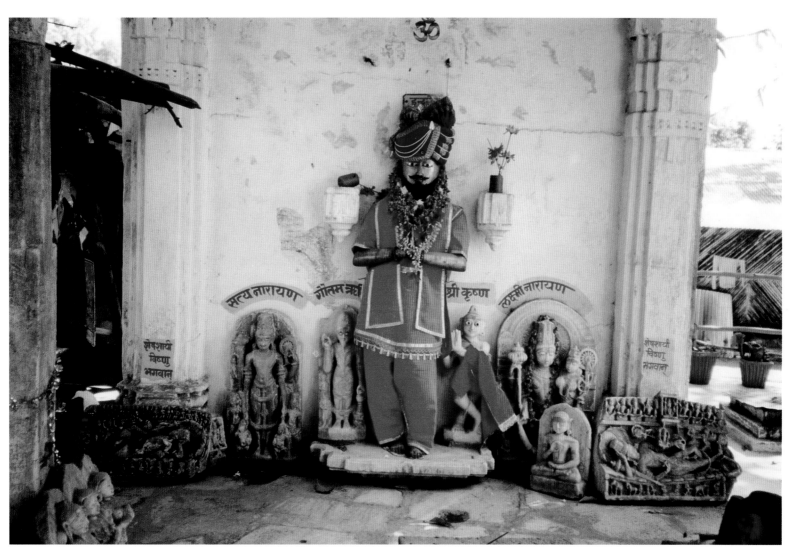

*Indra, king of the gods, dressed as a Rajput maharajah, Ghamuk, Mt. Abu,
Rajasthan. An image is clothed when a god who has been invoked is believed
to be present within.*

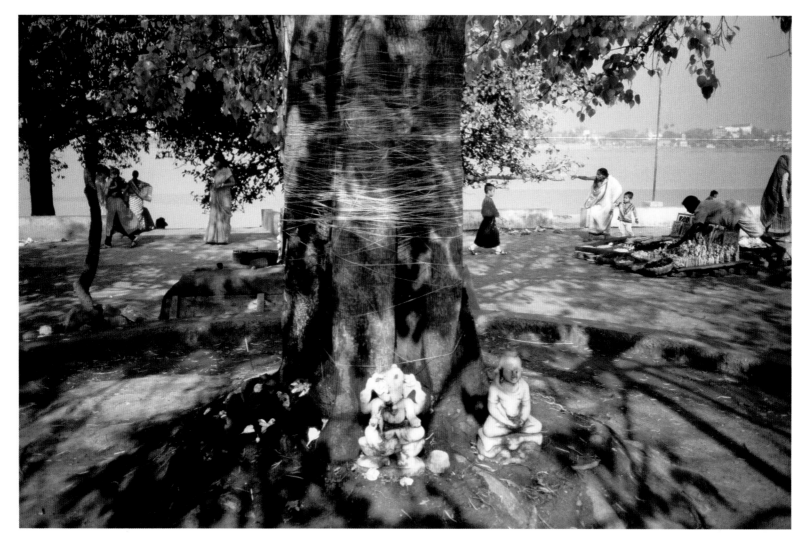

*A pipal tree (*Ficus religiosa*) just outside the Kali Temple at Daksheneswar on the east bank of the Hooghly River north of Calcutta. It is said the pipal is the abode of the Hindu trinity—Brahma, Vishnu, and Shiva—and devout Hindus worship the tree, pour water at its base, and smear the base with red ocher. Beneath it are placed rough stones dabbed with vermilion, which form the shrine of many local village deities. Women pray to the tree for sons and wind a cotton thread around the trunk to attest to their devotion.*

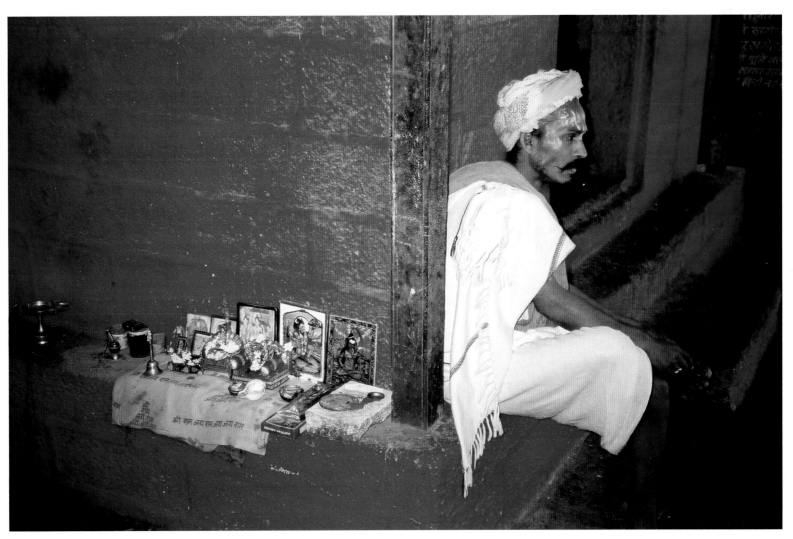

*A priest at a Ganesh shrine with icons displayed on his personal altar around the corner. Unknown in early religious texts, icons were said to be introduced for the benefit of the common man who had difficulty believing in abstractions. Hindus do not say that they are going to a temple to pray, but to do* darshan— *to see and be seen by the image of a deity.*

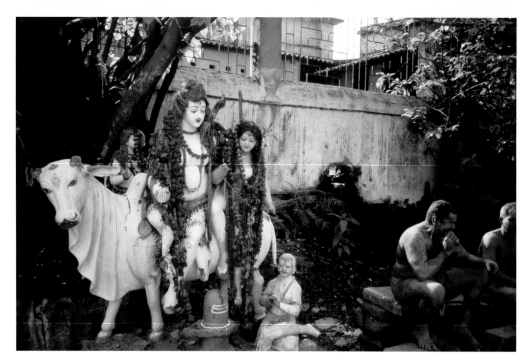

*Shiva and Parvati, his female emanation, are seated on the god's vehicle, Nandi,*
*shortly after an offering ritual. This statue is in a wrestlers' club in Calcutta,*
*although it is usually Hanuman, the monkey god, who presides over wrestling clubs.*

*Nandi the bull is the symbol of the soul of man yearning for the Great Soul.*
*Therefore, in all Shiva temples Nandi faces Shiva. Pushkar, Rajasthan*

OPPOSITE: *Temple sentries in the morning mist, Observation Hill, Darjeeling*

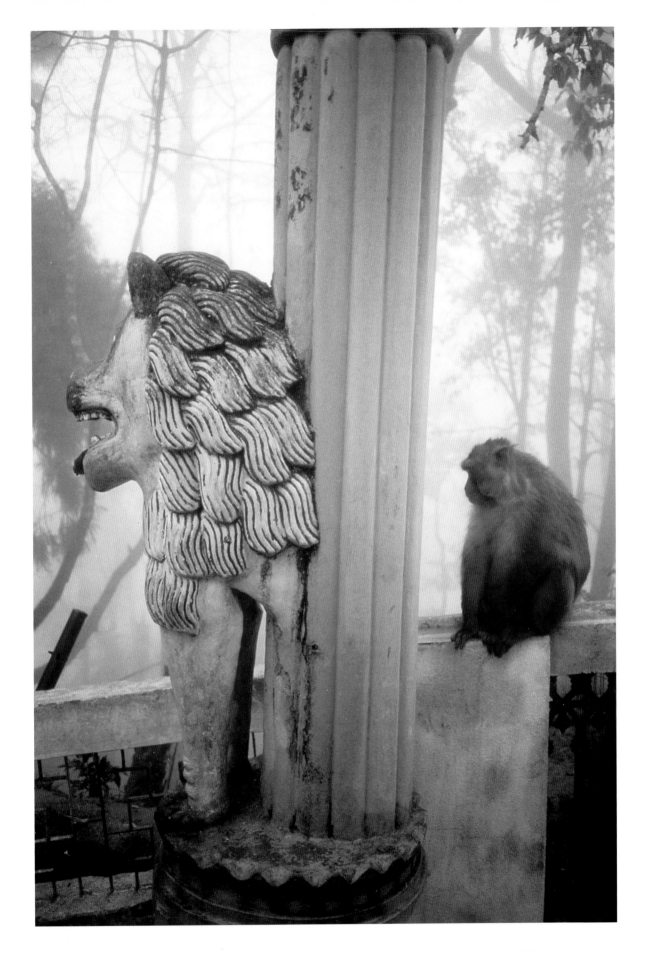

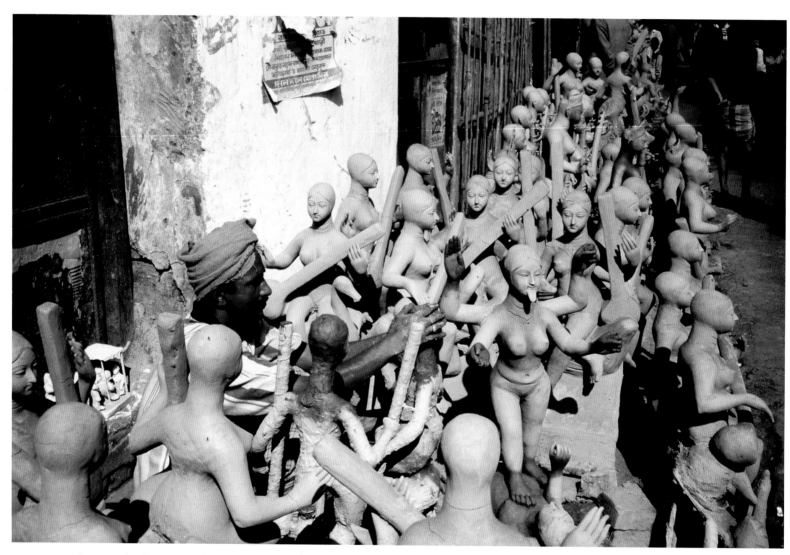

*An artisan finishing statues of Saraswati, the goddess of learning and music, on Kali Street, Calcutta. The hands, feet, and heads are added last, by more highly skilled craftsmen. Saraswati, the goddess of learning and music, presides over the entrance doors of Hindu schools and colleges.*

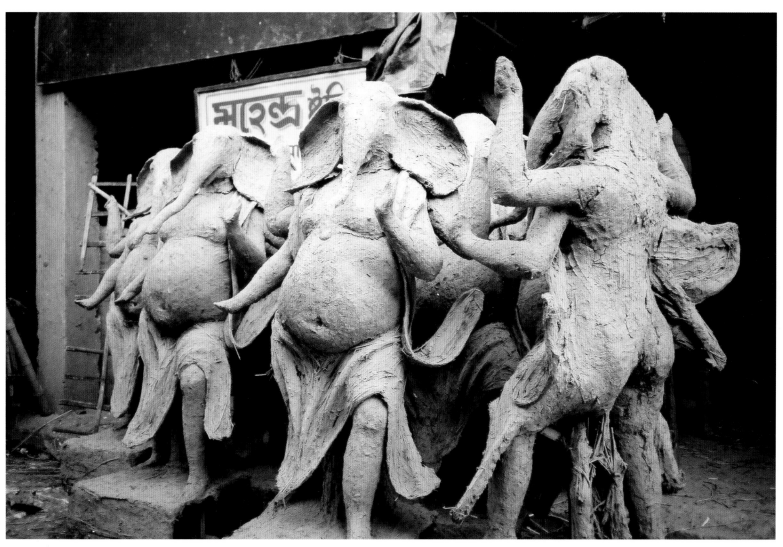

*A contingent of Ganesh statues in an early stage of preparation, Calcutta. The elephant-headed god, who helps overcome obstacles and may be India's most popular deity, is corpulent and clumsy, reminding those who look at him that appearances are unconnected to the inner beauty of spiritual perfection.*

*A wishing tree in the fields outside Poshina, Gujarat. Petitioners of the gods leave what they can afford— a terra-cotta horse or elephant or a strip of rag tied to a branch. Tree worship is a relic of Pre-Aryan aboriginal tribes. Buddhism gives strong support to tree worship, for Buddha was a tree spirit in no fewer than forty-three of his transmigrations.*

122

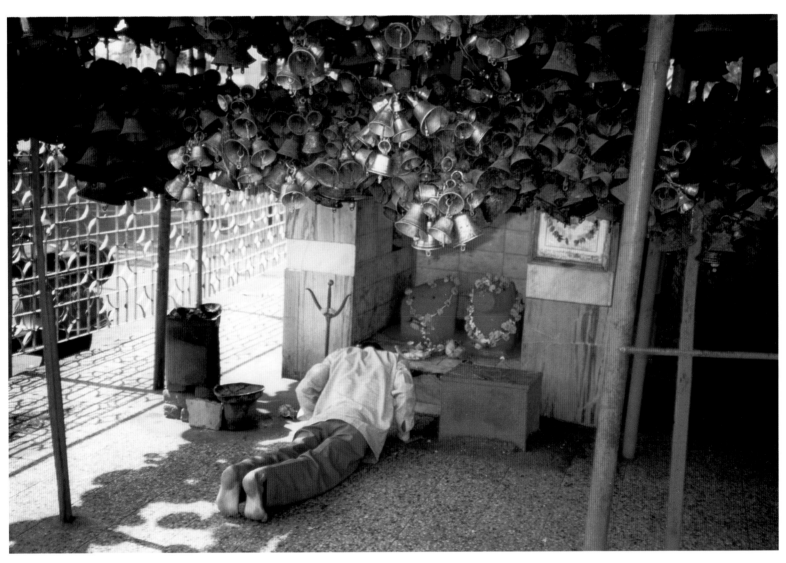

*Shiva shrine barnacled with votive bells on the outskirts of Nasik, Maharasta*

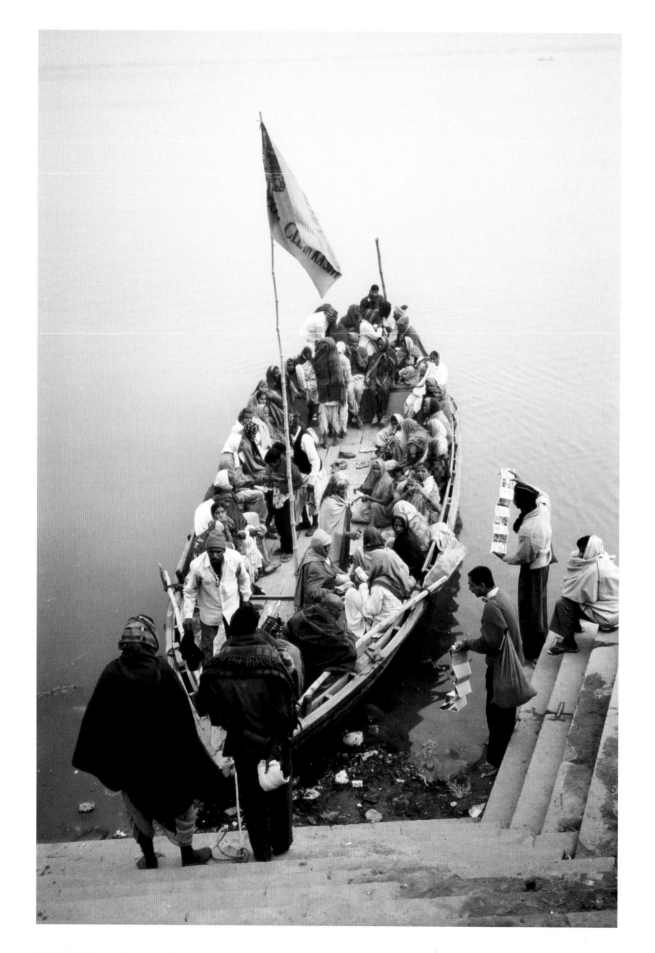

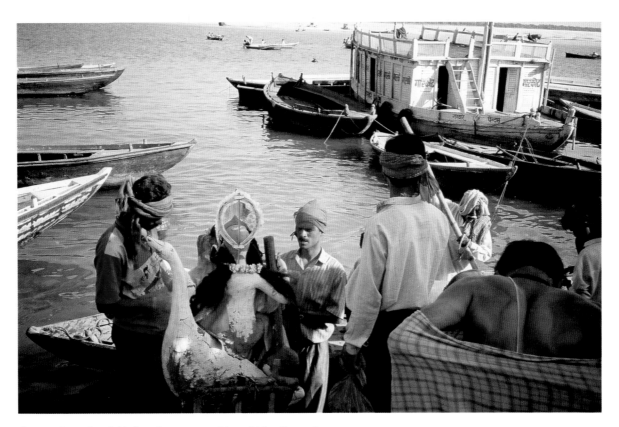

*Saraswati seen from behind on the goose, one of her vehicles, Varanasi.*
*"Saraswati" was the ancient name of a mythical stream in the Punjab, the*
*scene of sacrifices to the gods. The water's purifying flow was likened to*
*teloquent speech and the music of repetitions of holy texts and prayers.*

*A sand artist administers a final caress to Buddha's cheek, Puri beach, Orissa*

OPPOSITE: *A pilgrims' boat and postcard vendors, Varanasi*

*This shaman from a mountain village in Himachal Pradesh is one of the hundreds who carry their local god down to Kullu for the annual festival of Dussehra, led by a group of musicians.*

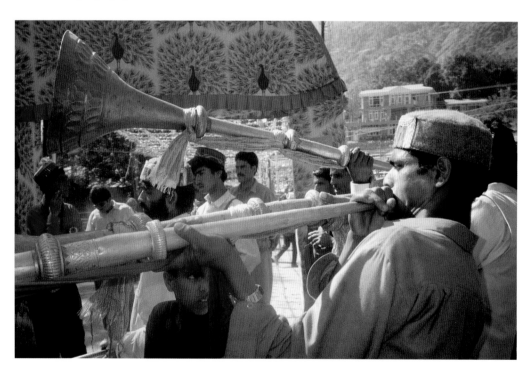

*Wind instruments sounding the approach of a deity during Dussehra, Kullu*

OPPOSITE: *An itinerant holy man at Dussehra festival, Kullu. The ash on his face is a reminder of life's transience.*

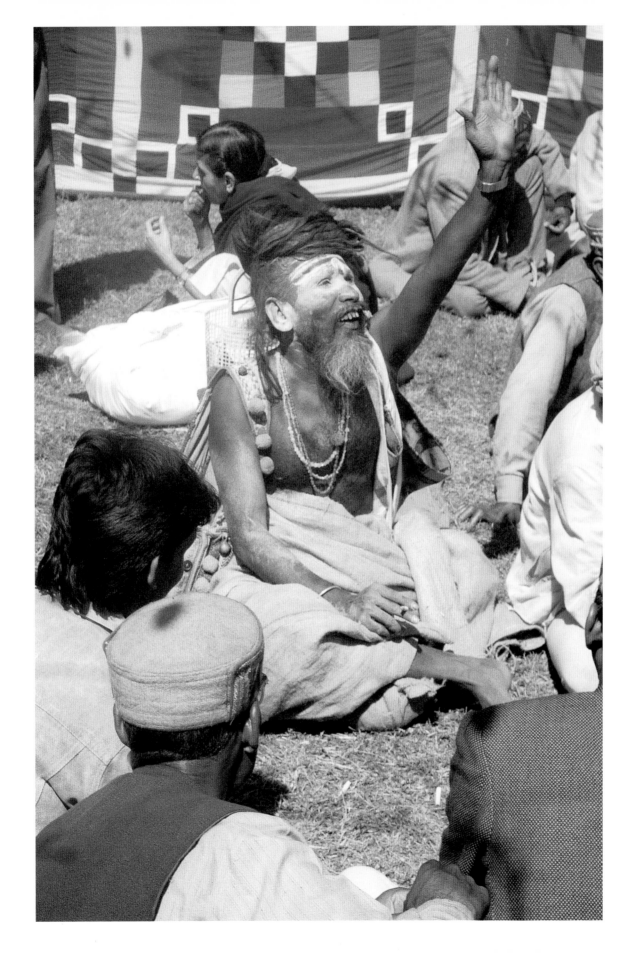

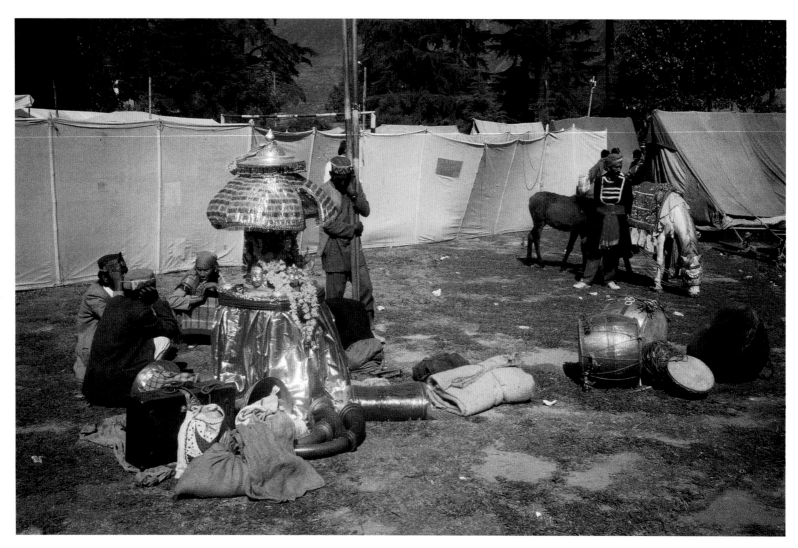

*A dismantled deity and his team of bearers rest inside the pavilion
of the former maharajah of Kullu during the Dussehra celebration*

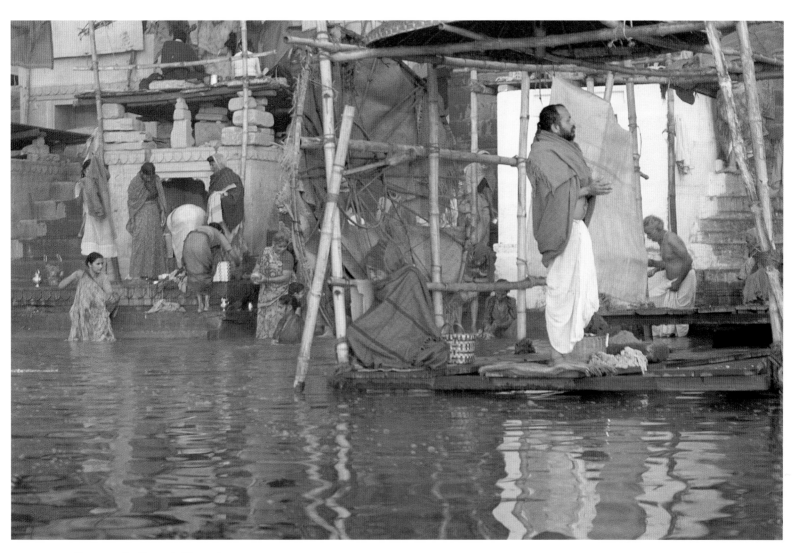

*Prayers to the Ganges in Varanasi*

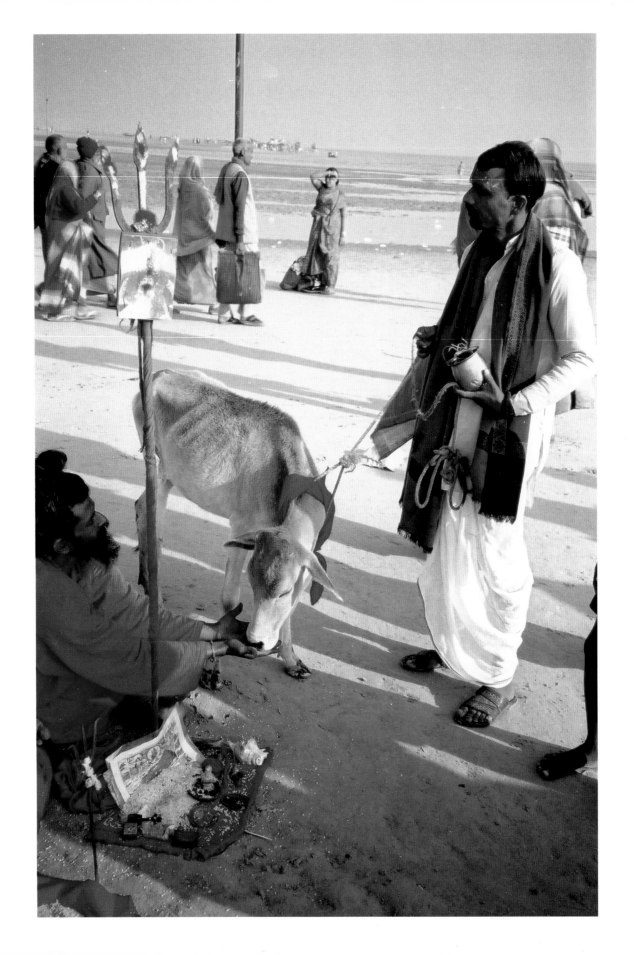

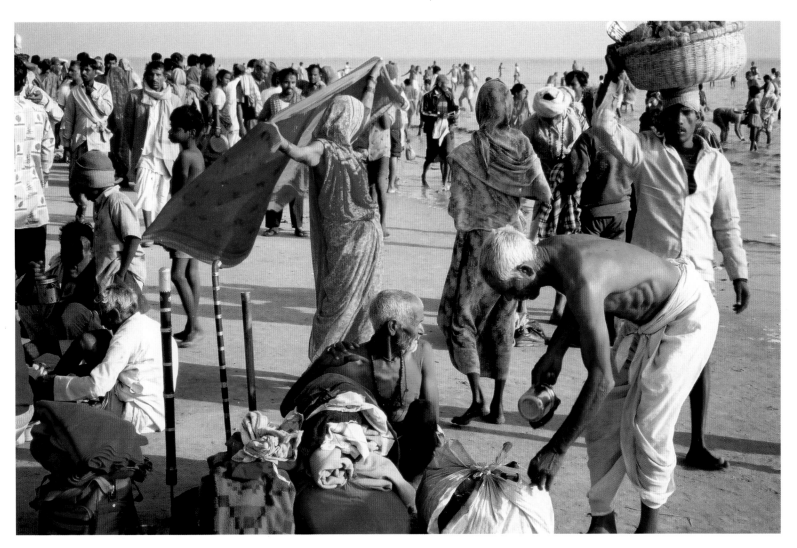

*These pilgrims have reached the goal of their journey to Gangasagar—to bathe in the Ganges where it enters the Bay of Bengal to flow into the underworld, West Bengal.*

OPPOSITE: *A sadhu converses with a pilgrim who is collecting contributions in order to buy a calf to be released as part of the memorial service for a relative. Gangasagar*

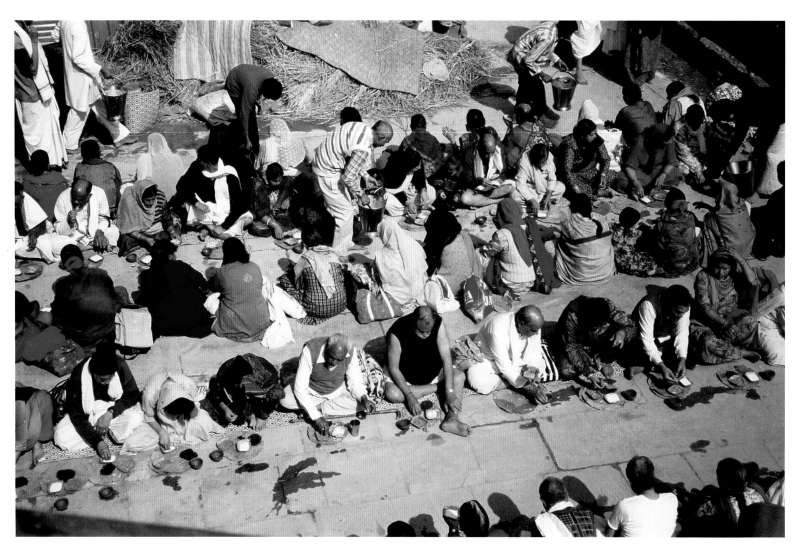

*Pilgrims from the far corners of India share a charity meal in Gangasagar.*

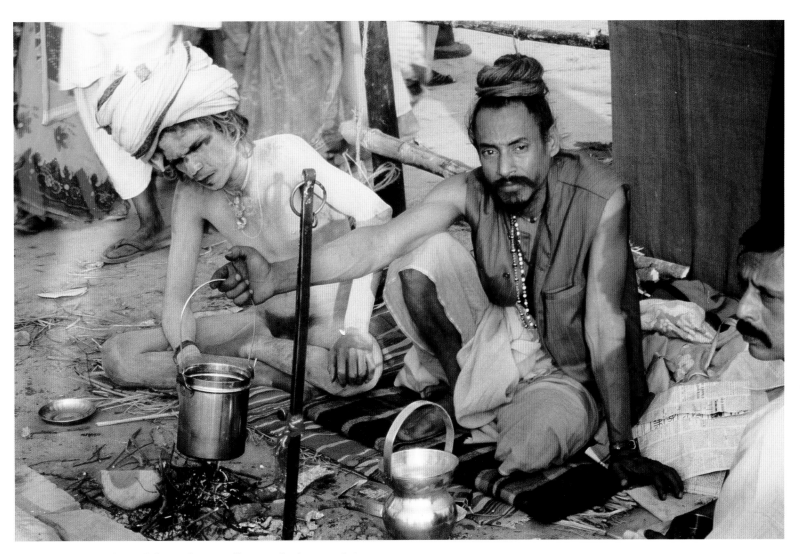

*Two sadhus, or holy men, heating milk over tinder during a pilgrimage to Gangasagar, West Bengal. The figure covered in ash is a naga, one of an order of warriors created hundreds of years ago to defend Hinduism from the encroaches of Islam and Buddhism. Nagas are always naked and undergo an initiation that deprives their sexual organs of all feeling. The ash, mixed with aloes, deadens the sensitivity of their skin.*

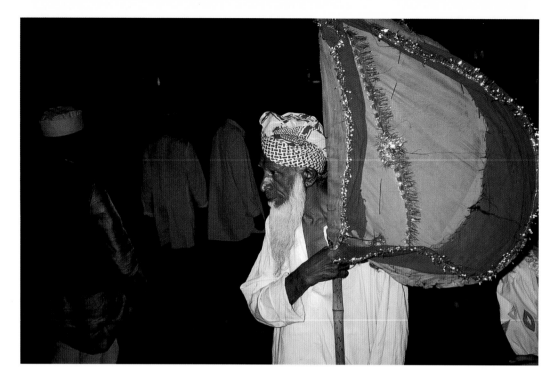

*A flag bearer, Shivaratri, Madurai*

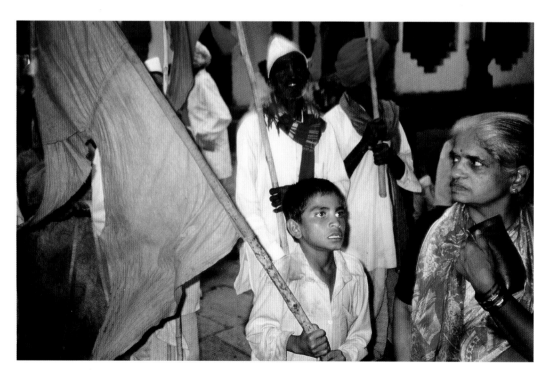

*A procession in honor of Saint Eknath, Paithan*

OPPOSITE: *An ecstatic dancer at the Saint Eknath celebration, Paithan*

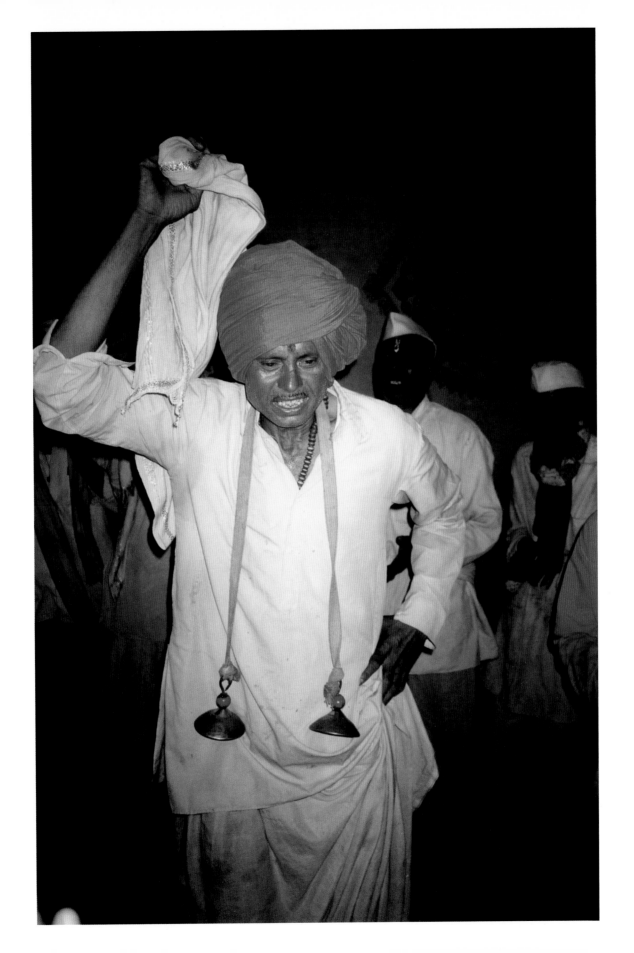

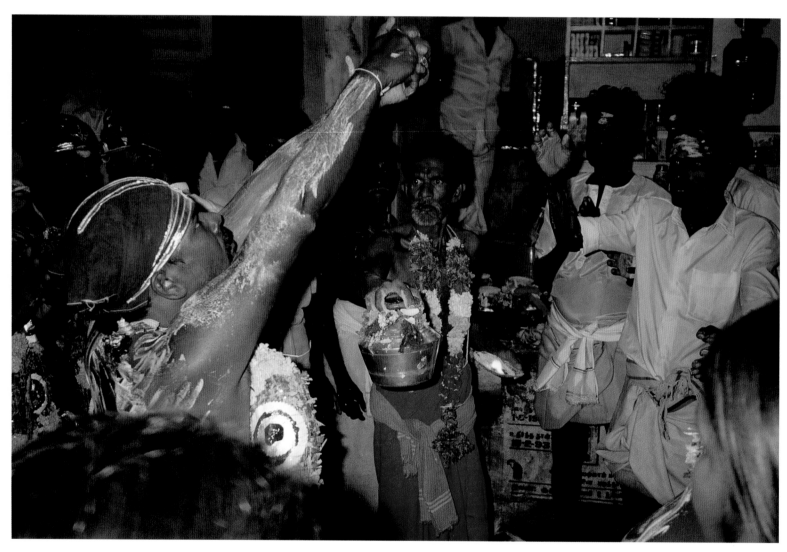

*The Shivaratri celebration in the streets of Madurai outside Shree Meenakshi Temple in Madurai, southern Tamil Nadu. Legend has it on this night Lord Shiva, the Great God of Destruction, and Lord of Mad, Frantic Folly, clad in the blood-soaked skin of an elephant, danced the* tandav, *his celestial dance that shook the cosmos.*

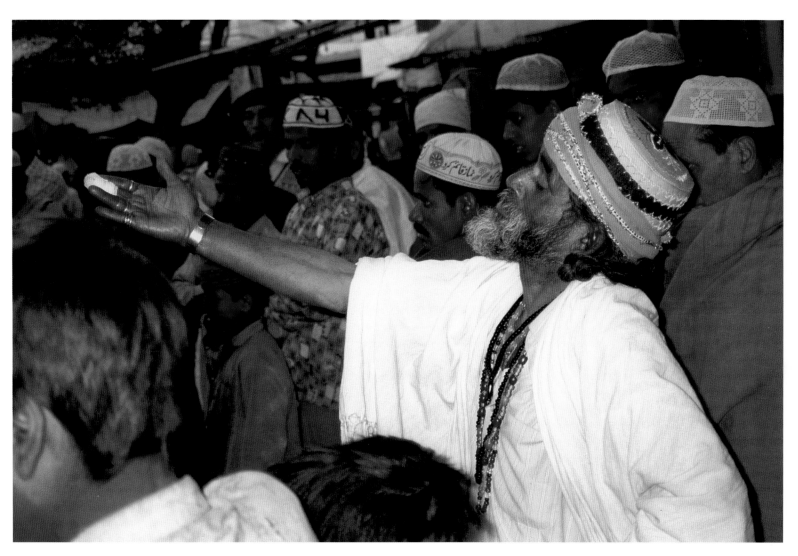

*An obsessed Sufi responding to* kawali *(devotional songs) during
the commemoration of the Sufi saint Hazrat Khwaja Moinuddin
Chisti at the saint's tomb in Ajmer, Rajasthan.*

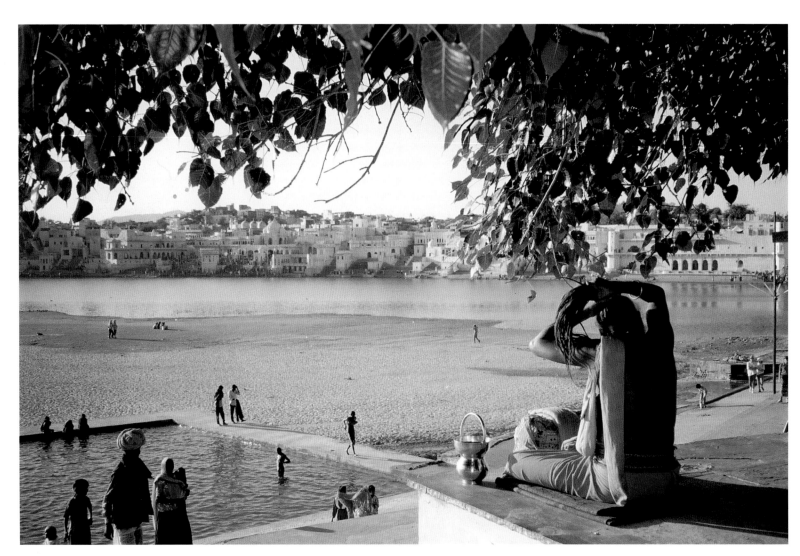

*The lake at Pushkar, one of the holiest in India, believed to have sprung up where Brahma let a lotus flower (pushkara) drop in the desert wastes of Rajasthan. The oldest known records of pilgrimages to Pushkar date from the second century A.D.*

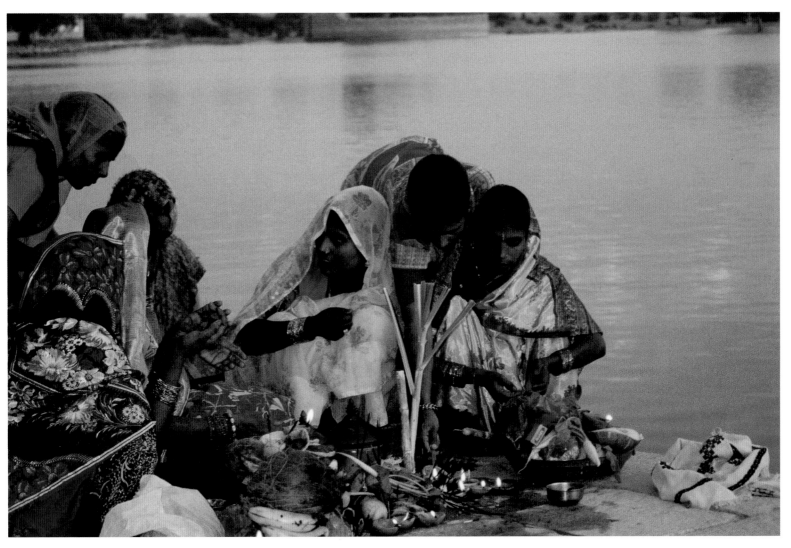

*Migrant laborers from Bihar living in western Rajasthan worship Surya,
the sun god, far from home. Garsisar Water Tank, Jaisalmer.*

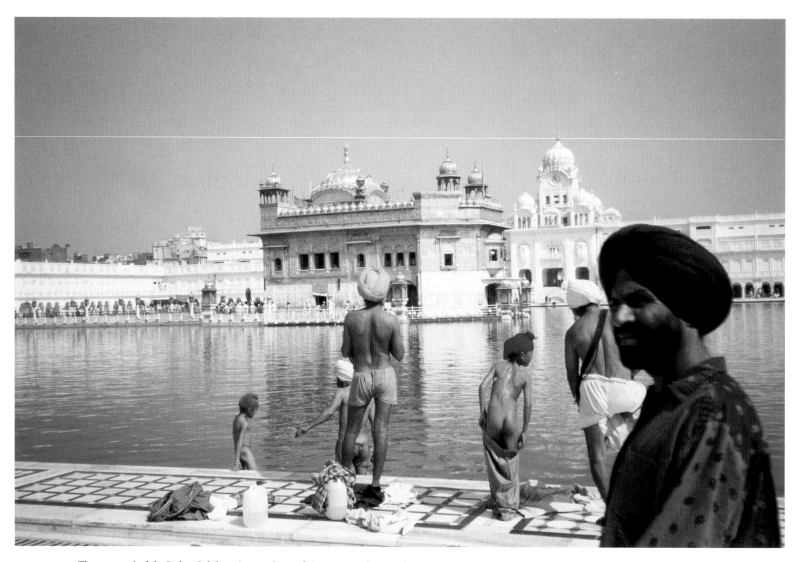

*The courtyard of the Dabar Sahib, or Divine Court of Amritsar, in the Punjab, popularly called the Golden Temple, the holiest shrine of the Sikh religion.*

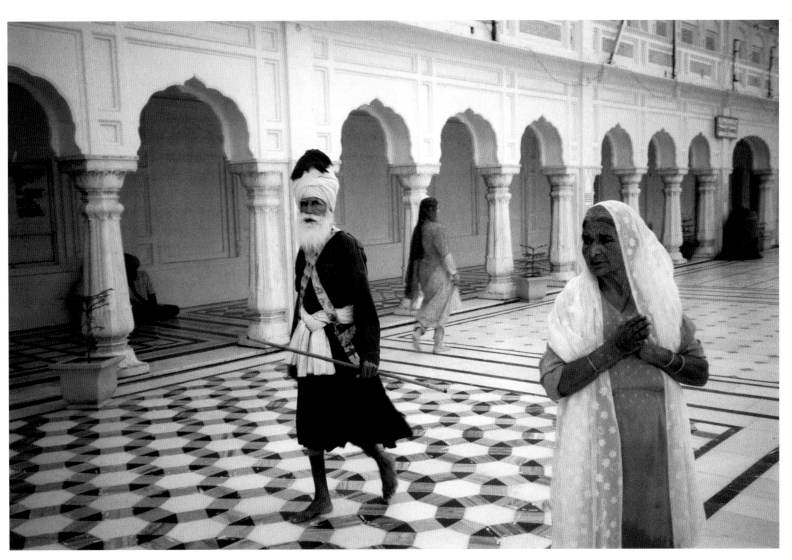

*An honor guard and a prayerful pilgrim in the courtyard of the Golden Temple, Amritsar*

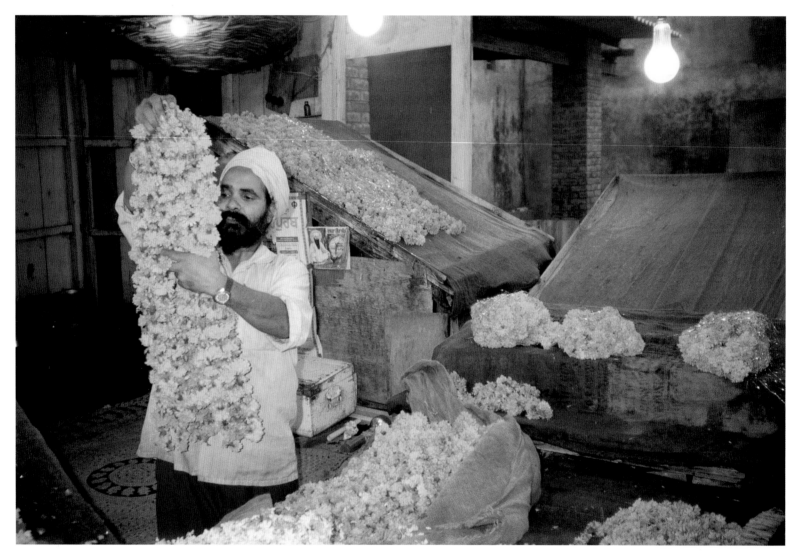

*A vendor of marigold garlands in a corner of the courtyard of the Golden Temple*

OPPOSITE: *An eccentric priest at an altar he has erected in Calcutta's flower market*

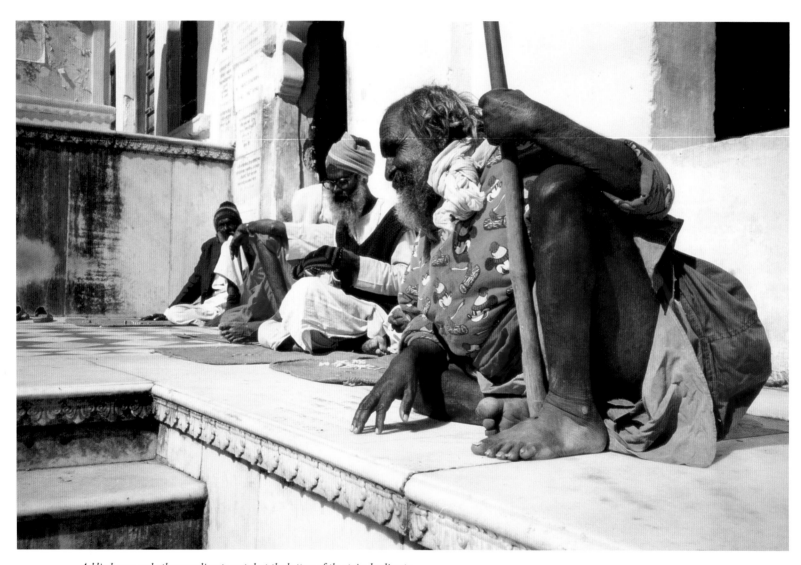

*A blind man and other mendicants seated at the bottom of the stairs leading to the only temple exclusively dedicated to Brahma in India, Pushkar, Rajasthan*

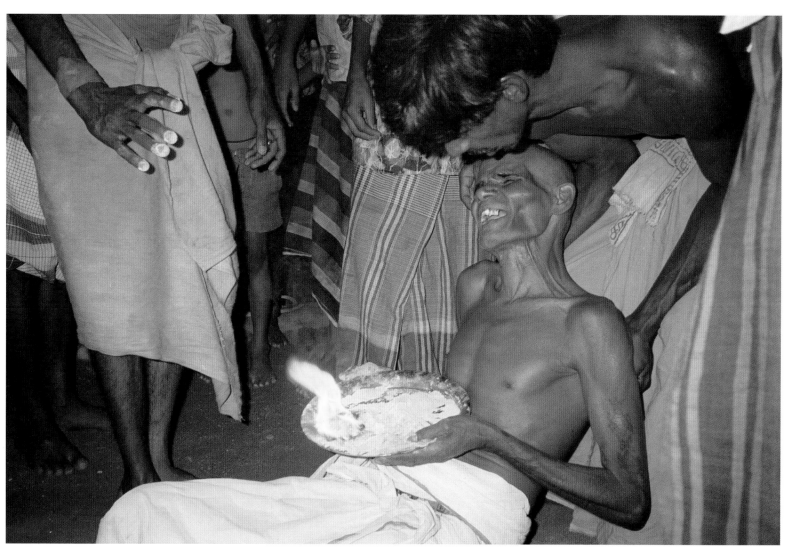

*A possessed priest speaking in tongues, an incorporation of early animist beliefs within Hinduism, small temple outside Madurai, Tamil Nadu*

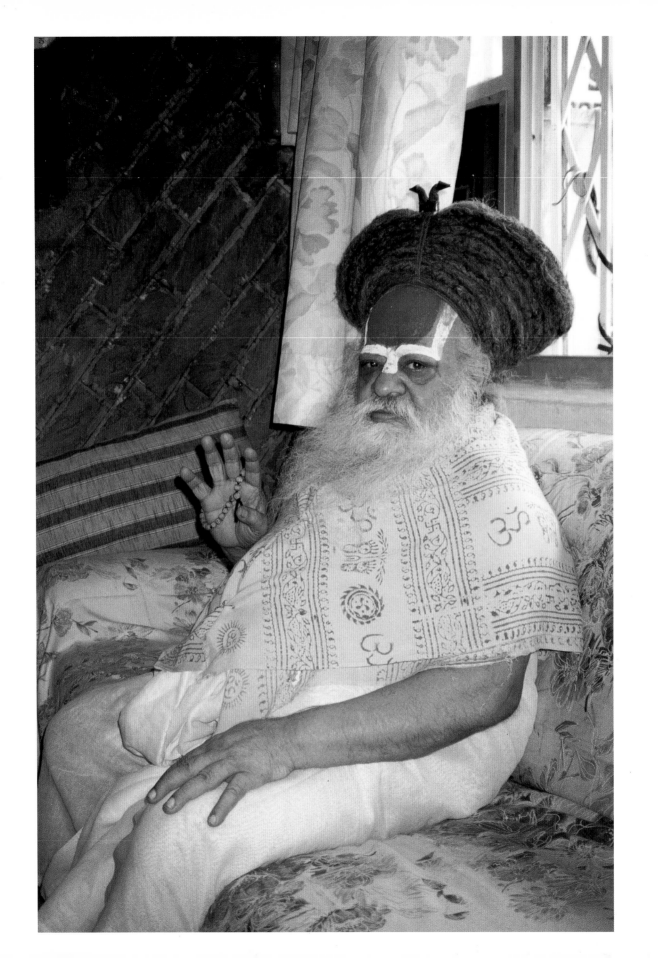

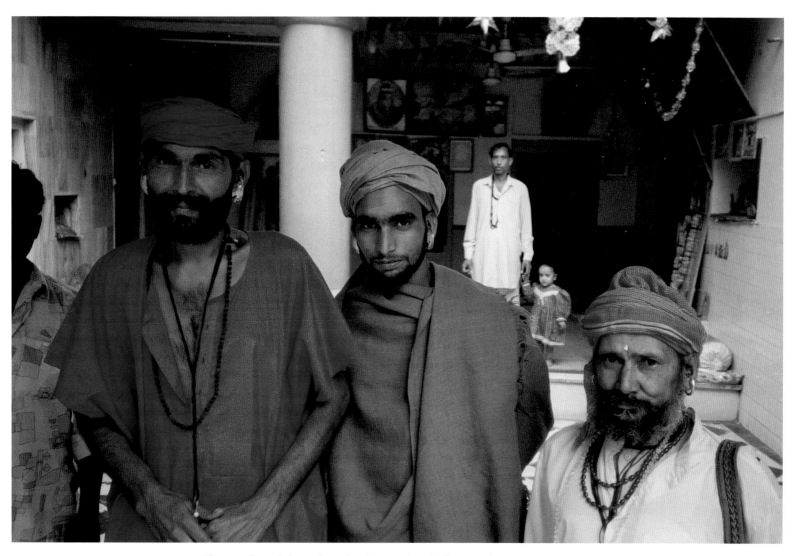

*Three wandering holy men leave their* dharamsala, *or pilgrim guesthouse, opposite Durgiana Temple, the old city of Amritsar, Punjab*

OPPOSITE: *Babu, or "Father," who is 110 years old by his own calculations, on one of his daily rounds of visits. He carries prayer beads, and his shawl is block-printed with Hindu symbols.*

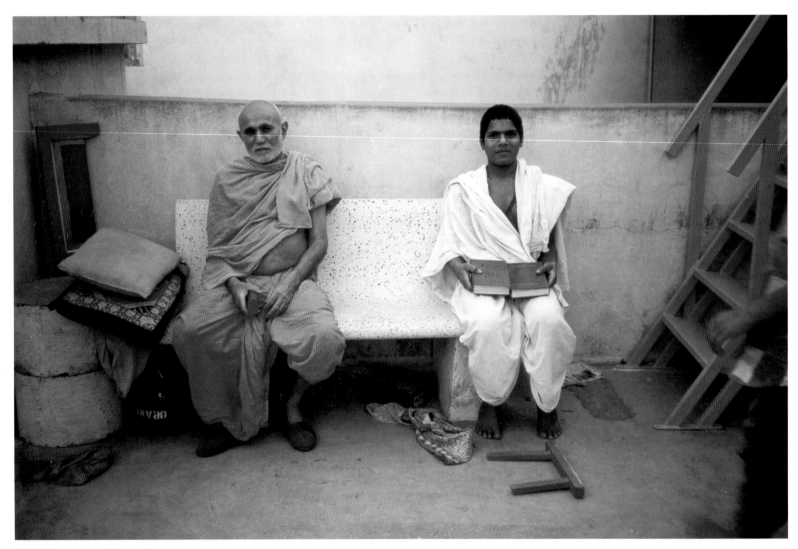

*A Hindu monk and novice at Shree Swami Narayan Temple, Bhuj, Gujarat.*
*A would-be monk wears white for the first year, changing to orange once his*
*commitment is definite.*

OPPOSITE: *A sadhu, or holy man, in Varanasi*

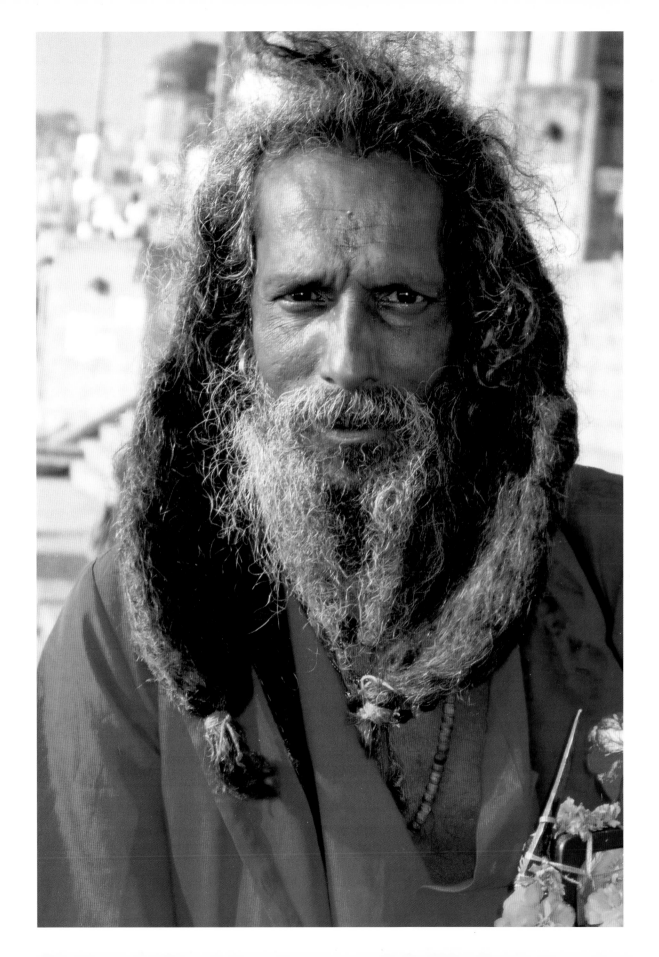

*Two Hindu monks relaxing on the rooftop of their dormitory attached to Shree Swami Narayan Temple, Bhuj, Gujarat. In the foreground is a pot of basil* (Ocimum sanctum), *sacred to Lord Vishnu, who is often ceremonially married to the plant, probably the holiest in India.*

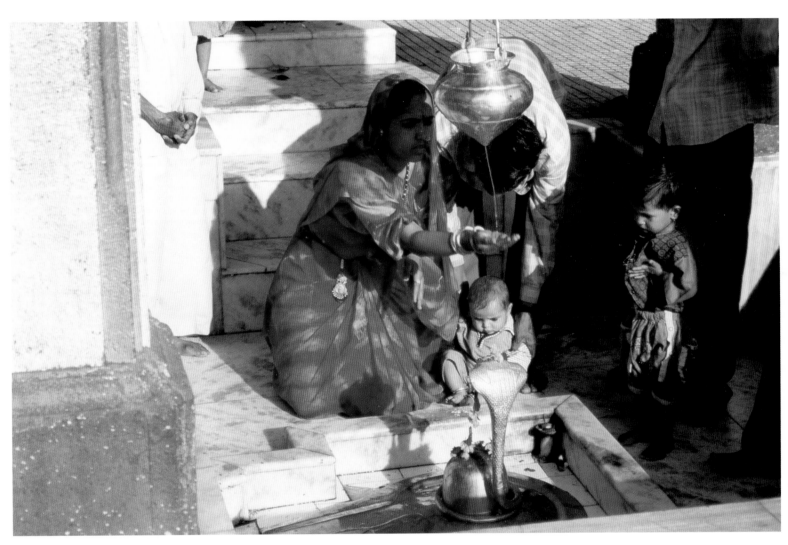

*A family worshiping at a Vishnu shrine, Nasik, Maharastra*

*A child monk studying Buddhist texts at Ghoom Monastery, outside Darjeeling, West Bengal*

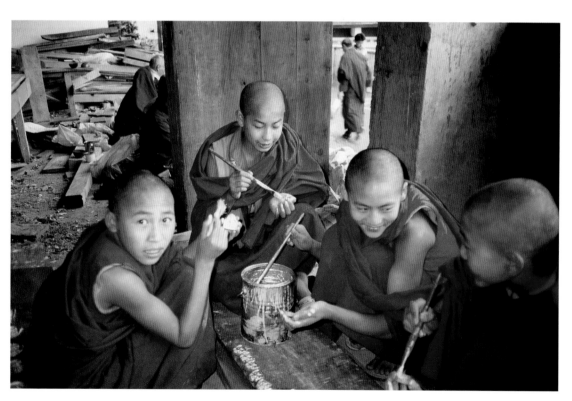

*Young monks painting utterances from Buddha's teachings to be inserted in the hollow core of a large new image of Buddha. When the statue is consecrated, these mantras act as a soul to give it life. Alloobari Monastery, Darjeeling, west Bengal*

OPPOSITE: *A book printer at Rumtek Buddhist Monastery, Sikkim. The literature of the dominant tribe of the area, the Lepcha, consists wholly of translations from Tibetan holy texts.*

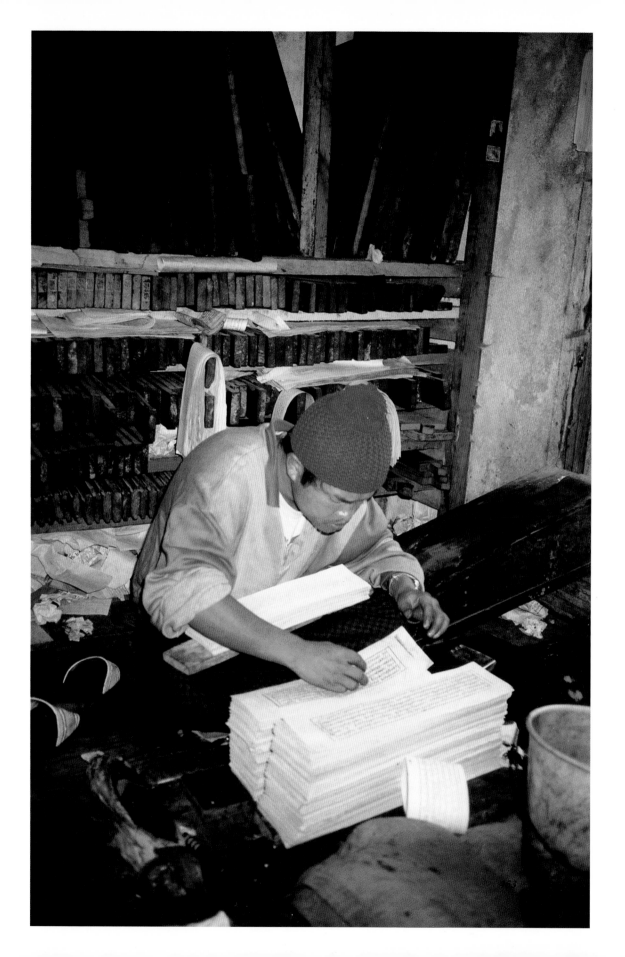

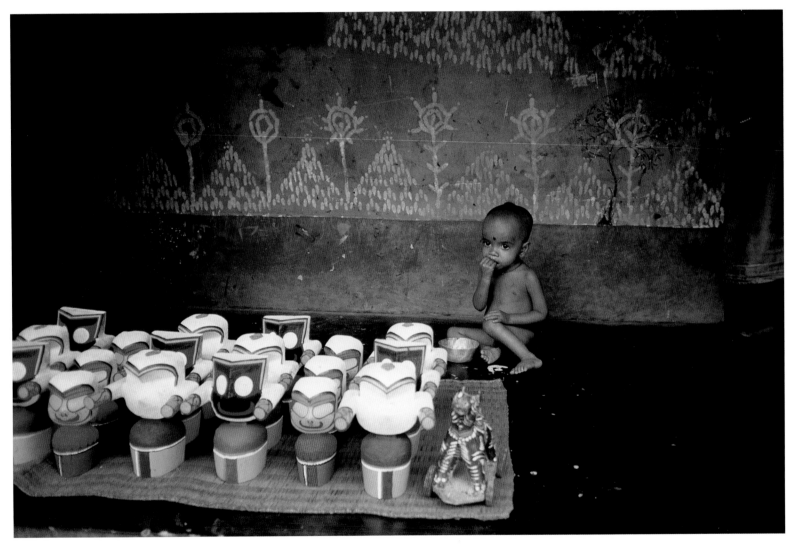

*Papier mâché images of Jagganath, Lord of the World, a manifestation of Vishnu as Krishna. The eyes are invariably the last part of the deity to be completed. The Jagganath cult is of Saora tribal origin. This explains its unique look: head out of proportion, goggle eyes, no legs or hands, only stumps of arms.*

OPPOSITE *This begging child wears the body decorations of Shiva and a seed necklace typically worn by priests. People give* prasad, *food offerings blessed by the gods—rice, bread, and sweets—rather than money. Pushkar*

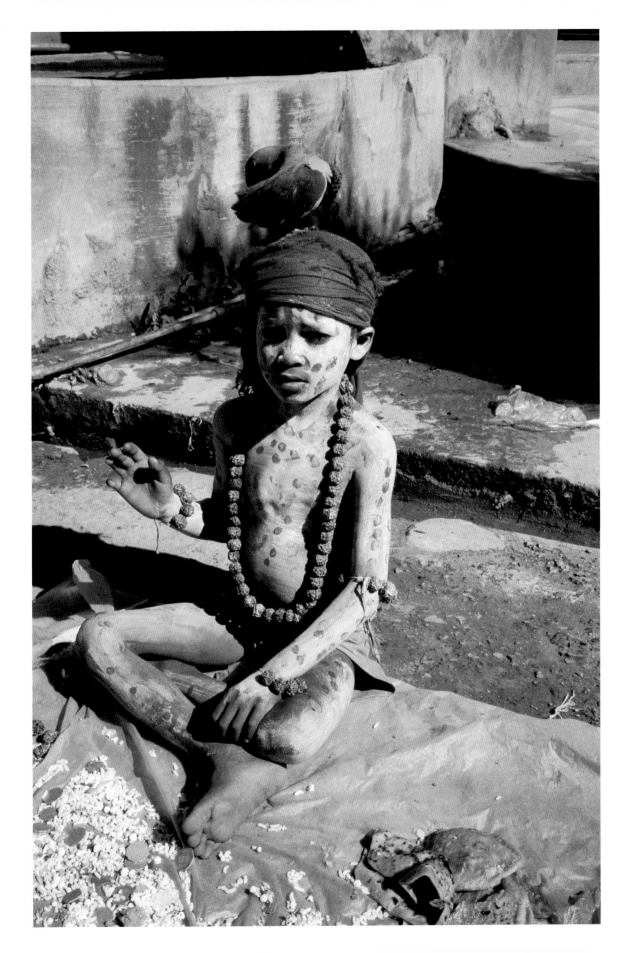

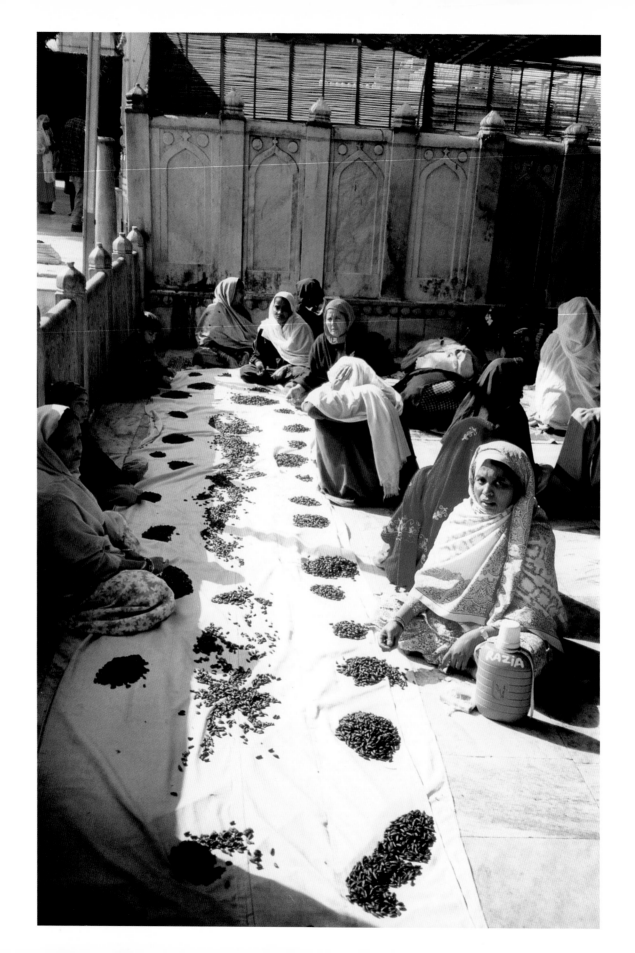

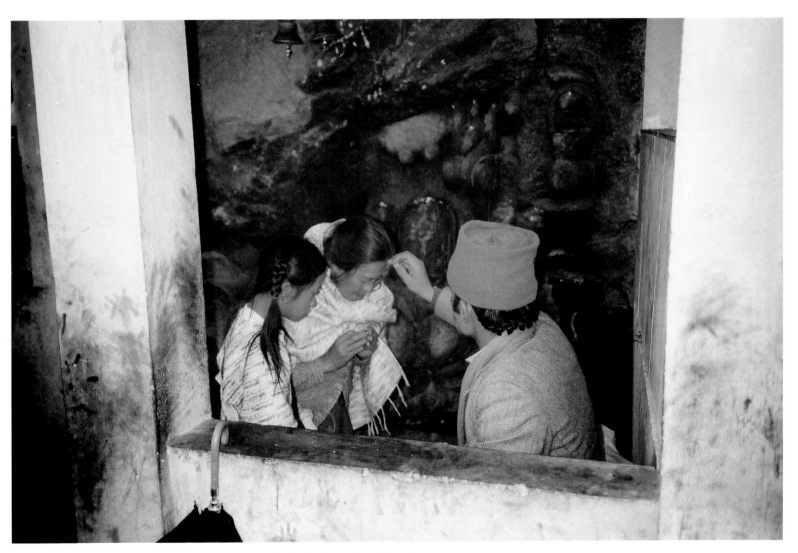

*A Hindu priest applying vermilion* tilak *to the foreheads of a mother and daughter making an offering at a cave shrine to Krishna, Observation Hill, Darjeeling*

OPPOSITE: *Sufi women honor Allah by counting 250,000 coffee beans beside the tomb of the great Sufi teacher who brought Islam to India. For Sufis this site is second in importance only to Mecca as a destination for pilgrims. Ajmer*

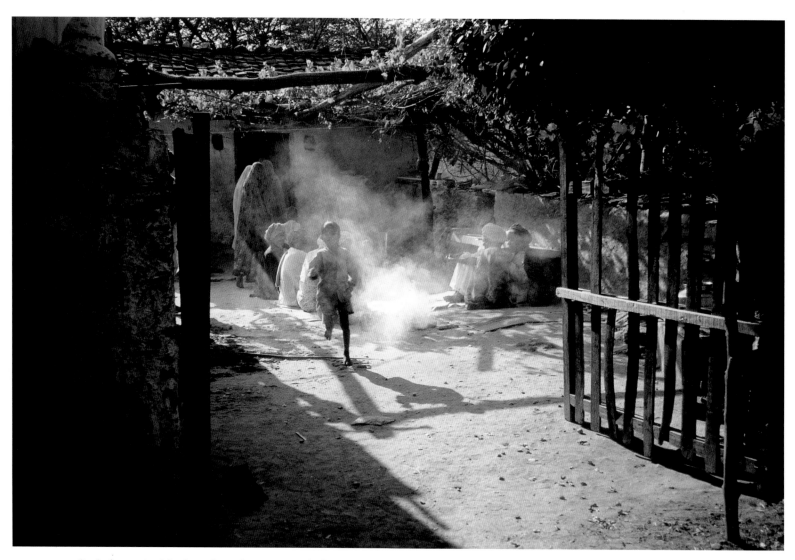

*Smoke from a ritual fire lit on the tenth anniversary of a father's death,*
*near Eklingi, Rajasthan*

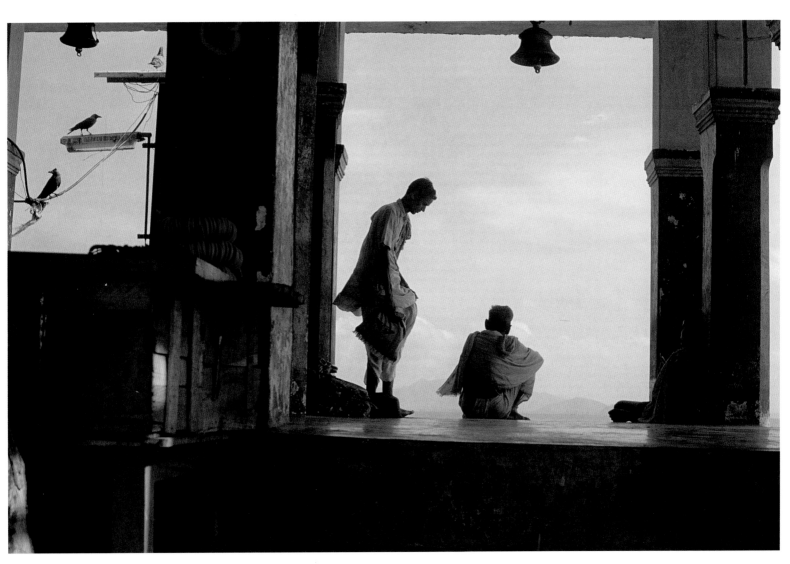

*The island temple of Kalijai, a local legendary goddess,*
*inside Chilika Lake, Orissa*

# PART III

## *seduced by the beauty of the world*

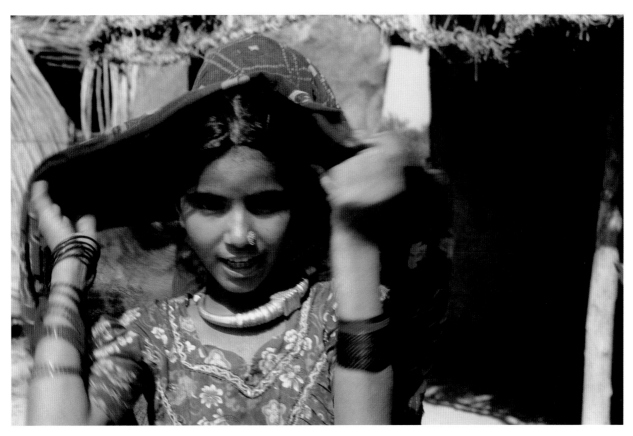

*A Jat tribal girl, Kutch village, Gujarat*

# 7

## *the body wanders*

INITIALLY, GAURAMJI WAS ON A ROLL AT THIS YEAR'S Pushkar Camel Fair. Within a few hours of the opening, he had already clinched the sale of three stroppy male camels for a handsome price. Of course, he had painted them with black designs to look their best and shaved geometric figures in their coats, even snipped the long hairs that tufted from their ears. And then in the big camel derby, Ranaki, his eleven-year-old daughter, caused a sensation by leaving the rest of the pack—all grown men—to choke in her camel's tail dust. The victory increased not only the market value of her mount for breeding purposes, but also her own. Just as suddenly and mysteriously as it had arrived, however, Gauramji's luck vanished. His star camel came down with a mysterious malady. Not trypanosomiasis; Gauramji would have sniffed out "tryp" in the bull's urine. And he had vaccinated the prize beast against "camel pox" with blistered skin from an infected camel, which he mixed with water and rubbed into shallow incisions in the beast's spongy nostrils. The vigilant herdsman had even "fired" the camel recently against chronic complaints, speeding the circulation of its blood by applying a hot iron to prescribed spots. Still, the bull had gone sluggish and lay on his side heaving, his large, bulbous eyes murky. At such a moment, most of Gauramji's children knew enough to keep out of their father's way. Rumarkan, however, not yet seven, asked once too often for the money Gauramji had promised him to ride the giant wheel, and for his persistence he bought a swift cuff to the side of his head. "Go help Jivati." Gauramji shoved the stunned boy toward the family's camel cart, which was stacked with quilts and saddle cloths and cooking gear. Behind it, on a smoothly raked patch of sand, a small girl was carefully spreading fresh dung from a basket balanced on her hip. "She doesn't know

the others' tricks. Go on, you keep an eye on her or they'll rob us blind."

Come sundown, a fretful Gauramji sent for the "doctor." As Ranaki lay beside the ailing camel, head to head, she pressed her medal against its neck. She also filled her hands with water and coaxed the camel to drink. The beast's lips and huge tongue, lolling sideways, were coated with a frothy green scum. At dusk a cattle fair on the fringe of the desert is always a stirring sight, with thousands of camels, cows, and horses watering at long troughs and feeding from great green bundles of grass and leafy fodder, but Ranaki had no eyes for the larger scene. At long last, the doctor arrived with his special set of tools: a simple stringed instrument made from a gourd and a parchment scroll. This scroll contained paintings that traced the history of the camel from its creation to its arrival in Rajasthan. Through the night—under a sky spangled with stars that with the passing hours seemed to huddle closer and closer, the better to listen—the bard-healer sang in a warm, hoarse voice how Parvati, Shiva's wife, playfully molded the first camel from a piece of clay and cajoled Shiva into breathing life into her toy. Her delight was immense, but soon the living camel proved too much for her to handle. Shiva gave in again to her nagging and from his own skin and sweat he created a caste of camel herdsmen, the Raikas. At dawn, as the sun came up a blazing red, the doctor's singing recounted how, despite many hardships, the Raikas drove their animals from Beluchistan in the west to the sea of rippling sand dunes near Jaisalmer. By cock's crow, the patient was back on his feet, albeit wobbly. "It is our best, surefire treatment," Gauramji could smile again. "Otherwise the camel sickens and dies."

* * *

RABARI IS THE GENERIC name for twelve nomadic subgroups that descend from the Raika. In waves of migration dating back to the eleventh century, Rabaris penetrated and settled in such harsh, arid areas as the Sind in Pakistan and the Kutch in northern Gujarat. We ran into a Rabari family with all its livestock moving south along the main road from Poshina to Ahmedabad. Not only along the road, but all over it, snarling vehicular traffic with bemused indifference and strung out over a distance of many miles in successive, sex-segregated constellations. At this time of year, Rabaris sign on in the plains as piece-work cotton pickers. Where winter wheat has been cut, stubble in the fields makes good pasturage for their animals. First we came across a trio of men on camelback whose lurching steeds looked deceptively like ostriches to me. Little did we suspect this was the top of an iceberg! About fifteen minutes behind them, we met up with several lean, long-legged young men in red turbans driving two hundred-odd sheep before them. These, in turn, were followed after a similar interval by a pair of men escorting about twenty young camels, which constantly broke ranks to munch at every leafy roadside branch within reach. A donkey pack advanced on their heels with Rabari babies in saddle bags or swaddled to

string beds strapped to the beasts' backs. More donkeys lagged slightly behind, loaded down with pyramids of cooking pots and water jars. Women in splendid reds and purples were quick to give malingerers an occasional hefty whack with a stick. Some older girls, whose eyes were ringed emphatically with kohl, carried children astride their necksl. After a lengthy patch of empty road, we had just inferred that the caravan must be over when a cloud of dust up ahead, moving toward us, proved to enclose a sizable herd of cows. Hump-backed, broad-horned beasts, swaying along several abreast in the custody of men and boys wearing characteristic white Rabari jackets, long, pleated white cotton trousers, and the by-now-familiar red turbans. And, bringing up the rear, young girls clad in bright colors passed us, keeping their faces veiled and slashing fitfully with willow rods at the ankles of calves so young that for them walking, indeed life itself, was still a daunting novelty. By now the vanguard might well already have picked the spot for the night's camp, where without negotiation they would appropriate grazing rights in exchange for fertile deposits of their livestock's dung, and the first Rabaris we had seen would be climbing down from their camels to check the water supply.

Various accounts coexist of why Rabaris migrated from Rajasthan in the distant past. They themselves especially like to attribute their relocation to loyalty, claiming to have accompanied their Rajput kings who were driven into exile. Others maintain they shifted as a community when outsiders became obsessed with the beauty of their women. Even today Rabaris do not marry non-Rabaris. Historically, like all pastoral nomads, they have gravitated to places too rugged, hot, or erratic weather-wise for farming. Their surroundings have also limited the kinds and number of animals they can keep. In the best of times, accustomed to wander over a wide area to meet the needs of their herds, it probably took a cataclysm—drought, flood, earthquake, war—to push them in panic beyond their familiar haunts, as often as not into yet bleaker territories, where they would have to strike a new balance with hostile nature. To be sure, as the family we observed on the move illustrates, Rabaris in time have come to realize they can no longer hope to survive in the wastelands of Gujarat with only their beloved camels—all the more so, since for them "selling camel milk is like selling your children." Not only have they had to diversify their livestock holdings; some have even undertaken farming, work that their ancestors derided.

\* \* \*

"NO PLACE IN GUJARAT has a richer mix of people than here in Dasada," Mujahid Malik, twenty-eight, boasts during a tour of the town's tribal neighborhoods, "or more harmony." Until Independence, the Maliks had ruled in Dasada on the edge of the Little Rann for some seven hundred unbroken years. "The different tribes have totally different clothes, houses, even spoons—different characters, really. From here to the hill Banjiri are living. They are all nervous wrecks. They're

afraid of everything. Afraid of flooding, so they build on high ground. Afraid of earthquakes, so they build with reinforcements. Afraid of their own shadow, so they keep out of the sun. They're praying and singing all the time."

"And Rabaris?" we ask, entering a *ness* (neighborhood) of Rabari houses. Livestock is sauntering back home at the day's dusty end. Mujahid, clearly a familiar, well-liked visitor, clasps forearms with a Rabari, and they exchange the formal greeting that never deviates: "Ram, Ram." Together we enter the compound of the foreman of Mujahid's cotton pickers, jostled by sheep as we pass under a covered gate. Only a thin partition separates the animal pens from the family's own living quarters.

It is common knowledge that the Maliks feel indebted to the Rabaris, who, legend has it, preserved their lineage. About 750 years ago, a party of Maliks, pilgrims on their way from the Sufi tomb in Ajmer to Mecca, camped near Dasada. When one hunter shot an antelope with an arrow, the reigning Hindu king was misinformed that a cow had been killed. The intruders were exterminated, all save one, a baby Malik, whom the Rabaris spirited away and nurtured. In his manhood, the foundling demonstrated such valor in the service of the king that the grateful monarch granted him as much land as he could circle on horseback during twenty-four hours. Today Mujahid's tourist lodge, Rann Riders, stands on a remnant of that ancient land grant.

"The Rabaris are ribald," Mujahid says, liking the sound of it. "Raucous. They don't waste time worrying. And their women are beautiful." To prove his point, he calls a few by name. They come outside confidently, their necks, chest, and arms patterned with tattoos. On their left cheeks, a small cross has been burned into the flesh to ward off the evil eye. "Rabari girls become engaged at the age of four or five—but it can be twenty-five years before they go live with their partner. There's the bride price and the dowry and first everything must be paid in full. Payment is usually in three installments a few years apart, starting from when they're old enough to hold a wedding ceremony. When I was young, a Rabari wedding party would go on for six months—and bankrupt the family. Now it can be gotten over in a day."

A child comes in through the gate talking to the camel she tows on a lead. He wears flowers behind his ears. She and I stare at each other, and I am the first to look away.

"What are the camels for?"

"These people are Rabaris! They keep few camels now, symbolically. The groom rides to his wedding on a camel, and their god, Momai Mata, she rides one, too." Mujahid breaks into a language I had not heard him speak before. He is fluent in seven, all of which he can use in Dasada. A man laughs, spits and chants a verse as he strokes the camel's strong neck. Mujahid translates, "They say a Rabari is still known by the number of *tansali* [bronze bowls] of camel milk he can drink." Older women with typical Rabari black wool veils come to share in the talk.

"Why do the Rabaris wear black?" I ask, and Mujahid passes the question on.

"To mourn the king who defended Rabari women at the cost of his life."

"We have the sheep, and otherwise the black would go to waste!"

"It was Krishna's gift to his chosen people."

*  *  *

MUJAHID DUCKS THROUGH a doorway into a house with me a step behind him. The interior is dark, cool, and neat as a new pin. It takes a moment for my eyes to adjust. Although Rabaris are wanderers, for centuries they have kept homes to return to. These are austere, but decorated with ornate storage cabinets and shelves sculpted from clay and inlaid with mirrors. Sparkling wall designs imitate embroidery stitches: camels, peacocks, and preening parrots adorn the walls. There is a stack of colorful quilts, a number of photographs in hand-carved frames, drinking vessels, pots, and trinkets of prosperity. And, of course, an altar.

Most Rabaris, Mujahid explains, worship the Mother Goddess, but, needless to say, in combination with other deities. Special to the Rabaris are their *pir* (saints). "These are neither Muslim nor Hindu." A cluster of young boys comes barreling through the door. They have a traditional *ghok* (gold ornament) in the center of their ears. With their arms slung around each other's shoulders, they stare at me without bothering to hide their curiosity. One is bold enough to rub the hair on my forearm between his fingers. Mujahid calls a teenage girl who has been hovering near the cooking stones at the far end of the room. (We will not be able to leave without taking some food—the Rabaris are notoriously hospitable.) She comes closer and asks me a question which Mujahid translates as, "What is your *nakh?*" (*Nakh* literally means fingernails.) This is how Rabaris inquire about lineage, a friendly opening to conversation with a stranger.

Another question follows. "Who is your goddess?"

*  *  *

FROM THE MOMENT Mujahid collapsed the jeep's windshield on to the hood and accelerated across the wasteland of the Little Rann straight toward the sinking sun, I lost my heart to the desert. Freedom! Standing among spare tires in the back, with a warm wind sculpting my body, I stared into the emptiness trying to sight a wild ass—the last survivors of the species live here—but not really caring if I see one. This blind plunge into space was more than enough. The drive over from Rann Riders was disastrous. Pot holes, cement factories, crowded taxis blocking the road, advertisements for men's underwear painted on the sides of tea shops in the middle of nowhere, grease pits, rubble, mounds of garbage. Maybe—was I beginning to think Indian?—it all served a Larger Purpose, for the contrast made the austerity of this pure landscape all the more stark. Actually we were racing across the bottom of a sea, bone dry now and cracking, but during the monsoon there would be water, salt water, everywhere and sparsely dotted islands of vegetation.

Because there was nothing between the crust of the earth and the immense, glowing sky, the tiniest object stood out prominently at a great distance. As we approached, a speck grew into a solitary hawk that displayed not the least interest in our noisy earthbound speed. A mound of steaming turds isolated on the desert floor seemed ineffably sad, a solitary beast stopping, voiding, moving on. We scrambled down for a closer look. Shit of a marvelous color, losing heat. "Wild ass," Mujahid confirmed. If I looked into the sun first and then down at the fissures in the earth by my feet, they seemed to fill with blood. As we drove on, Mujahid began to swerve, refusing now to follow a straight course, but steering in wide, sweeping loops.

"Look!" My eyes were playing tricks on me. The horizon was moving, vibrating.

"Rabaris," Mujahid exclaimed and raced with an arrow's single-mindedness in their direction. The wasteland swarms with thousands of animals. Maybe thirty or forty men, women, and children pitch camp. Black and white cows, sheep, goats—there's a kind of ceaseless Brownian movement of livestock. Camels with embroidered blankets, leather saddles, and necklaces lower themselves knee first to the ground. They have brought precious firewood with them. Children tote babies, their chubby legs scissored around one hip. Mujahid has told us about the assimilation of Rabaris in Dasada, how they are adopting urban ways. Indeed, one with a chemical engineering degree is in charge of quality control in a milk factory. But, here, face to face with

the real thing, time simply has stopped. The sunset could be any from the last 750 years. This was all the Rabaris knew, and all they needed to know. They were in their element. The rest of the world was irrelevant. Later, the women would do their embroidery by firelight, whatever few stitches their tired, clever hands could manage, and in the morning they would pack up, break camp, move on.

"They've been making a nuisance of themselves." Mujahid's unexpected outburst brought me crashing back down to earth. For the first time, I asked myself if he didn't look a little garish in his camouflage safari jacket and baseball cap. "Overgrazing, disturbing the ecology of the Little Rann." Am I wrong, or isn't he the one who has been driving a hard bargain now for weeks to land a service station franchise? In the gathering dark, flames leapt up from a fire in camp as if someone had sprinkled it with ghee. Smiling, the Rabaris inched toward us. Suddenly Mujahid switched on his brights, and they retreated a few steps backward. "They don't belong here."

For me, one look at them was sufficient to convince me otherwise.

* * *

MUJAHID DRIVES FAST, heading back to where we had entered the Little Rann. We stayed longer than we had intended. There is no moon. In fact, before long he begins driving recklessly. We careen along, until without warning thorn bushes block our way. Mujahid swerves, accelerates, and then swerves again. Twice he drives into blind alleys of

prickly acacia and has to back out. It seems impossible that anyone could keep his bearings in that vast, blanketing darkness. It's no good looking for our inbound tracks, for in the glare of our headlights tire marks crisscross each other and veer off abruptly in all directions, no one track more traveled than any other.

Just as I am at the point of asking Mujahid if he has any idea where we are, his face lights up. He points to a fire in the distance and gooses the gas pedal through the floor. There are more fires now, spread in a circle. Safe! Relief and disappointment, the combination confuses me. We are maybe two, three hundred yards away when I stand up again, although I had long ago crouched down in back to shelter from the biting cold. Before I know it, I'm shouting, "Rabaris!" like some kind of bloodcur-

dling victory cry. We are back at their camp. I recognize faces. We have driven in a huge circle.

"We're lost!" The pleasure I feel almost tears me apart. To join them, stay here, forsake the world beyond—for an instant it seems totally desirable and altogether within reach. Mujahid, however, has other ideas. With a moan, he brakes and wrenches the steering wheel half a turn to the left. He stalls out, restarts, and snaps the windshield back into place. Soon he has achieved a hazardous speed, craning his neck forward as he hurtles into the eerie, opaque void of the barren salt flats. And all the while, chanting like a gleeful child, my voice sings out in the cold, streaming air: "We're lost, we're lost, we're lost."

# 8

## *after-images*

AFTER ORISSA, I DIDN'T WANT TO TALK ABOUT IT. MY memory wasn't just drawing blanks, it had walked out on strike. To friends I complained that it was like being one of the street cows that forage at large so serenely in India, only instead of cud, what I had to chew over were my experiences. Before I could relive it, our journey so full of discoveries had to settle. Then one freezing winter's night in Amsterdam, I sat and watched a live televised broadcast of the pairs World Championships in figure skating, and the Canadian couple, in contention for gold, came speeding down the rink straight at me, accelerating faster and faster until suddenly the man lifted his partner high over his head with one hand. She spread her arms wide, one leg extended, the other flexed at the knee. Around and around they whirled, spinning in place, while the music, Gershwin, lifted the roof and thousands of spectators clapped rhythmically. Suddenly, improbably, without willing it, I was standing in the hot dust of Baripada again watching the dazed *bhaktis* fly!

We had made our way to Baripada, a small and sleepy provincial capital in the north of Orissa, for the Chhow Dance, a spectacular marathon dance contest that has been the climax of local New Year's festivities now for well over a century. The Chhow Dance pits the northern and southern halves of town against one another. Each team has its own costumes, musicians, choreography, and star soloists, even its own stage. For twenty-four hours, rival troops of dancers some thirty men strong alternate performances, acting out epic accounts of love and war to the music of drums, clarinets, and flutes. One kettle drum that arrived by rickshaw filled the entire back seat. Aggressive sequences alternate with lyrical ones. Certain cadences (*ulfi*) try to capture rhythms from daily life,

such as the grinding of turmeric, a tiger's lapping up water, or the flashy jerks a prawn makes if you expose it to the air.

The Chhow Dance took place in the large, grassy central square of Baripada, recently freshened by drizzle. The public, split into factions, sat or lay on blankets. The leafless, coral-like branches of tall trees surrounding the square were strung with colored lanterns, which resembled giant glowing fruits, red, orange, and gold. Two elevated wooden platforms stood side by side, both with a proscenium arch and curtains near the back, one, North, painted with gaudy peacocks, the other, South, with writhing serpents. In addition to footlights, stage lighting consisted of parallel lines of colored bulbs overhead, which attracted tens of thousands of white moths whose quivering wings were singed by the heat. The moths' compulsive fluttering made palpable how the dancers with their pearl-inlaid helmets, their ankle and wrist bells, spears, and bows and arrows charged the night air with frenzied energy. Sinewy young men in face paint and feminine finery danced the female roles. This is not a matter of propriety, but safety. Women's weaker hearts would burst under the strain of the pounding Chhow rhythm. At midnight, well after the tandem dancing had begun to gather momentum, there was a surprise in store. A torch-lit procession of *bhaktis* arrived. Forty or fifty men with bare chests swept in, mounting the stage platform in their bright red wraps, some venerable with gray topknots, others striplings, all wild-eyed from two weeks of fasting to secure merit. The *bhaktis* are Hindus who believe devotion is enough to bring a man to God. You can pray your own way straight to him without the meddling of intermediaries, i.e., priests. Facing us, the *bhaktis* raised their knees high, stamping in unison on the stage, which shook and thundered as the crowd, on its feet now, every last person, roared itself hoarse. "Tomorrow they will fly," a young man whispered to me. "You must come and see for yourselves."

All my attempts to find out more beforehand about the promised marvel met with profuse, sincere assurances that left me none the wiser. "Yes, truly fly. Like birds." I had heard of holy men walking barefoot over coals or hanging by their heels and swinging upside down through flames, preserved from harm by their ardent faith. But flight, that was a new one. We made sure to get there early. In front of the former royal palace, for years now a dilapidated college whose high front gates are papered with old examination results, workmen were putting the finishing touches to a towering gallowslike wood scaffold mounted by means of a crude ladder. An armature that looked like a giant pump handle dangled from the top of the principal upright, which rose through the center of the platform. Galleries of small shops: barbers, tinsmiths, deep-fry stalls, tailors, and scribes flanked Baripada's broad, unpaved main street. Along its dirt margins an expectant host of spectators had staked out the best vantage points, while a good many others peered down from behind the shops' crenelated rooftops. Children skittered about with whizzing noisemakers and taut balloons bobbing on strings. The sun seemed to vaporize the very dust.

I was trying to drown myself in the sweet, thin milk of a green coconut when drums and horns at both far ends of the street heralded the arrival of the *bhaktis*. On they came, their red cloths vibrant by day, long chains of white flowers gleaming against their sweat-drenched chests, bare feet shuffling in a dance that raised puff after puff of dust. The men in front swallowed ghee and spat it out in a spray that they ignited with torches. The *bhaktis* massed around the scaffold, their dark eyes shining and fixed on the vault of the sky. "Fly!" they began to cry, and as the crowd took up the chant, the youngest *bhakti*, no more than four, began to howl from pure terror.

One of the most senior *bhaktis* suddenly scampered up the rungs of the ladder, spry as you please, and a barrel-chested, lowering monster of a fellow with a wild thicket of black beard followed him up, heavily. If *he* could fly, who couldn't? My first reaction to what happened next was a smug, knowing shake of the head. Another highly touted miracle was sputtering out in a hoax, one more promise of a wonder was proving hollow. Using red cloth, two men strapped the excited *bhaktis*, who climbed onto the platform to the far end of the armature. These then in turn sprang into space with a wild yell, propelled by the main body of *bhaktis* on the ground, who clenched thick ropes as they ran clamoring in a circle around the scaffold. Airborne, each who flew cut a swift orbit overhead, kicking, screaming, flapping, or swimming, with his arms and wrenching with both hands at his flower necklace until petals showered down

on the cheering, upturned faces below, bringing them luck. (Inversely, ice-skating fans from their balcony seats hurled bouquets down onto the dancing pairs.) The longer I watched, the more my ironic reserve melted. From somewhere deep inside me I began to see the spinning world through the eyes of the death-defying, aeronautical *bhakti* who spent almost their whole lives with both feet on the ground. "Fly," my lips formed the word. And when an hysterical child launched in the arms of his father tore fistfuls of flowers from his garland and flung them wide, I cheered. As he regained his footing on the platform, our eyes met and he flashed a smile that had wings.

\* \* \*

AS SOON AS THE CORK that plugged my memory popped under the pressure of unexpected visual analogy, images bottled up since returning from Orissa overflowed. My mind, for example, filled with sights, sounds, and smells from the rites we had seen enacted in honor of Lurni, the earth goddess of Chantikoma. Chantikoma is the leading market of the Dongria Kondh, one of several Dravidian tribal groups in Orissa's rugged, barely accessible eastern ghats. Indeed, hundreds of tribes survive in India who predate the arrival of the Aryans to the subcontinent. Many continue to live in the same primitive circumstances that their distant ancestors knew, even though cities and modern lifestyles have begun to swallow up their sons and daughters. For much of the twentieth century, Christian

missionaries courted converts with material, as well as spiritual incentives, in competition with the government that promised "pagans" who fell outside the caste system similar rewards if they chose to become Hindus. In a recent reversal of policy, India nowadays encourages its original indigenous populations to retain as much of their cultural and religious identities as possible. With some ambivalence, the authorities incline to shield tribes from outside influences, including foreign tourism.

The Dongria Khondh, who are of Proto-Australoid stock, are animists and slash-and-burn agriculturists. Lurni, an ancestor of the widely disseminated Vaishnite cult of Jagganath with its hearth in Puri, grants her followers fertility if they sprinkle the earth with blood at the beginning of the crop cycle. This blood, drained from humans until British intercession early in the 1900s, is supplied at present by animal sacrifice. The ceremony we witnessed took place in and around a village that was an easy walk from Chantikoma market. From here twice daily you can see the Madras Express pass along the horizon, while to the west listless wisps of smoke rise from primeval land-clearing methods used to denude the hump-backed hills of all shrubs and trees with inedible foliage. The strident music of Lurni's instrumental escort of drum, fiddle, and flute reached my ears at about the same moment I first caught sight of her mammoth, lurid yellow papier-mâché head trundling along beneath the jackfruit trees that stood like sentinels in rows on the outskirts of the small, densely populated settlement.

As Lurni advanced in fits and starts along the dirt footpath, her multiple arms spread wide, old saris were constantly unfurled and laid in front of her, for the goddess's feet may not touch the bare ground. She stood fifteen feet high, crowned with palm fronds, her body assembled from bamboo slats draped with leaves and flowers to which new bolts of cloth were pinned by women seeking her blessing. People tacked paper money to her bosom as well, donations for the priest. Lurni's animation was provided by a man strapped into a harness inside her. Droves of Kondhs with characteristic nose rings and earrings, plastic combs, or cigars stuck jauntily in their wiry hair behind one ear, and with a home-woven shawl flung over one shoulder, had come down to Chantikoma to celebrate. For some, the journey of a few miles from their homes also carried them forward in time a thousand years, from what was in many respects still a Stone Age society to a world launched irreversibly on the transition to modernity. Assimilated locals in silks and glass bangles were out in force, too. Tight clusters of girls with their arms around each other's waists danced in chorus lines of four or five as they sang challenges to the boys, who in imitation linked arms and flirted back. As Lurni completed her ritual circuit of the village, women pressed forward to welcome her, handing over a chicken or a dove in a basket of woven grass to the wiry priest wrapped in red who knelt down before her. The trembling birds would be allowed a quick peck or two at maize kernels mixed with ash on a tray before the priest deftly snapped off their heads,

which he tossed into a basket piled high with scores of others. Vessels were filled with blood to fertilize the land. Blood also drenched Lurni's hem and stained it red. From time to time, the music would stop to give the drummer a chance to pass his instrument through a hastily lit fire to tauten its membrane. Villagers crouched to trace mystical matrixes in the earth with rice powder. From Lurni's exaggerated, frozen grin and the scope of her attributed powers, we concluded she was an avatar of the dreaded Kali.

Once Lurni had returned to the point of her departure at dead center of the village, the tempo of the music accelerated and the musicians began to dance as they played. On both sides of the low entrance to a thatched hut, a black kid stood pegged, wreathed in flowers. The tender green shoots that the young goats chewed greedily twitched between their teeth. Here the priest and his attendants dismantled the goddess, stripping away layers of veils as she turned in place. Yet it was more a dismemberment than a striptease, and it only ended when all that remained was a man in a loincloth holding up Lurni's bulging head on the end of a pole. He had danced himself into a fit, his thin limbs empowered, lips foaming, gaze inward. His flying feet scarcely touched the ground as he turned, and Lurni's head wobbled beyond reach overhead, her long red foil tongue fully extended, catching the light. Finally the human top faltered, stumbled, and collapsed in the arms of the excited crowd. Men laid him out in the dust, to all appearance lifeless, and backed away.

The priest seized Lurni's massive head and wrenched it off the tip of the pole, lifting it once triumphantly above his head before he disappeared with it into the windowless hut.

On all sides of me now people were dancing, raising gourds to their lips and guzzling wine tapped from sago palms in the hills. Then suddenly the black goats were lifted off the ground by their hind feet and beheaded with an ax less sharp than it should have been and an aim less true. It is one thing to read or hear about animal sacrifice, another to be there. Everything blurred around the edges, and closing my eyes only made it worse. I found myself recalling the story of a Dongria Kondh headman who ten days back had walked into the local police station with the head of his oldest son tucked under his arm. When the father confessed to cutting it off in a blind rage, the duty officer responded skeptically. To settle the question of whether he was telling the truth or not, the man pulled out his bush knife and with a single swift stroke decapitated his second son, who was standing right beside him.

Hands started prodding and shaking me. Hedged in by the growing crowd, I felt my discomfort increasing by the minute. The Kondh, I thought, must have begun to resent my being there as an intrusion. Then a smiling prune of a face mere inches from mine jabbered at me rapidly, incomprehensibly, and a second dwarfish figure who was puffing on a cigar pressed a wedge of coconut meat into my hand and nudged me—shoes off first!—to enter the ceremonial hut.

I had never before seen so many candles burning in such a small space, hundreds of them, all white, mostly fixed to the ground in a hardened clump of wax. In a sweet cloud of incense Lurni's grotesque, commanding visage presided over an altar of several tiers encircled by gory goats' heads in nests of leaves and fruit. The priest in red crouched in the corner farthest from me and urged me with gestures to add my coconut to the offerings. The silence inside the hut was absolute, and I felt utterly and entirely remote from anything I had ever known before. To make the moment last, I held my breath and floated free in the flickering lambency of the self-consuming altar lights.

* * *

THE CALM OF MY final audience with the detached head of the pop-eyed goddess Lurni was matched soon afterward on a very different but no less impressive occasion, among a neighboring hill tribe where I was introduced to the healing magic of the icons of the Saora. The Saora village of Rungrungwah lies in the far western reaches of Orissa, about an hour's trek from any track a motorized vehicle might negotiate. A few dozen thatched houses huddle around a clearing where buffalo and pigs wallow and scrawny chickens scratch the soil. Slabs of stone that lean like dominoes against a venerable tree trunk keep tabs of deaths. From afar the village appears to float on top of rising terraces of paddy, the young shoots an electric green. The woods behind are anemic, thinned for today's use as if there were no tomorrow. Red clay Saora houses have

porches with built-in "furniture," chairs and beds modeled out of the same material as the thick walls. A traditional tribal leader, a kind of sorcerer, is known in Oriya, the language of Orissa, as a *viju*. *Littal* is the name of the murals with stick figures that a *viju* chalks on the inside walls of his hut, depicting the scenes he uses to effect his cures.

Entering Rungrungwah, we came upon two men crouched over a threshing floor where a large, round piece of flayed buffalo hide had been spread out on a bed of green leaves. Naked except for a scrap of cloth, they were engrossed in their task: while one kept the hide moist, sprinkling it with water from a calabash, the other, starting at the center and moving out, used a small knife to cut a perfect spiral. His steady hand produced a thin strip of leather of uniform width some twenty-five yards long, which he would later braid with similar thongs to make a strong rope for lashing his team of buffalo to the plow. The older of the two men, the one who did the cutting, turned out to be the village *viju*. This was a surprise, for male *vijus* are uncommon, a late spin-off of missionary prose-lytizing among the Saora. The coming of the white fathers was the first time that the tribe experienced men acting as religious func-tionaries, and consequently Saora females lost their monopoly hold on spiritual offices.

When I asked the *viju* if he would show us his *littal,* he struck out with enormous strides to lead us uphill to his place, with a tight-lipped smile that I found disconcerting. We passed under a thick stand of kajunga trees

that roared at us: swarms of bees pillaging their white blossoms. To fit through the opening into his hut, the *viju* had to bend double. The doorway gave directly on to a narrow cooking area with a clay oven built into the wall and a handful of charred clay cooking vessels and wooden utensils worn smooth from use. And there on the wall was the icon, its white lines nearly shimmering in the gloom. Two adjoining tablets had been sketched, four-and-a-half-feet tall, two-and-a-half-feet wide, both rounded at the top and divided into bands by parallel lines some ten inches apart. The bands were peopled with stick figures performing all the principal daily activities of Saora life: farming, fighting, dancing, cooking. Beyond the boundaries of the twin tablets, a number of more elaborately executed figures adorned the dark wall: a deadly krait, a chameleon ("remedies against some poisons"), a figure on a bicycle, a propeller plane ("if the goddess is needed in a hurry"). The icon as a whole was powerful, rhythmic, and integrated. The *viju* had applied the rice paste paint with a twig that he had chewed into bristles at one end. The same steady hand had been at work that I had just watched cut the buffalo hide in a spiral.

The *viju* told us that it was a witch he had met in the woods who had taught him to paint and to heal people with his paintings. You name it, he cured it. When someone came to him feeling bad, he had the patient sit under the icon. Next he would go into a self-induced trance, and, acting as a channel for spirits, he would identify the ancestor behind the illness and determine how to placate its discontent, with a rooster, a goat, or even, if the situation was critical, with a bullock. "There you see the goddess, Kudamgoei, our protector." With his long-stem, fragrant clay pipe, the *viju* pointed at three figures who had joined hands in the top arches of the tablets and looked as if they were skipping in place. The tripartite Kudamgoei was no different in proportion, however, no richer in detail than the human stick figures rendered below. A highly democratic magic image!

Before we left him, the *viju* took down a stringed instrument from a peg on the wall and sang a hymn for us. The collector's deep-seated greed got the better of me, but I'm happy to say the *viju* turned down the small fortune I tempted him with, saying that if he parted with his instrument he would feel terribly lonely.

\* \* \*

BACK ONCE AGAIN in Amsterdam, I get an eyeful of technique, style, fashion everywhere I look. Dutch song, dance, art—triumphs of professionalism. Surfaces are polished, seams invisible. Orissan performances are, by comparison, crude and awkward. The endurance test of the Chhow Dance, the conniving *bhakti*, the lurching god-doll Lurni, the scenes painted in swift, white strokes on the mud walls of the *viju*'s smoke-stained kitchen. Amateurs all! And still, what they share, something missing on the home front, is what finally makes them so compelling: the belief of the participants in the immanence of gods ready and willing to implicate themselves in human lives.

# 9

## *the body perishable*

ONCE SEVEN SEPARATE ISLANDS, MUMBAI, FORMERLY
Bombay, now stretches like a grasping hand into the Arabian Sea. On his way to
Sri Lanka to free Sita, his captive queen, Rama halted with his men at the tip of
the peninsula's opposed thumb. Lush jungle then, Malabar Hill today is a jumble
of cavernous Parsi mansions badly in need of maintenance and of concrete-and-
glass modern high-rise eyesores. To relieve his forces, who were tired and thirsty,
Rama shot an arrow into the ground, and fresh water gushed forth. At this

very same spot tonight, at Banganga Tank,
Hariprasad Chaurasia (flute) and Kishori
Amonkar (voice) are giving a benefit concert to
fight cancer, "the enemy within." The megastars
sit on a float encircled by lamps that drift and
collide on the dark water. The public is distract-
ingly elegant. Countless beautiful women in
splendid silk saris sit on red carpets that
mask the tank's crumbling stone steps. As is
customary in India, flowers are presented to
the performers *before* they begin. A diamond
flashes on the master's hand as his fingers
complete acrobatic turns on his flute that no
one else dares hazard. La Amonkar's peerless
voice flutters and growls at us across the tank.

After nearly every phrase, she clears her
throat of vines of phlegm. Ragas, according
to a program note, have "proven" effective
in reducing hypertension, and they show an
"immense prowess" as a "de-addiction agent"
as well. Yet to sing certain very high notes
was until not so long ago prohibited by law,
forbidden because the sound could inflict pain,
could even cost the lives of those within
hearing range. Earlier in the day, moreover,
one of Chaurasia's students described to us
how the classical raga rhythmically reenacts
sexual desire. The fastest segment, the *drut,*
renders the climax of sexual intercourse, "small
death," with a sheer joy "transcending the bodies

of the partners, filling the whole universe with sparks of lightning and thunder, finally dissolving in a flood of rain water." More relief for the parched! "Wah, wah," knowing members of the audience gasp after virtuoso passages. Five hours of music pass in next to no time.

* * *

THEY HAVE RIPPED open Falkland Road to repair the sewers, but the stench and slime underfoot have hardly thinned the traffic of men shopping for whores. The girls (few of whom look old enough to be called anything else) pack doorways and hang out of second-story windows, some sassy, some bored, some plainly spaced-out. Shiny fabrics, costume jewelry, too much lipstick and rouge. We are at a far remove from Banganga Tank! Many who turn tricks here are kidnapped from Nepal. For even more from villages along the Karnataka-Maharastra border, the road to the brothel leads first through the temple. Matted hair, boils on the scalp, lice —on a girl of four these are signs the goddess Yellamma is calling her. Should a child recover from an illness after her parents have prayed to Yellamma, her fate is sealed as a temple prostitute (*devidasi*). Sated priests, it is widely alleged, later auction these minions to Falkland Road whoremongers. Halfway down the notorious block, three bright red and blue pony carriages, looking like props straight out of a fairy tale, await repairs. Women tattoo artists, most of whose clients choose to have religious symbols burned into their skin, squat in the gutter.

A few of those lolling in doorways stand out because of their broad shoulders, the shadow of a beard, and their large hands and feet. As we pass they cock a hip, call out in deep voices, or fling the hair provocatively out of their eyes. These are *hijra*, neither man nor woman, assumed to be eunuchs although it is estimated that a third of the five thousand who live in Mumbai are not castrated. All over India *hijra* dance and sing at births and funerals, turning up without fail, uninvited, diverting any malevolence streaming from an evil eye that might otherwise harm the newborn. If you refuse to give the money and the dresses that they demand as their fee for the ribald lightning-rod service they provide, they will not shrink from lifting their skirts, cursing your household, or, worse yet, revealing who among the men in the family can't get it up. (A Hindu woman's marriage vows include her swearing that she will not mock her husband for being either poor or impotent. When Viagra hit the streets of Mumbai, it vied with India's nuclear tests for page one headlines. Erection reinforcement pills cost the earth on the black market.)

Muslim eunuchs, who came in the train of triumphant Mogul invaders to India, were highly prized slaves who were frequently entrusted with preventing penetration of their master's harem. Nowadays the *hijra* manage brothels, tough enough to hold their own in the Mumbai underworld of commercial sex controlled by organized crime.

Four cinemas operate right on Falkland Road, several more in the vicinity. And they all do a brisk business with shows at 12, 3, 6,

and 9 o'clock. A film, a drink, and then sex—that is the standard pattern of single, lower-caste, urban male recreation. At the Regal today, *Soldier* is playing, and lurid posters everywhere mix promises of patriotic gore and romance in large doses. As the crowd for the first show mills about in the courtyard in front of the theater, a short, chubby fellow with a hand microphone and amplifier boxes launches into impersonations of Bollywood film idols. Once he has captured the attention of his listeners, he changes his act. Holding up a condom for all to see, he unpacks it and pulls it down over his ring and index fingers, the whole time delivering a steady patter of information about STDs (sexually transmitted diseases), highlighting the HIV virus. Men and boys accept the folders that the mimic hands out, but, wary of gossip, they pass up the free prophylactics. "The Vedas tell us only one woman is our wife, all women our sisters and mothers. But now Bollywood's gone and changed all that." The sex educator has four more theaters to visit today. "Thanks to the silver screen, men imagine every woman is their girlfriend." Packing up, he confides, "We are few and the AIDS epidemic is claiming so many. Our work is like a drop of water in the ocean." Immediately, he corrects himself, "No, like a drop of water in the desert, for what we do does make some small difference."

* * *

AT THE HEIGHT of the evening rush hour in Churchgate Station, I spot a slogan beside the tracks—"Many positions with one partner are better than one with many"—courtesy of the Kama Sutra condom campaign to prevent the spread of HIV. The swollen crowd propels me willy-nilly toward an arriving train. The air, torrid outside, is even hotter here. I have no control over my body. Kicking myself for the folly of insisting that I experience this mad crush for myself, I spy a nearly empty carriage and manage to heave myself into it, but staccato handclaps soon shatter my mood of self-congratulation. The rapid clapping of large hands is the *hijra's* trademark. This particular eunuch, dressed to kill, resembles a bulldog in a lace veil. She's working the ladies' compartments of the commuter trains. As she gruffly shoos me back outside, women hand her money.

Somehow I squeeze into a men's carriage and stand with both arms pinned to my sides. Everyone is looking at me, but they avoid my eyes when I try to catch them at it. As we pull out, I find myself thinking of the three little girls we had come across recently in a desert village in Gujarat. Beauties, only five years old, but sirens with thick manes of jet black hair and come-hither eyes. Except, we were asked to believe, the three of them were not girls. "Come on, we have eyes!" The father of one, laughing at my disbelief, seized my wrist and shoved my hand between the children's legs. One, two, three. Boys. Their clothing should have clued us in, really: tatty trousers and shirts instead of long, bright skirts and blouses flashing with sewn-in mirrors. They were laughing, too. Presently, after a priest

had shaved their skulls in a *rite de passage,* they would be unmistakably male. "To mislead the evil spirits," Iman guessed about the function of delaying the first haircut. "No one's going to be half as jealous of another's daughters as of his sons."

Then again I often have more than a little difficulty telling the sex of a Hindu god at first glance. Full-melon breasts are a dead giveaway (burnished, if within reach, by centuries of impudent fingers unable to resist fondling them), but the gods are a beardless crew, with long tresses, pouting lips, and a tendency to be roly-poly. This same hermaphroditic plumpness is characteristic of male Indian movie stars, and when, to increase their sex appeal to the Indian eye, Western actors are blown up on billboards, added pounds make them hardly recognizable to their fans back home. The *Koka Shastra,* a medieval sex manual, sorts men by the size of their penis into three physical types: hares, bullocks, and stallions. None, though, are described as lean; all rather are fleshy, with round faces and stout necks. And male gods do not hesitate to wear revealing garments and to encrust themselves with jewelry. Indeed, my first encounter with Shiva Ardanarisva—half him, half her, one full female mammary, one male, one woman's earring, one man's—reassured me that the sexual twilight zone wasn't all in the eye of this beholder! The divine androgyne split right down the middle, a common image in stone, on calendars and postcards, is the form that Shiva assumed to instill fear back in the heart of the upstart demon to whom Vishnu

had too quickly granted the boon that he could be killed neither by man nor by woman. Then there are the arresting statues of the fish-eyed Menakshee in her temple in Madurai (Tamil Nadu) where she displays three breasts. At her birth, the king, her father, was assured that one breast would disappear when she came face to face with her true husband. When Lord Shiva stood before her, it vanished. Until that moment the king, who had wanted a son, had dressed and raised her as a boy.

The station on my train ticket and two more come and go without my being able to worm my way free and get off. Caught in the tight web of flesh, however, I begin to feel connected. The others sardined with me, all with black hair, skin tones from fair to blue-black, dressed in long-sleeve white shirts and dark striped ties, have just logged another day at the office. What are those impassive faces running with sweat thinking about? Something cold to drink, no doubt. Or have they simply emptied their minds? Some of the pressure of bodies against mine is so insistent, that it is, I suspect, opportunistic.

From Menakshee's retractable breast, my mind skips by association to the deified martyr Bahuchara. How, when the earliest inhabitants of Mumbai were plundering her village, she seized the sword of one Koli attacker and sliced off her breasts, handing them to him to save her honor. Few of the middle-class commuters around me, I suppose, know her story, although in the whole of India some say there may be a million *hijra* and surely *they* know it backward and forward. In Gujarat

*hijra* trace their origin to the childless king of Chipaner, who went on pestering the goddess Bahuchara with his prayers until she gave him a son, Jero. When poor Jero proved impotent, Bahuchara came to him in a dream and told him to cut off his manhood and dress as a woman, which he did and lived happily ever after.

Forty miles northwest of Ahmedabad in Gujarat, Bahuchara's temple, all pink and apricot and robin's-egg blue, is dedicated to sexual abstinence, impotency, and mutilation. On the Sunday of our visit, there was a lot happening. Two families from Rajasthan were celebrating fire ceremonies. Next to a tank, priests were shaving the heads of a cohort of naked boys and dousing them with buckets of water before painting their denuded crowns with swastikas, symbols of the sun. Close by, a walleyed sword swallower who had painted his body blue drew admiring stares. And a formidable quartet of aging *hijra* stalked the parents of infants, cadging money, outbursts of their harsh, admonitory clapping audible above the day's muted murmur. When I asked the *mohunt* (head priest) about the history of the temple, I was relishing how surprised he was going to be by how much I already knew. He led me to a gallery where a series of large murals narrated a story very different from Jero's. Two kings, close friends, agreed to marry their firstborns to each other. After one queen was delivered of a daughter, the second followed suit. She, however, half-dead with anxiety, passed her baby off as a boy. At the age of four, the "prince" sent a sword

to the princess to confirm their betrothal. Years passed and the sham continued until the children were old enough to consummate their marriage. The prince, with pounding heart, rode off manfully to claim his bride. On his way he dismounted beside the lake that once had occupied the site of the present temple and prayed to Bahuchara for help. His mount, a mare, strayed into the lake and emerged a stallion. In went the trembling young woman, and out came a strapping young man. Rather an odd founding story for a temple that until 1900 specialized in the castration of the divinity's devotees in a procedure "not uncommonly fatal". First the operator used the knife, and then spat betel nut and leaf juice on the wound, and, for good measure, sprinkled on a handful of acacia ashes.

* * *

ON THE WEEKEND the lifestyle supplements of the Mumbai papers dish up more of the usual slick gibberish. In the *Times* the lead story is "Bi, Bi, Love—Is Bisexuality an Emerging Trend? Has liberation redefined sexuality? Or is it just too staid to be straight?" The acronym BUG appears, new to me, campus slang for "bisexual until graduation." Another tidbit of media fodder, "Gym & Mary," reports that "more and more couples are now discovering each other over a good sweat. Meeting up for cardio rather than a cappuchino coffee is very today." One of the world's least surprising statistics leaps out from a *Hindustan Times* story called "Fighting Fat" ("As obesity gains proportions, upwardly mobile India is

trying out every weapon in its battle against the bulge: liposuction, tummy trimmers, corsets and belts"): a study by the Nutrition Foundation of India showed 50 percent of all high-income females and 32.2 percent of males were overweight compared to only 4 and 1 percent of the poor in slums. You don't say! By the year 2010, India anticipates having a caseload of 25 million diabetes patients. "Bottom of the Problem" describes how "cellulite played foul in this year's Miss India contest, causing many disqualifications." In this very same city just one day before I had sat in on an AIDS counseling session on Falkland Road at which social workers with plastic flip charts were teachig CSWs (commercial sex workers) how their sex organs worked. Curious that—how the poor admire fat and worship gods and movie idols for the bulk they hope never to acquire, while the compulsive consumers of the middle classes begin to despise the spare tires and corporations that are the identifying badge of their prosperity.

How, don't you wonder, would Bahucharia go about picking up Mr. Fitness at the gym?

\* \* \*

AT CHOWPATTY BEACH the bodies come in all shapes and sizes. The scene is brisk and colorful, but there is an undercurrent of decay. The beach occupies the northwestern end of the smart stretch of Art Deco residences along Mumbai's Back Bay, dubbed the Queen's Necklace early last century because of the glittering arc of iron street lamps that by night trace the curve of the shoreline drive. A sandy beach, three hundred yards long by thirty deep, it is empty at midday but teems with bodies once the heat of day starts to break. Gandhis and Buddhas and all gradations in between. When a breeze stirs to life, chunky ponies with screaming children in the saddle canter among families who sit to picnic or feast on the favorite local confection, the oversweet *bel puri,* purchased from one of a double row of glass kiosks. Young couples push each other on swings, throw darts at balloons, ride in hand-cranked, overloaded mini-Ferris wheels, or pause to watch a man with a bright red beard perform magic tricks with a water pitcher that never runs dry. (He should sell his secret to the city council where water-rationing is chronic, and a politically volatile issue.) Ankle deep in listless surf rank with sewage, pigeon-chested boys in baggy under-pants seek relief from the blowtorch air. They clamber onto each others' backs while onlookers—keeping a hand pressed to their wallet pocket if they know what's good for them—egg them on. In the morning I see the skinny acrobats again, for a photo of their rickety human pyramid is splashed across the paper's front page. They look even frailer in the picture. Very perishable. There is, more-over, a banner legible in the background that I had missed the first time around: Support Polio Vaccination.

\* \* \*

ABOVE MIDTOWN MUMBAI, bill-boards advertising Web sites that offer a keyhole to another world fight for air. Directly oppo-

site the swanky city racecourse, a curved cement causeway juts out into the choppy Arabian Sea, joining the mainland to the tomb of Haji Ali, a saint who left instructions to set his corpse afloat and to build a shrine at whatever place it washed ashore. His remains, however, quickly snagged on a cluster of offshore rocks that high tides sever from the city. At low tide, vendors claim the far side of the access road as theirs, hawking souvenir photos of the tomb on glass that lights up from behind, a menagerie of Chinese lead-painted wind-up toys, fly whisks, and sticky snacks. The inner edge of the causeway is the turf of beggars of every description. Many improvise parasols from black umbrellas and weighted tin cans to provide them with a shifting patch of shade. On Friday, alms day, the beggars strike me as methodical and deliberate, in their preparations for the crowd of visitors that will soon arrive, some mopping up last bits of boiled rice from tin plates, others rewinding a turban, plucking out a chin hair between two coins, rubbing their necks with scented oil. Before setting out, I emptied the amenities basket in my hotel bathroom-of-many-mirrors, and now, on the way to pay my respects to Haji Ali, for as long as it lasts, I give the loot away: ear swabs, a loofah, an emery board, pine-scented soap, ayurvedic crabapple shampoo, watercress hair conditioner, apricot skin moisturizer. (Good for curing scalp and skin infections, the labels say. Shades of Yellamma?)

On my way back from the gleaming white marble tomb (where lovers sneak off to the jumble of rocks behind the shrine to steal a caress), as I approach the halfway point, up ahead I hear singing, haunting harmonies. On a square sheet of black plastic, its corners held down by rocks, four men lie in a circle, head to foot, each deformed or crippled in his own way. Elephantiasis, blindness, leprosy— and the lead singer has scabby, flipperlike stumps for arms. In immaculate, embroidered prayer caps, they lie on their sides, facing in, and sing, so hard, so reverently, that their wreath of bodies bounces on the pavement. "Wah, wah," says a voice inside me. And somehow, as their voices trail off behind me and I regain the mainland, the encounter is uplifting.

OPPOSITE: *Women preparing food in the courtyard of a desert village outside Jaisalmer, Rajasthan*

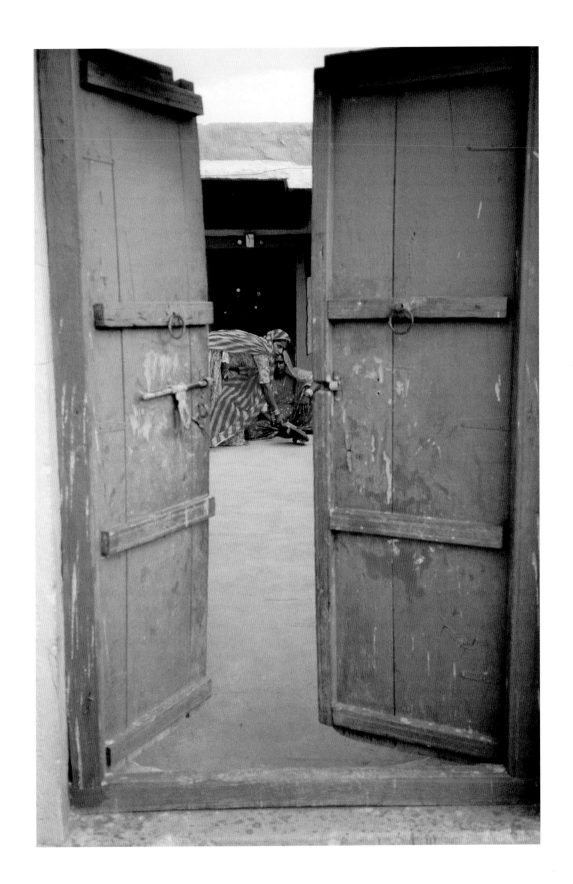

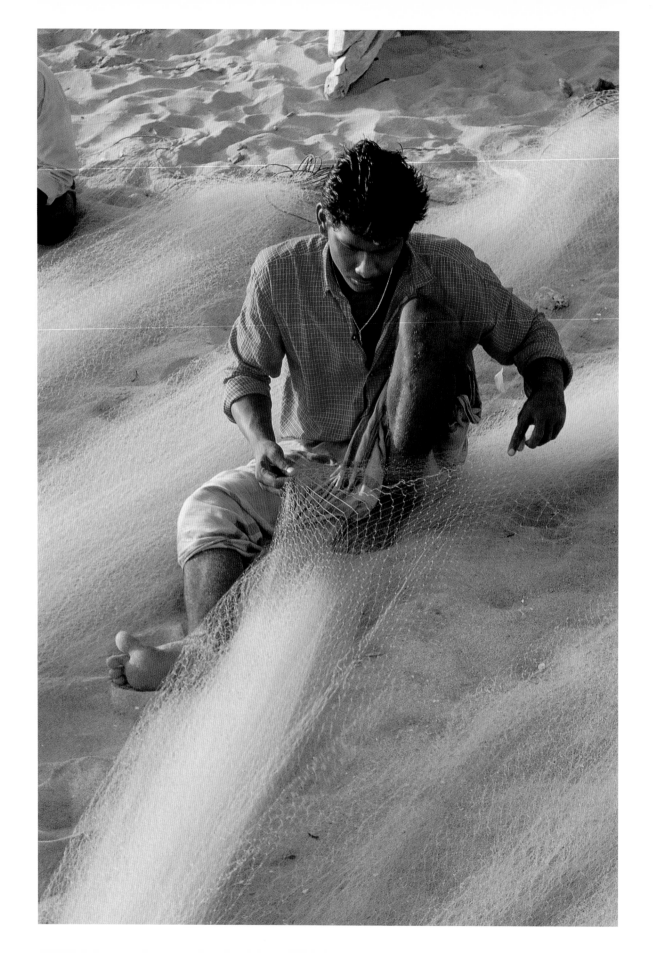

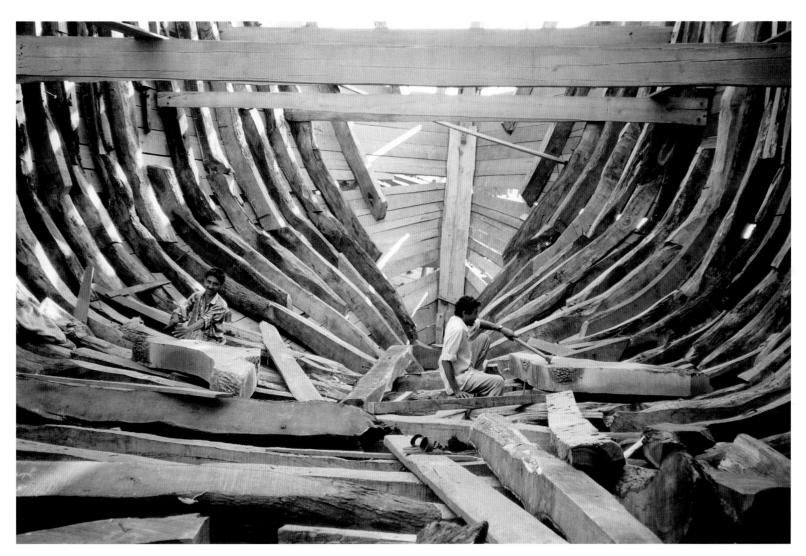

*Shipbuilders repair the hull of a dhow, a single-masted, 800-ton Portuguese sailboat. Now a sleepy town, Mandvi was a bustling port in the eighteenth century, linked by a fleet of four hundred dhows with not only with Africa's east coast, but also with faraway China and Japan.*

OPPOSITE: *A fisherman mends his net in Konarak, Orissa.*

185

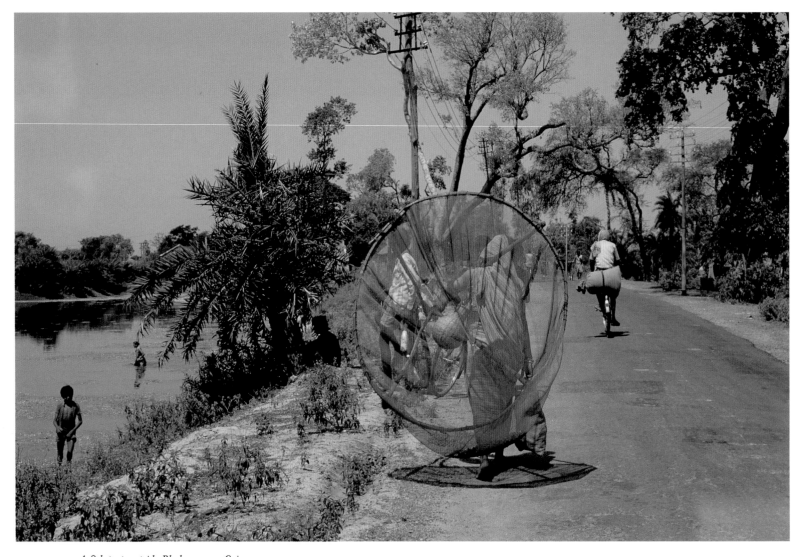

*A fish trap outside Bhubaneswar, Orissa*

OPPOSITE: *A sailboat in the Bay of Bengal near the mouth of the Hoogly River, West Bengal*

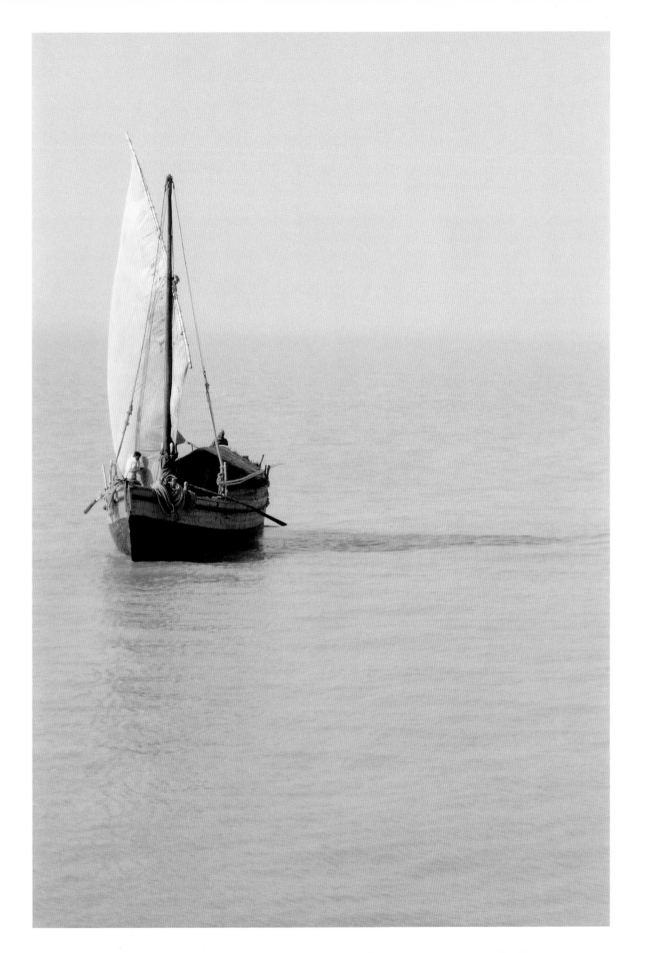

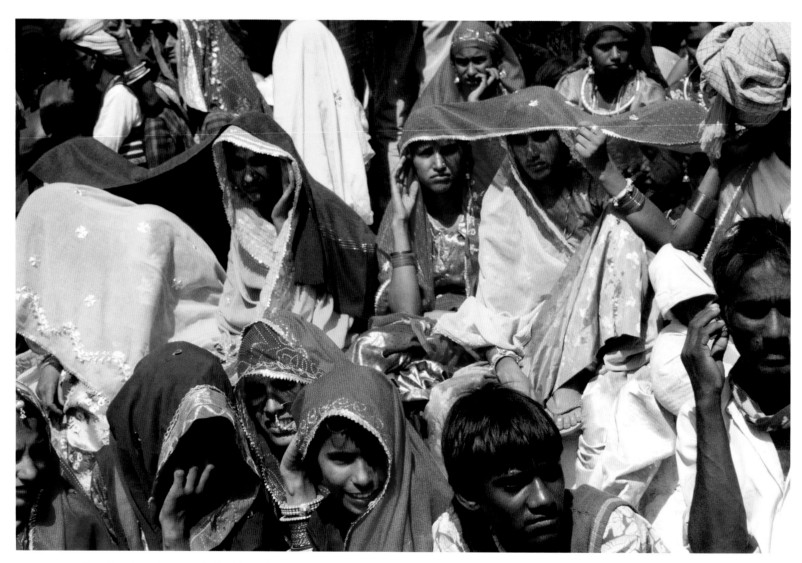

*Spectators at camel races in the Pushkar stadium*

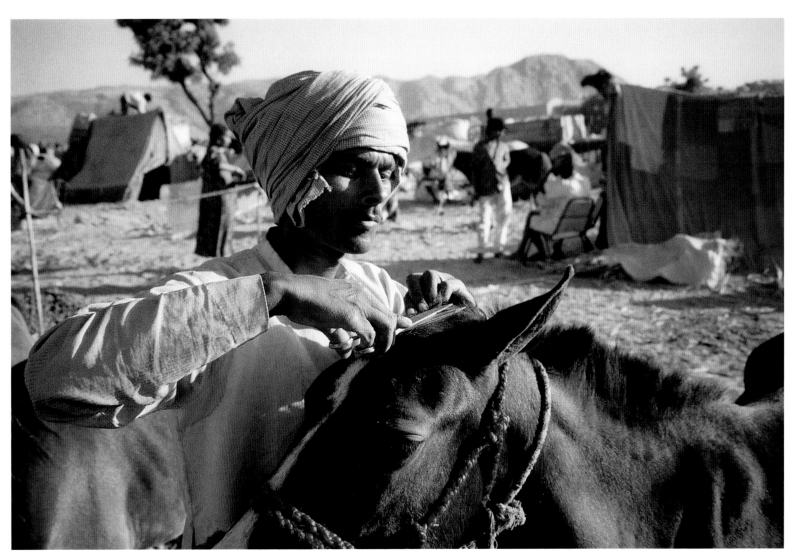

*An owner trims a horse's mane before selling him, Pushkar Mela.*

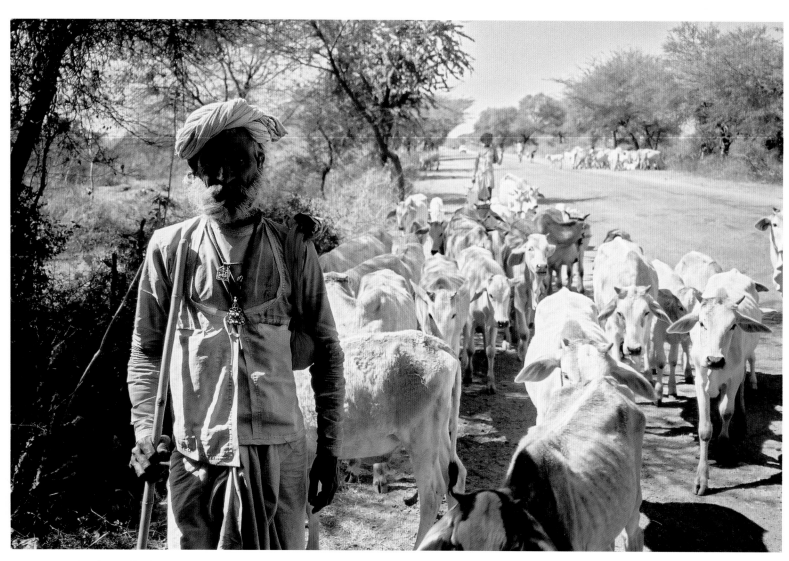

*A Rabari with calves on the main road from Poshina to Ahmedabad*

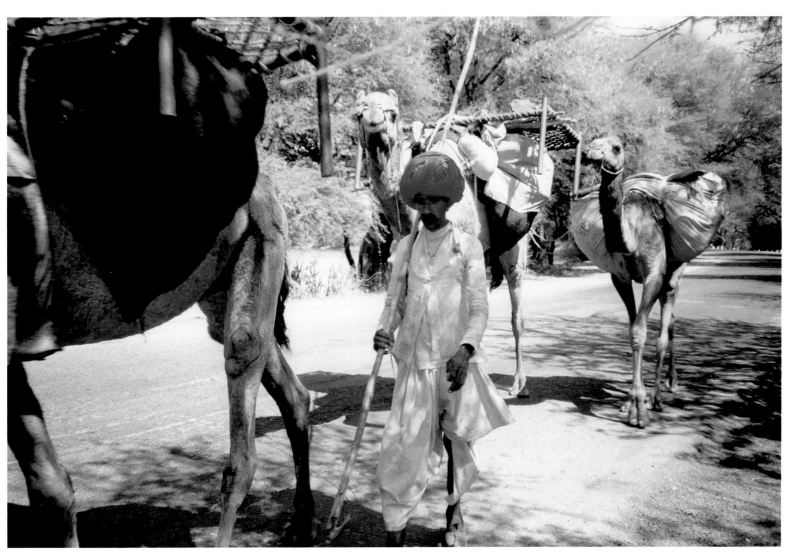

*Rabari nomads and camels on the main road from Poshina to Ahmedabad.*
*The vanguard of many family members to follow, each successive cluster*
*drives a different kind of livestock: camels, cattle, sheep, donkeys, calves.*

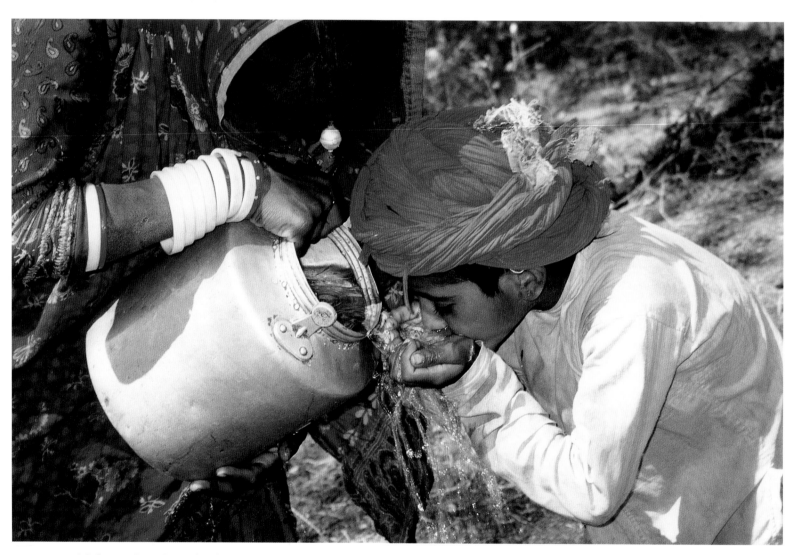

*A Rabari on the road, quenching his thirst, Gujarat*

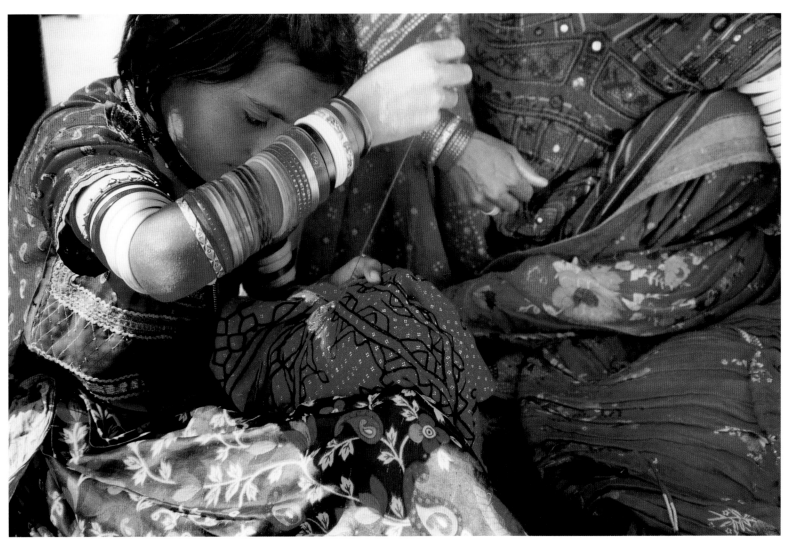

*A Rabari girl embroidering in a Kutch village in Gujarat. We know the history
of this nomadic people only through the dispersal of their embroidery and clothing,
and changes in their design.*

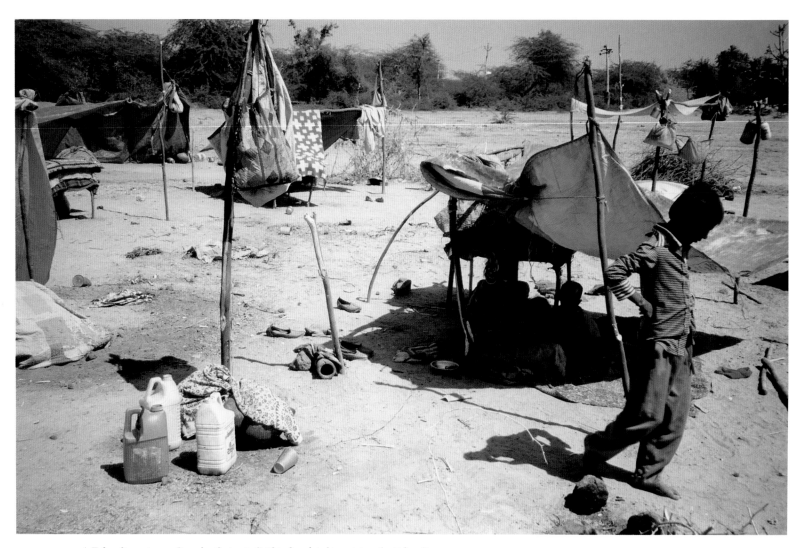

*A Fulwadi camp near Dasada, Gujarat. Said to be related to gypsies, the Fulwadis are itinerant poachers, snake charmers, magicians, and the owners of whippet-like hunting dogs.*

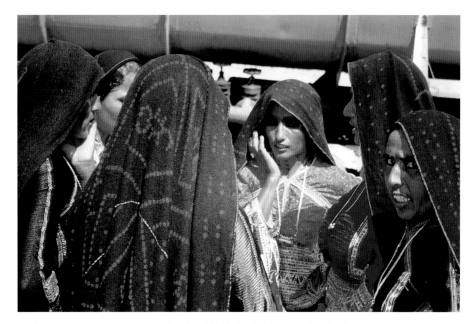

*Rabari women in characteristic embroidered black headcloths serenade a bride's family, Midialo, Gujarat*

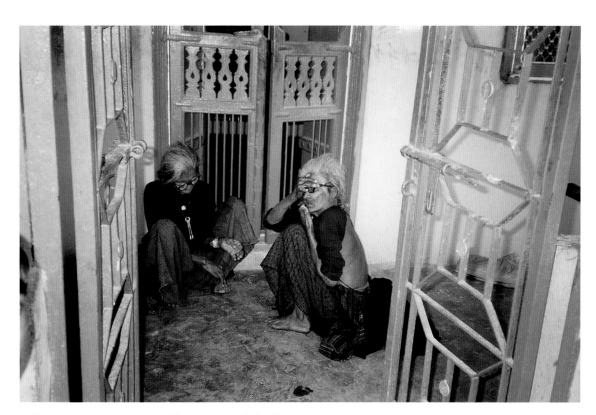

*Old Rabari women in traditional black blouses, Midialo, Gujarat*

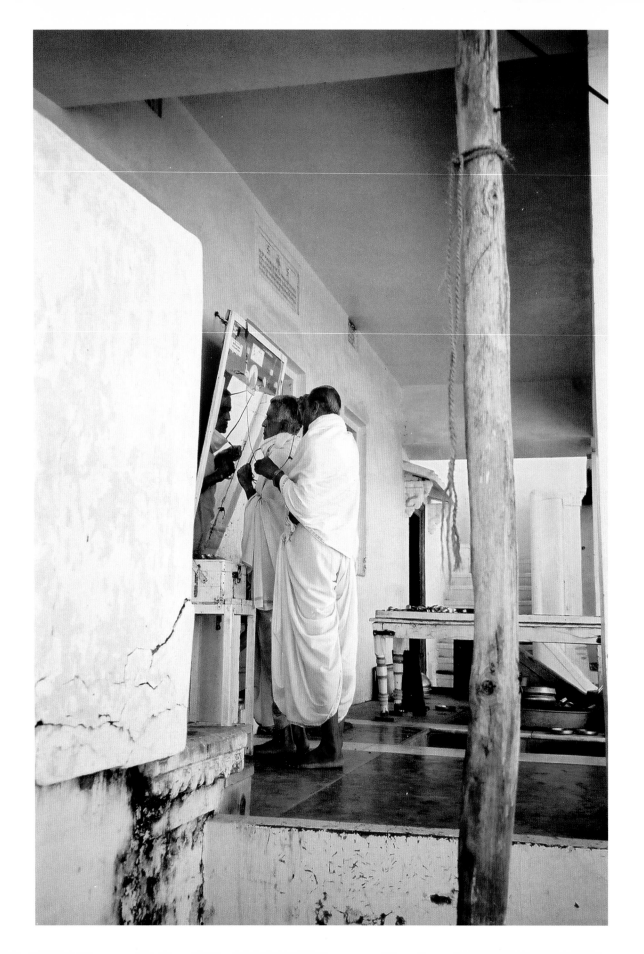

*Boys in white suits, their wedding band uniform, seated in front of the band clubhouse on a back street, Pushkar*

OPPOSITE: *Jain priests contemplating themselves in a temple mirror, Samdi, Gujarat. Jains believe that all life is sacred and that the infinite universe was not created by any deity.*

*A society wedding, Varanasi*

OPPOSITE: *Newlyweds in Trimbak, Maharastra. The electric keyboard is wired to the car's engine.*

*A Chhow Dance drummer with his son during an interval, Baripada*

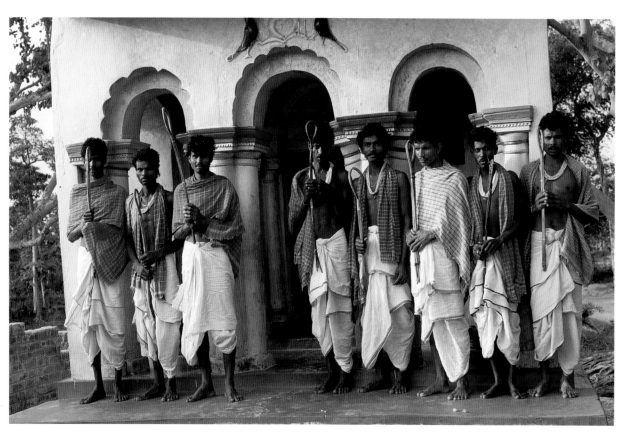

*Dancers as shepherds in a village festival along the*
*Calcutta-Vishnipur road in West Bengal*

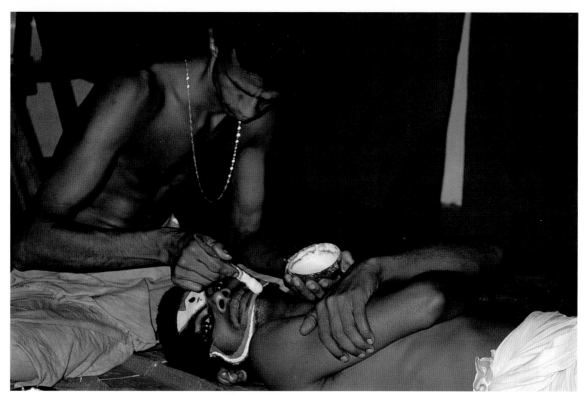

*A Kathakali ("story-play") star and his make-up man, Cochin, Kerala. It takes hours to transform dancers into gods and demons for this puppetlike court dance indigenous to Kerala in which scenes from the great epics, the* Ramayana *and* Mahabarata, *are enacted. Manayola, the primary make-up base, is an Ayurvedic germicide that prevents skin diseases from spreading among dancers who share the same make-up gear.*

*A dresser, diva, and leading man from a* jatra *company that performs traditional traveling plays and operas in tents, Bhubaneswar, Orissa. In Orissa today, even in the Age of Bollywood, acting in such groups is not considered altogether proper for women.*

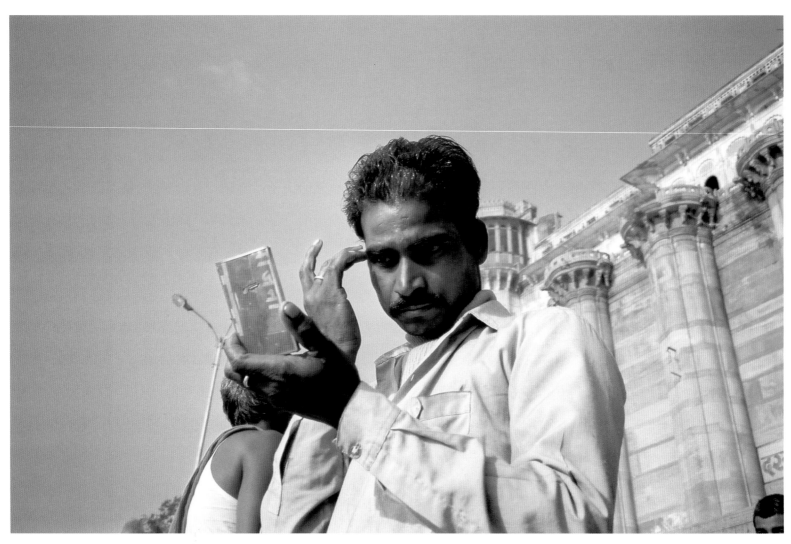

*A bather intent on putting the finishing touches to his
morning's grooming on the ghats, Varanasi*

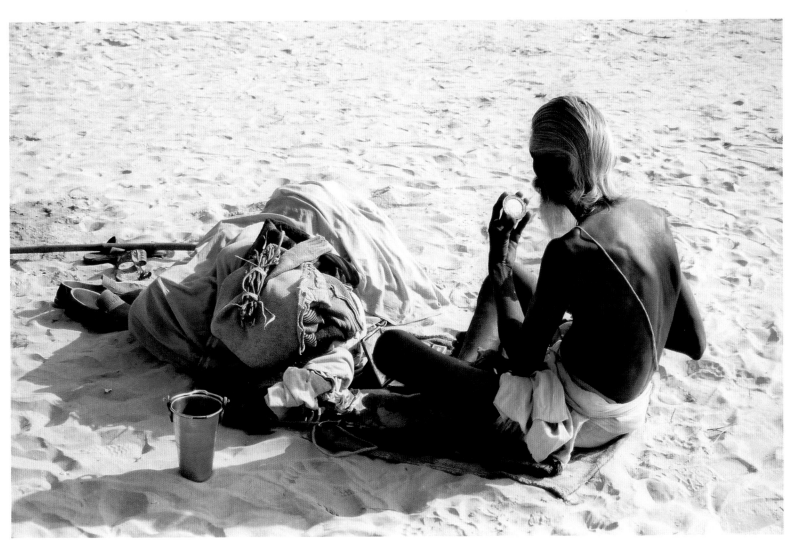

*Pilgrim after bathing, Gangasagar, West Bengal*

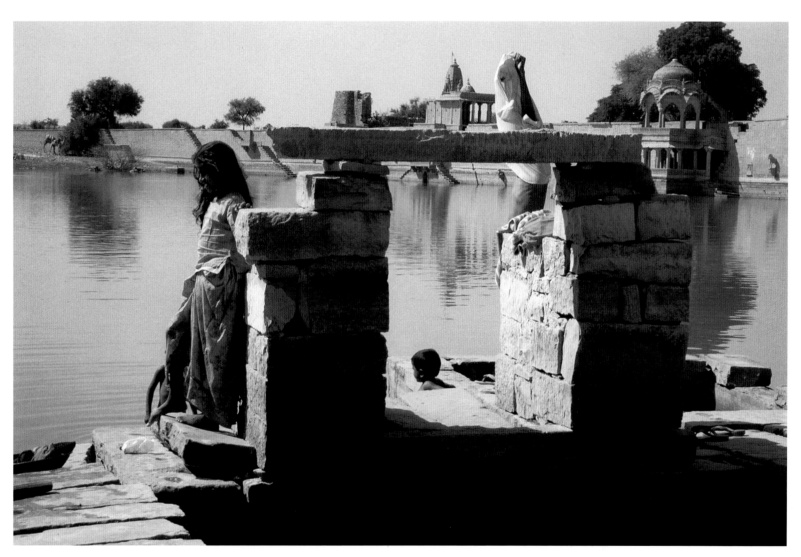

*A family bathing at Amar Sagar, outside Jaisalmer, Rajasthan*

OPPOSITE: *Sand sculpture, Puri beach, Orissa*

*A Lepcha dwelling in Dharap village, outside Gantok, Sikkim*

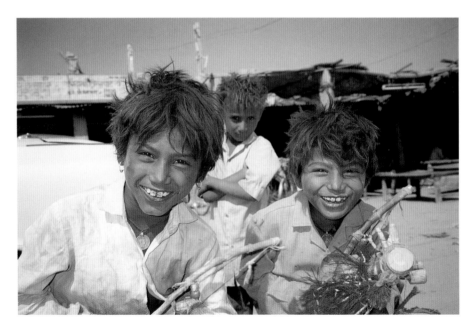

*Buskers at highway truck stop west of Bikaner, Rajasthan*

OPPOSITE: *Friends, Puri*

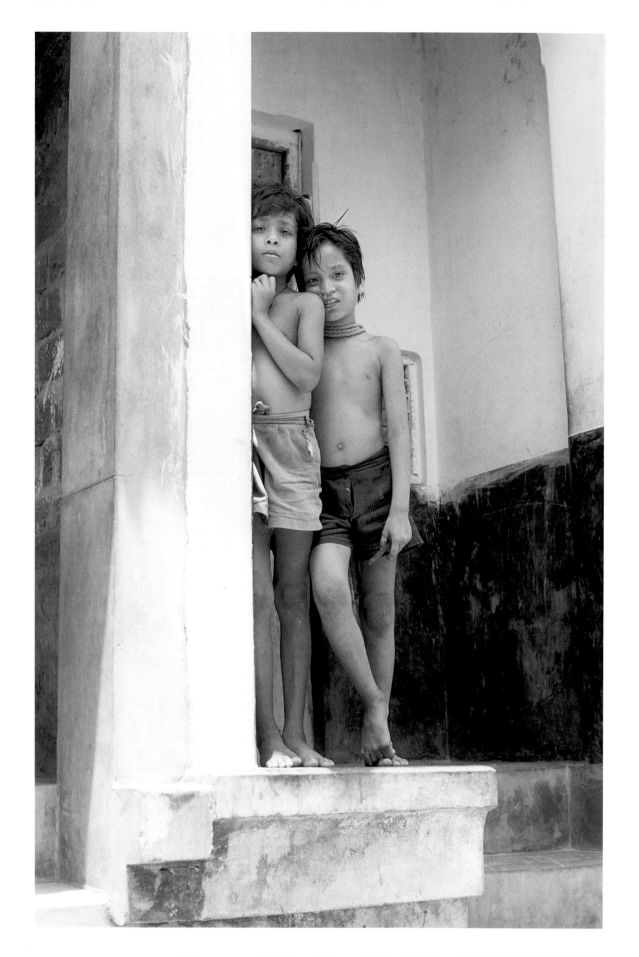

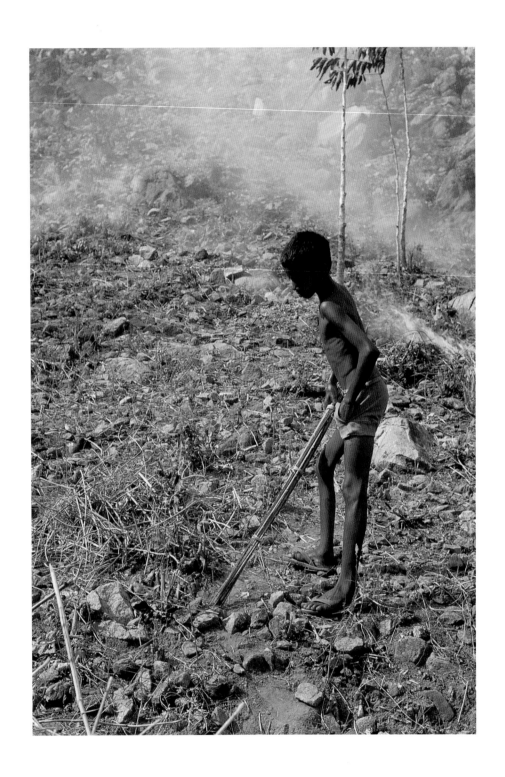

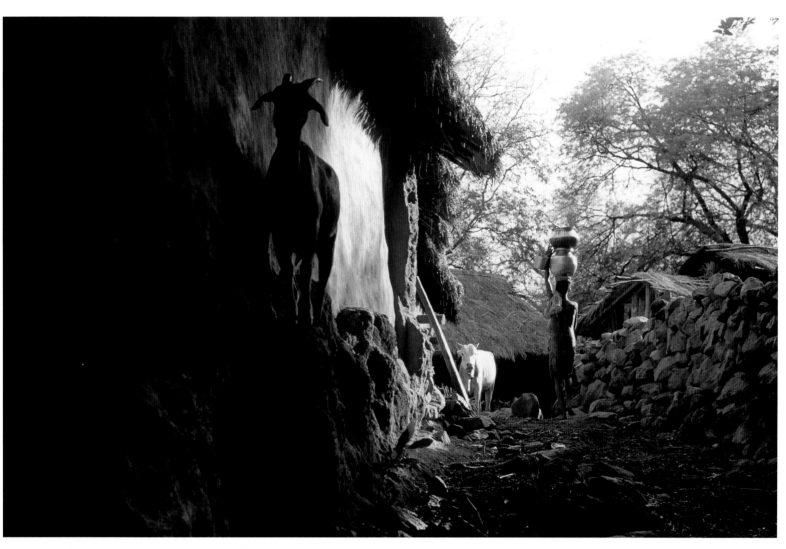

*A Saora village, Eastern ghats, Ganjam District, Orissa*

OPPOSITE: *The Saora, who practice slash-and-burn, the oldest of all agricultural methods to make their hilly land ready for seeding, raise only enough cereals and millet to last them for four months. For the rest they depend on wild nuts, tubers, and the leaves of edible plants. Phulabani District, Orissa*

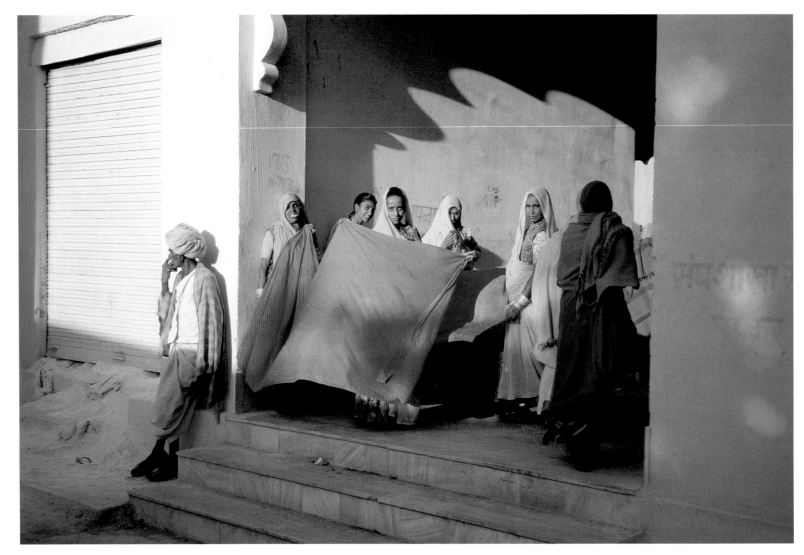

*An entrance archway to a village near Khimsa, Rajasthan. Visitors who call when a husband is away from home are not permitted to advance farther than the village gate.*

OPPOSITE: *Gossip at the gate to a haveli, Jaipur, Rajasthan*

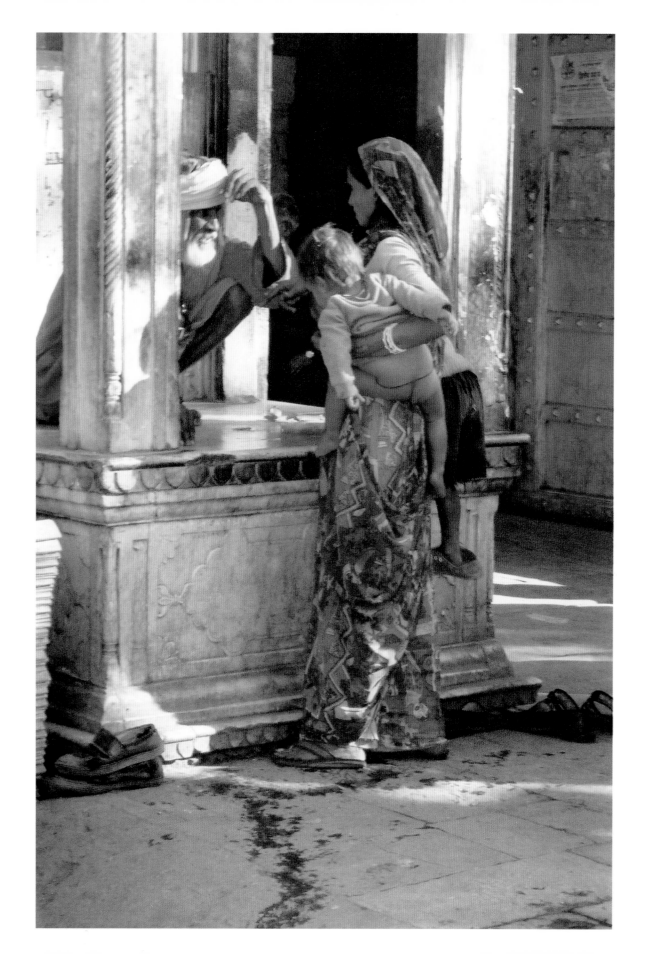

*Horse-drawn carriage awaits repairs, red-light district, Falkland Road, Mumbai*

OPPOSITE: *A cow in front of a haveli, a grand house surrounding a courtyard in Fatepur, Shekawati, Rajasthan. Shekawati has many villages filled with havelis built by Marwaris, clever traders who left home in the early 1880s when the East India Company began to levy oppressive taxes. They headed for Maharastra, especially Bombay. When they made their fortunes, they commissioned artists from outside the region to paint their houses back home lavishly, highlighting sprightly thematic murals with silver and gilt and mirrorwork.*

212

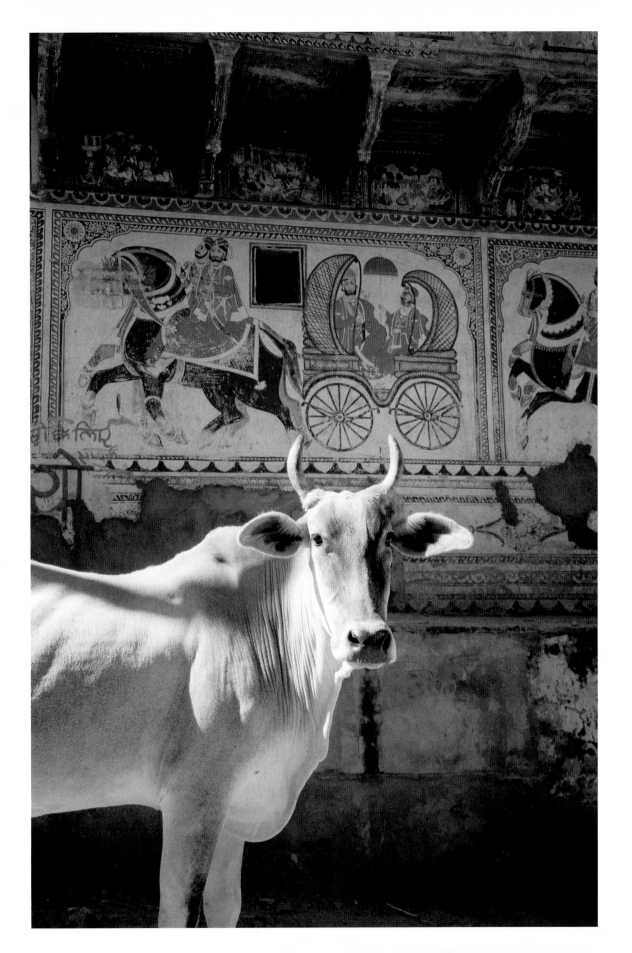

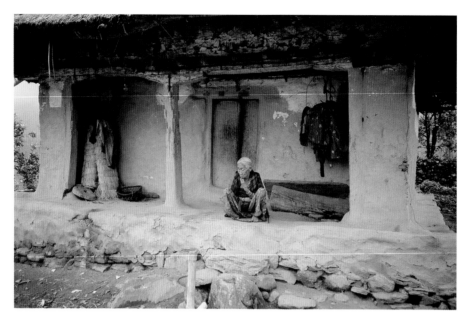

*Elevated "li"—traditional house of the Lepcha tribe, mountain village, Sikkim*

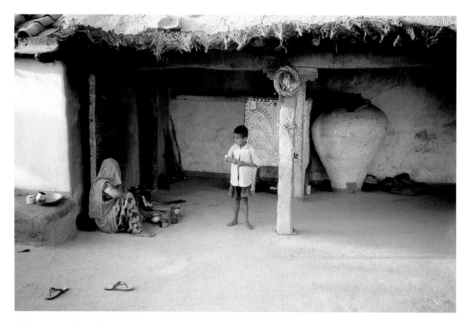

*The interior of a village compound near Rohatgarh, Rajasthan*

*Krishna's Butterball, Mahabilapuram, Tamil Nadu. Krishna, often depicted as a child looking after cattle, was fond of mischievously hurling balls of butter.*

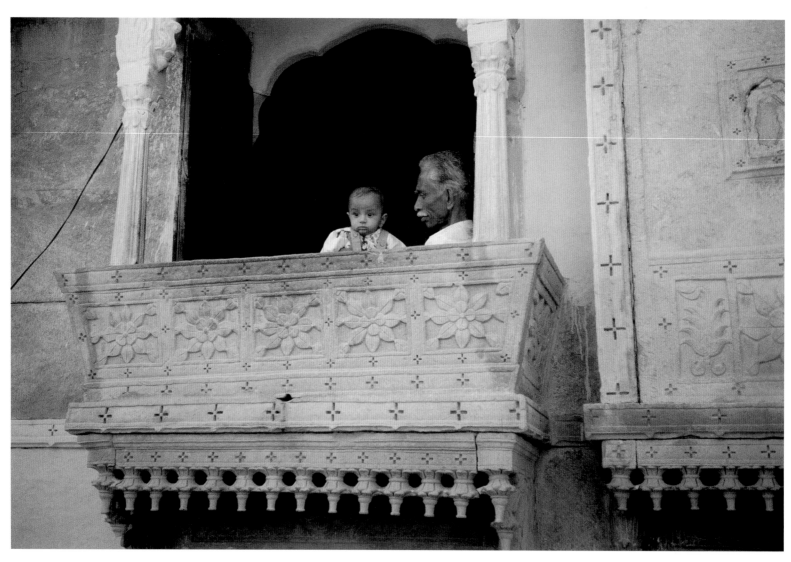

*A grandfather dandles an infant on his lap in a balcony window,
inside Jaisalmer Fort, Rajasthan.*

*A front porch in Puri*

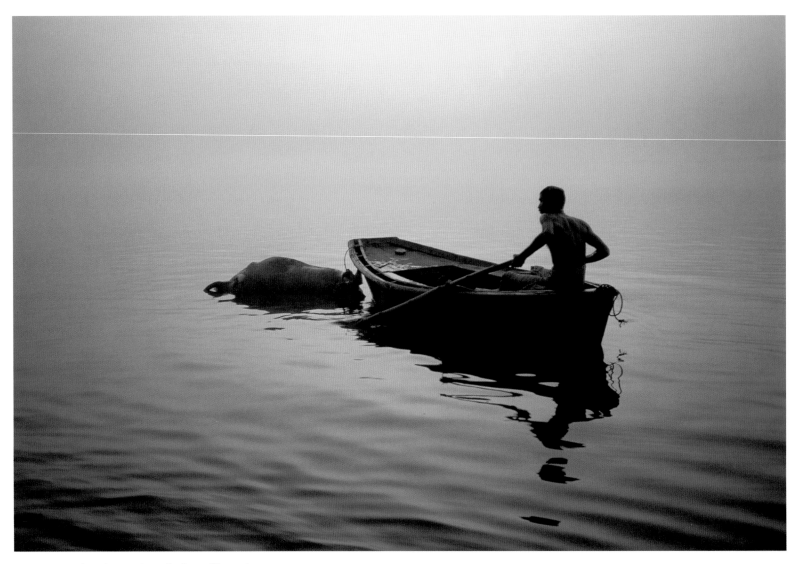

*A rowboat towing a dead cow, Varanasi*

OPPOSITE: *A Rabari elder at the end of the day's travels, the Little Rann, Gujarat*

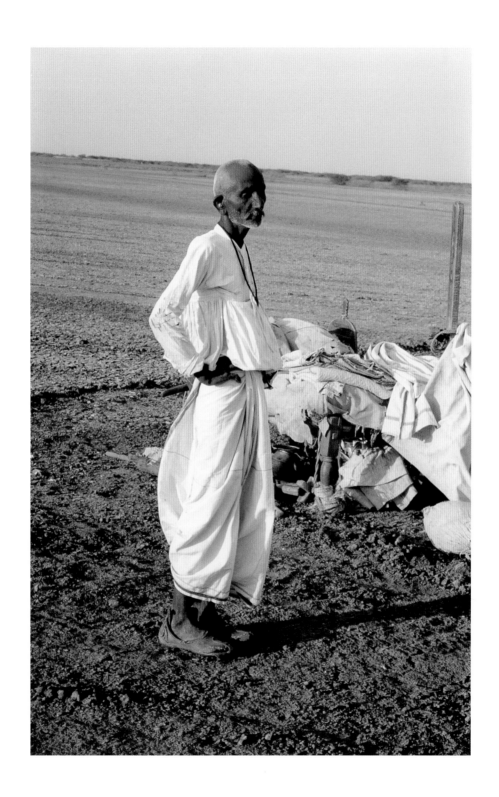

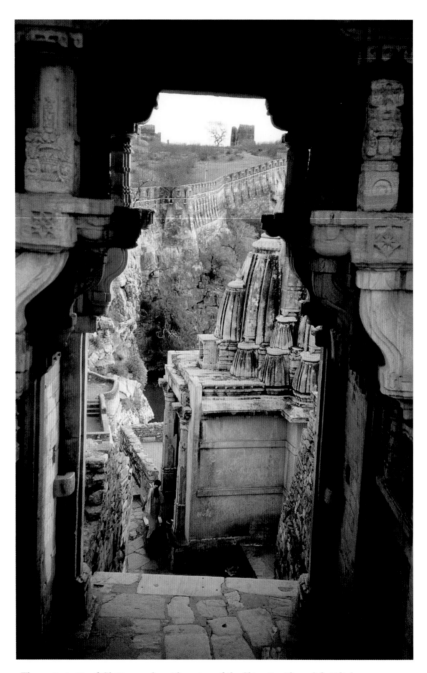

*The ancient city of Chittaurgarh, with a view of the Shiva temple and fortified wall through a stone gate. Despite its apparent impregnability, the city fell repeatedly to besiegers, and each time its womenfolk committed suicide en masse by hurling themselves into fire. Rajasthan*

# *index*

Page references in *italics* indicate illustrations.

**A**
Abdullah, Nawab Jafar Mir, 18–19
absolute or Universal Soul, 97
Agra, 8, *44, 45, 62*
agriculture and farming, *57, 69, 70, 208*
Ahmedabad, 19, 163, 180, *190, 191*
AIDS/HIV, 15, 178, 181
Ajanta, 20
Ajmer, *46, 54–55, 137, 156,* 165
Alamgir Mosque, 25
alcohol, 100
Allebad, 30
Alloobari Monastery, *152*
Amar Sagar, *205*
Amritsar, 20, *48, 140, 147*
androgynous/hermaphroditic
    characteristics, 178–79. *See also hijra*
animism, pre-Hindu, 96, *122, 145,* 166,
    171–72
art, sculpture, and statues, 14, 19, 20, *66,* 83,
    89, 92–98, 108–10, *115–22, 125, 152–54,*
    172–75, *204*
Aryans, 13
ash, use of, 87, *127, 133*
ashrams, 16, 85
Assam, 88
Aurangabad, 21, *58–59,* 92
Auribindo, 88

**B**
Babu ("Father"), *146*
Bahuchara, 179–81
Banjiri, 164–68
barbers and shaving, 29, 30, *40, 41,* 98
Baripada, 169–71, *200*
basil plant, *150*
bathing and washing, public, 9, 13–14, 20, 24,
    26, 28–30, *32–39, 49, 53, 64,* 87–90, *138,*
    *140, 202–3, 205*
Bauls, 86, 89
bazaars, markets, and shops, 8, 13, 28–30,
    *54–55, 71,* 99–100, 182
Beas River, 107, 110
Becha Mata Temple, 12, *75*
beggars and con artists, 8, 13, 15, 82, 89, *144,*
    *155,* 180, 182, *206*
Behula, 89
Beluchistan, 163
Benares. *See* Varanasi
*bhaktis,* 95, 169–71, 175
*bhang,* 29
Bharat Sevashram Sanghe, 85

Bhavnagar, *72*
Bhubaneswar, *186, 201*
Bhuj, *148, 150*
Bhutias, 99, 104
Bihar, *139*
Bikaner, *206*
bisexuality, 180
Biswamber Pith, 17
boats, 20–21, 25–26, *27, 33, 124, 125, 185,*
    *187, 218*
Bollywood and films, 177–79
Bombay. *See* Mumbai
Bon religion, 103
Brahma, 22, 95, 97, *116, 138, 144*
Brahmanas, 22
Brahmins, 16, 22, 82, 88
*Brihadaranyaka Upanishad,* 88
Buddha and Buddhism, *4,* 20, 26, 86, 87,
    92–106, *125, 133, 152*

**C**
Calcutta, 8, 12, 20, *38, 42, 65, 79,* 83, 91, 102,
    *116–21, 143, 200*
camels, 7, 162–63, *188, 191*
caste system, 22, *65,* 95, 172
cattle, 24, *68, 118, 130, 190–91, 213*
Chaitana, *63*
Chantikoma, 171, 172
Chhow Dance, 169–71, 175, *200*
children, 8, 12, 26, 29, *36, 50–51,* 104–6,
    *154–55,* 162–63, 170–71, 178–79, *206–8,*
    *216*
Chilika Lake, *68, 159*
chillum, 88
Chinese, 13
Chisti, Hazrat Khwaja Moinuddin, *54–55*
Chittaurgarh, *220*
Chowpatty Beach, 181
clothing and textiles, 13, 14, 16–17, 24, *54,*
    *58–59, 115, 146,* 164, 165, *193, 195*
Cochin, 12, *201*
corpses, death, and cremation, 14, 25, 29–30,
    85, *158*
cricket, 13, 24, 96

**D**
Dabar Sahib, *140*
Daksa, 22
Daksheneswar, *116*
dancing, 15, 18–19, 77, 109, *135, 136,* 169–75,
    *199, 200*
the Dargah, *54–55*
Darjeeling, *50,* 94, 99, *119, 152, 157*
*darshan, 117*

Dasada, *39, 58,* 164–67, *194*
death, corpses, and cremation, 14, 25, 29–30,
    85, *158*
the Deccan, 96, 98
Delhi, 12, 13, 14, 16
*devidasi* (temple prostitutes), 177
*dharamsala, 147*
Dharap village, *206*
Dongria Kondh, *71,* 171–74
Dravidians, 13, 171
drugs, 88, 100
Dubdhi, 102, 103
Dughti Temple, 107
Durga, 20
Durgiana Temple, *147*
Dussehra, 7, 107–14, *126–28*

**E**
Eklingi, *158*
Eknath (Saint), 7, 95–96, *134, 135*
Ellora caves, 92–98

**F**
farming and agriculture, *57, 69, 70, 208*
Fatepur, *213*
festivals and ceremonies, 7, 13, 15. *See also* spe-
    cific events
films, 177–79
fishing, 14, *53, 56, 184, 185, 187*
flooding and erosion, 107–14
flower markets, 8, *142, 143*
food and cooking, 24, *46, 47, 48, 183*
Fulwadi, *58, 194*

**G**
*gair,* 19
Gandhi, Indira, 96
Gandhi, Mahatma, *65*
Gandhi, Rajiv, 96
Ganesh, 27, 98, *121*
Ganga (Mother Ganga), 85, 86, 88, 89
Gangasagar, 7, 82–91, *130–33, 203*
Ganges River, 6, 16, 23–27, 29, *31, 35, 67, 74,*
    82–91, *129, 131, 218*
ganja, 88
Ganjam District, Orissa, *209*
Gantok, 99–102, *206*
gems and gem trade, 11, *46*
genital modifications and ascetic practices, 87,
    90, *133,* 177
Ghamuk, *115*
Godavari River, *81,* 96, 97
Golden Temple, Amritsar, 20, *140–42*
*gotipua,* 18

Gujarat, *2,* 8, 12, 19, *39, 53, 58, 69, 72, 75, 122, 148, 150,* 161, 164, 178–80, *192–96, 219*
*guurs* (shamans), 108, 110, 111, *126*

**H**
Hadimba, 107, 108, 109
Haji Ali, 182
Hanuman, 17, 24, *81,* 96, 97, *118*
Hare Krishna, 91
harijans (untouchables), *65*
haveli, *211, 213*
hermaphroditic/androgynous characteristics, 178–79. *See also hijra*
*hijra,* 55, 75, 177–80
Himachal Pradesh, 7, *57,* 107, *126*
Hinduism, 14–15, 16, 22–23, *65, 67, 75,* 92–98, *116–17, 120, 133*
HIV/AIDS, 15, 178, 181
holy men (sadhus), monks, and priests, 83–91, 96, 99–106, 108, 110, 111, *117, 126, 127, 130, 133, 143, 145–57,* 170, 173–74, *196*
homosexuality, 180
Hoogly River, 8, *116, 187*
horses, *189*
Howra Bridge, 8
human body, 7, 9, 12–30, 101, 176–82

**I**
icons, *117*
Indra, *115*
Islam, 14, 18–19, *54–55, 65, 75, 76,* 87, 89, *133, 137, 156,* 177
Iyengar, Shri B. K. S., 16–17

**J**
Jagagharas, 17
Jagannatha, 17
Jagganath, *154,* 172
Jain religion, 86, 92, *196*
Jaipur, *211*
Jaisalmer, *76, 139,* 163, *183, 205, 216*
Jalasayin Ghat, 25
Jama Mosque, 21
Jamraj, 89
Janghir Khan, 25
Jat, 161
*jatra,* 201
Jeru, 180
Jodhpur, 77

**K**
Kailasa Temple, 92–93
Kalarippayattu, 12
Kali, 105, 106, 173
Kali Puja, 84
Kali Temple, Calcutta, 82–83, *116*
Kalijai, *159*
Kalinga, 17
Kama, 22

*Kama Sutra,* 14–15
Kamar, Kishore, 96
Kangra Valley, *57*
Kapaleshwar Temple, 97
Kapil Muni Temple, 85, 86, 88
Kashi, 26
*Kashi Khanda,* 29
Kashmir, 88, 100
*Kathakali, 201*
Katrain, 110
*kattak,* 18
*Kerala, 201*
Khajaraho Temple, 13
Khangchendzonga Peak, 102
Khimsa, *210*
Kipling, Rudyard *(Kim),* 12, 15
Kitchen Ram Temple, *46*
*Koka Shastra,* 179
Konarak, 14, 18, *78, 184*
Kondhs, *71,* 171–74
Krishna, 86, 110, *154, 157,* 166
Krishna, Professor Anand, 27
Krishna's Butterball, *215*
Ksatriyas, 22
Kullu Valley, 7, 107–14, *126–28*
the Kutch, *53,* 161, 163, *193*

**L**
Lahore, 107
Lake Kecheoperi, 102
Lakshminder, 89
Lamas and Lamaism, 99–106
Lepchas, 99, 104, *153, 206, 214*
Lhatsun Namkh Jigme, 104
lingam stones, 23, 85, 97
the Little Rann, 164–68, *219*
Lucknow, 8
Lurni, 171–75

**M**
Madurai, 19, *134, 136, 145,* 179
*Mahabharata,* 85, 89, *201*
Mahabilapuram, *215*
Maharaj, Shri Tokdoji, 96
Maharastra, 7, 8, 15, 19–20, *41, 58–59, 81,* 92, *123, 151, 213*
Malabar Hill, 176
Maliks, 164–68
Manali, 107
Manayola, *201*
Mandvi, *185*
Manikaran, 112
Markendeya, 22
markets, bazaars, and shops, 8, 13, 28–30, *54–55, 71,* 99–100, 182
martial arts, 12, 15, 18. *See also* wrestling
Marvada, *53*
Marwaris, *213*
massage, 14, 29, *36*
*masti,* 6, 27–30, 105

*maya,* 22
Meenakshi Temple, 19
Menakshee, 179
Midialo, *195*
migrant laborers, *139*
Mirik, *70*
Momai Mata, 165
monks. *See* holy men (sadhus), monks, and priests
Mother Ganga, 85, 86, 88, 89
Mother Goddess, 96, 166
Mother Theresa, 83
movies, 177–79
Mt. Abu, *115*
*mudra,* 28
Mumbai (Bombay), 8, *40, 41, 49,* 176–82, *212, 213*
music, musicians, and musical instruments, 14, *55,* 76–77, 86–89, 101, 108–9, *126, 137,* 169–75, 176–77, *197–98, 206*
Muslims and Islam, 14, 18–19, *54–55, 65, 75, 76,* 87, 89, *133, 137, 156,* 177

**N**
nagas, 87, 90, *133*
Naggar, 110–11
Nal-Jor Ched-Shi, 103
Nandi, *118*
Naranda, 22
Nashik, 96–97
Nasik, *81, 123, 151*
Nataraja, 18
Nath Shastri, 95
Nehru, Pandit, 96
Nepalese, 99, 100, 110, 177
New Delhi, 21
Nimaj, *60*
Nirguna Brahman, 97
Nuanai River, *56, 78*

**O**
obesity and overweight, 179–81
Old Menali Village, *52*
opium, *73*
Orissa, 7, 14, 17, *42, 51, 56, 63, 66, 68, 71, 78, 125, 159,* 169–75, *184, 186, 201, 204*

**P**
Paithan, 7, 19, 95, *134, 135*
Palumpur, *57*
Pandey, Rakesh, 24–26, 28, 29
Parasurama, 12
*Partners of the Mind,* 86
Parvati, 19, 25, *118,* 163
Parvati Valley, 112
Pashina, *122*
Patnaik, Arun, 82–91
Pelling village, 105
Pemayangtze, 102
photography, 6–9

Phulabani District, Orissa, *208*
pilgrims and pilgrimage, 24, 82–91, 100, *124, 130–33, 138, 141, 147, 156, 203*
pipal trees, *116*
Poshina, 163, *190, 191*
pottery, 20, *60, 63*
Pradhan, Guru Gangahar, 18
*pranapratishta,* 94
*prasad,* 88, 111, *155*
prayer beads, *146*
prayer wheels and flags, *4,* 103, 105
priests. *See* holy men (sadhus), monks, and priests
printing, 101, *153*
prostitutes, 177
Puja, 7
*puja, 67,* 98
Punjab, *48, 125, 140, 147*
Puranas, 22
Puri, 11, 17, *42, 61,* 172, *207, 217*
Puri Beach sand sculptures, *125, 204*
Pushkar, 7, *47, 55, 118, 138, 144, 155,* 162, *188, 189, 197*
Pythagoras, 86

**R**
Rabari, *2,* 162–68, *189, 190, 191, 192, 193, 195, 219*
ragas, 176
Raghurajpur village, *51*
Ragunathji, 107
Raikas, 163
Rajasthan, 7, 8, 19, *46–47, 54–55, 60,* 73, *76, 115, 118, 137–39, 144, 158,* 163–64, 180, *183, 205–6, 210–11, 213–16, 220*
Rajputs, 22
Ram-Kund, 96–97
Rama, *81,* 96, 107, 108, 109, 111, 113, 176
*Ramayana, 81, 201*
Rampool Valley, 100
Rana Mahal Ghat, 28
Ravanna, *81,* 107
Rhagurajpur, *66*
Rishikesh, 16
Roghurajpura, 18
Rohang Pass, 108, 111
Rohatgarh, *46, 73, 214*
Rumtek, 100–102, *153*

**S**
Sa-nga-choe-ling, 105
sadhus. *See* holy men (sadhus), monks, and priests
Saint Eknath, 7, 95–96, *134, 135*
salt, transporting, *68*
Sam, *76*
Samdi, *196*
Samode, 19
Sankalpur, 12

Sankhya, 86
Saora, *154,* 173–75, *208, 209*
Saraswati, *120, 125*
Saraswati Puja, 7, 25–26, 27
Sarnath, 26
*satara,* 76
Sati, 22, 23, 83
sculpture, art, and statues, 14, 19, 20, *66,* 83, 89, 92–98, 108–10, *115–22, 125, 152–54,* 172–75, *204*
sexuality and eroticism, 14–15, 87, 88, 176–82
shamans *(guurs),* 108, 110, 111, *126*
Shankar, Professor T., 16
Shankaracharya, 84
Shekawati, *213*
shipbuilding, 20–21, *185*
Shiva, 18, 19, 22, 23, 83, 84, 85, 95, 97, *116, 118, 123, 136, 155,* 163, 179, *220*
Shivaratri, *134, 136*
shops, bazaars, and markets, 8, 13, 28–30, *54–55, 71,* 99–100, 182
Shree Meenakshi Temple, *136*
Shree Swami Narayan Temple, *148, 150*
Sikhs and Sikhism, 20, *140*
Sikkim, *4,* 7, 21, *41,* 99–106, *153, 206, 214*
Singh, M., 110–14
Singh, Paddy, 107–12
Singh, Vibhooti Narain (maharajah of Varanasi), 6, 26–27, 30
Sita, *81,* 96, 176
Sri Lanka, *81,* 176
stone-cutters, 20, *61, 62*
street entertainment, 12–13, 180, *206. See also* dancing; music, musicians, and musical instruments
substance abuse, 88, 100
Sudras, 22
Sufis and Sufism, *54–55, 137, 156*
Sun, Temple of, 18
Sunderbans, *53*
Supakar, Guru Gagunath, 17–18, *42*
Surya, *139*

**T**
Tamil Nadu, 19, *136, 145,* 179, *215*
*tanday, 136*
tanning, 65
Tantra, 88, 91
Tashidang, 102
tattooing, *41*
textiles and clothing, 13, 14, 16–17, 24, *54, 58–59, 115, 146,* 164, 165, *193, 195*
Thuggies, 91
tightrope walking, 12
Tin Tal cave, 93, 94, 98
tongues, speaking in, *145*
tree worship, *116, 121*
tribal groups, 99, 162–68, 173–75. *See also* specific groups

Trimbak, 97–98, *198*
Trimbakeshwar Temple, 97–98
Tulsi Das, 25

**U**
Universal Soul, 97
untouchables (harijans), *65*
urine and urinals, 111, 113, 114
Uttar Pradesh, 7, 16, *45, 52, 67*

**V**
Vahika, 29
Vaishnite cults, 172
Vaisyas, 22
Varanasi (Benares), 8, 13, 14, 22, 26, *32–37, 64, 67,* 74, 77, 113, *124–25, 129, 149, 199, 202, 218*
Varanasi, maharajah of (Vibhooti Narain Singh), 6, 26–27, 30
Vedas, 22, 98, 178
*viju,* 173–75
Vishnipur, *200*
Vishnos, 73
Vishnu, 22, 86, 95, *116, 150, 151, 154*
vultures, 29

**W**
Wankaner, *69*
water buffalo, 24
water cremation, 85
weddings, *197–99*
wells and water, *72*
West Bengal, 7, *38, 51, 53, 70,* 82, *131, 133, 152, 187, 200, 203*
white widows, *74*
work, human body at, 20–21. *See also* specific jobs
wrestling, 15, 17–18, *42, 43, 44, 45, 81, 118*

**Y**
Yaksam, 102–6
Yamuna River, 17
Yellamma, 177, 182
yoga, 16–17, 18, 24–26, 28

*Acknowledgments*

The realization of this project has been described as "a fairy tale in an age of iron." We are grateful to many people for helping the book come true. Thijs Chanowski set us on the path, and Andreas Landshoff spurred us on. Paul Gottlieb blessed the enterprise with enthusiasm: "These pictures are India the way it really is!" We regret his not living to share more of his contagious delight in the book that has emerged. Eric Himmel's unflappable tenacity saw us through. Barbara Burn's editing was consistently helpful, acute, and comparatively painless. Diana Blok gave valuable photographic advice and encouragement and shared our rickshaws. In India, Captain Paddy Singh opened doors and rescued us from difficulties, both man-made and natural. Bilou and Toshi Goswami, even while beleaguered by heavy government responsibilities, had time to help us appreciate the generosity of Indian friendship. India Tourism provided essential support, with Krishna Arya and Mrs. Roma Singh going to great lengths to make our memorable journeys possible. Cox and Kings spoiled us silly. Anup Kumar Saha, our first guide and now a friend, belies R. K. Narayan's bitter assessment of the vocation's dubious moral fiber. Mario Horne managed to produce photocopies of baffling high quality. Alice Rose George urged us on with critical acumen, heightened, not tempered, by love. Kathy Cox, in her present incarnation gaining renown as Madame Vastu, and Bobby Hamburger lured us to India, rightly confident that India would do the rest.

Editor: Barbara Burn
Designer: Carole Goodman/Blue Anchor Design
Production Manager: Stan Redfern

Library of Congress Cataloging-in-Publication Data

Bloch, Don.
  Seduced by the beauty of the world: travels in India/ text by Don Bloch; photographs by Iman Bijleveld.
    p. cm.
  ISBN 0–8109–4543–6 (hardcover)
  1. India–Description and travel. 2. India–Pictorial works. 3. Bloch, Don–Journeys–India. 4. Bijleveld, Iman–Journeys–India. I. Bijleveld, Iman. II. Title.

  DS414.2.B59 2003
  954.05'2–dc21
                                    2003004495

Text copyright © 2003 Don Bloch
Photographs copyright © 2003 Iman Bijleveld

Published in 2003 by Harry N. Abrams, Incorporated, New York.

Printed and bound in China

10  9  8  7  6  5  4  3  2  1

Harry N. Abrams, Inc.
100 Fifth Avenue
New York, N.Y. 10011
www.abramsbooks.com

Abrams is a subsidiary of

LA MARTINIÈRE
G R O U P E